REUTERS

OUR
WORLD
NOW

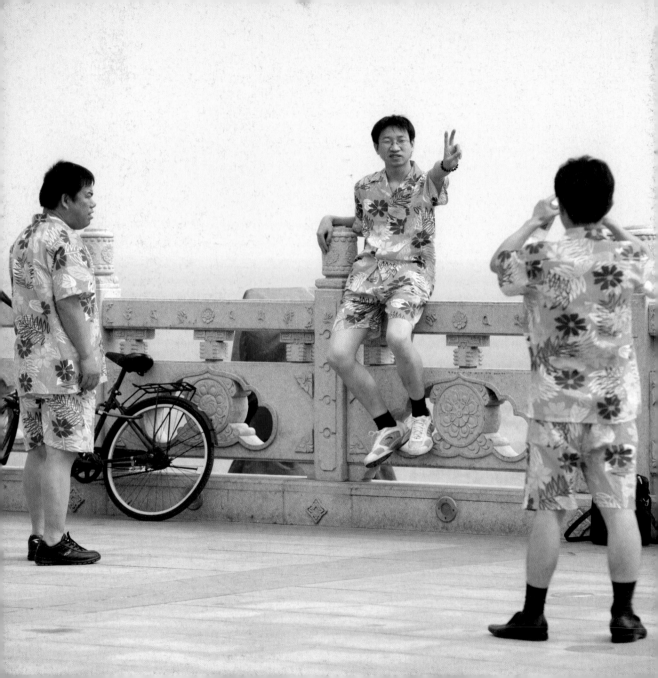

REUTERS

OUR WORLD NOW

With 361 color illustrations

Thames & Hudson

Page 2 Tourists photograph each other near a temple at Nanshan
Cultural Centre in south China's Hainan Island province. China's
domestic tourism is booming, while loosened travel restrictions and
economic growth mean that increasing numbers also travel abroad
as never before. Hainan Island, China. 26 November 2007. Nir Elias.

Conceived, designed and produced by Thames & Hudson Ltd, London

For Reuters:
Executive director Monique Villa
Picture editor Ayperi Karabuda Ecer
Project director Jassim Ahmad

Copyright © Reuters 2008

License pictures from Reuters for professional use at reuters.com/pictures

First published in 2008 in paperback in the United States of America by
Thames & Hudson Inc., 500 Fifth Avenue, New York, New York 10110

thamesandhudsonusa.com

Library of Congress Catalog Card Number 2007905649

ISBN 978-0-500-28730-9

Printed and bound in Slovenia by MKT Print d.d.

Contents

01
January / February / March

02
April / May / June

03
July / August / September

04
October / November / December

Framing Our World Now

Reuters photojournalists are continually bearing witness to events as they happen across the globe. They distribute some 1,500 photos a day – over half a million images each year. This award-winning work pushes the boundaries of what news photography is and can be.

Our World Now draws upon this unparalleled resource to document a year in the life of our vibrant, troubled, beautiful planet. Recalling 2007 in over 350 powerful photos, it offers a fresh take on the year's most memorable events, and plenty of surprises and less familiar stories too. It is the first volume in a series that will build year on year into an indispensable visual record of our era.

As the demand for in-the-moment news is met by broadcast and online media, the role of the printed press has shifted. Increasingly it falls to newspapers and magazines to provide commentary and perspective on the unceasing flow of reporting. There has been a corresponding shift in news

photography. While continuing to document events, photographers are also engaging with the big issues – the future of the planet, relations between the West and the rest of the world, human migration, the resurgence of faith.

Photographers must also rise to the challenge of constantly changing expectations: where once magazines might have printed a photo story in a sequence of pictures across several spreads, now it is ever more the individual image that must encapsulate the essence of the story.

News photography has come to encompass a vast spectrum of images that are in one way or another symbolic of our times – images that capture the atmosphere and go to the heart of the matter. Around the world, photographers are documenting their environment as never before. Totally at ease with the latest digital communications technology, they are reporting local news events for their own fast-developing national media as well as to meet

the appetite of international media organizations. They are producing a repertoire of images that are refreshing and real and much wider in scope and mood than anything we have seen to date.

Reuters is at the leading edge of all of these trends. It is the world's biggest international news organization, with 196 bureaux serving 131 countries and providing unmatched global news coverage. This book features work by 209 Reuters photographers of 65 different nationalities.

These remarkable images form a mirror of our times. Through them, we share an intimate, momentary encounter with well over a thousand individuals across the globe. Every reader will have a different response.

From the famous or infamous to the totally anonymous, here is a glimpse of destinies unfolding across our world now.

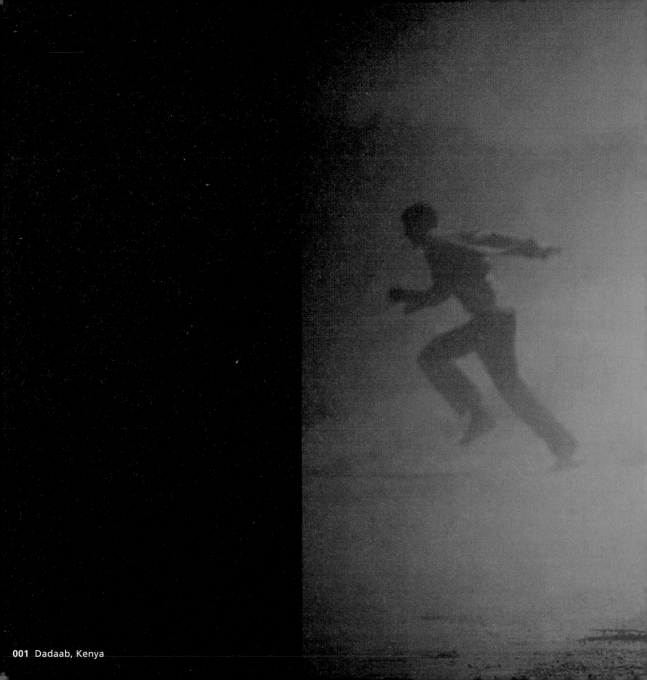

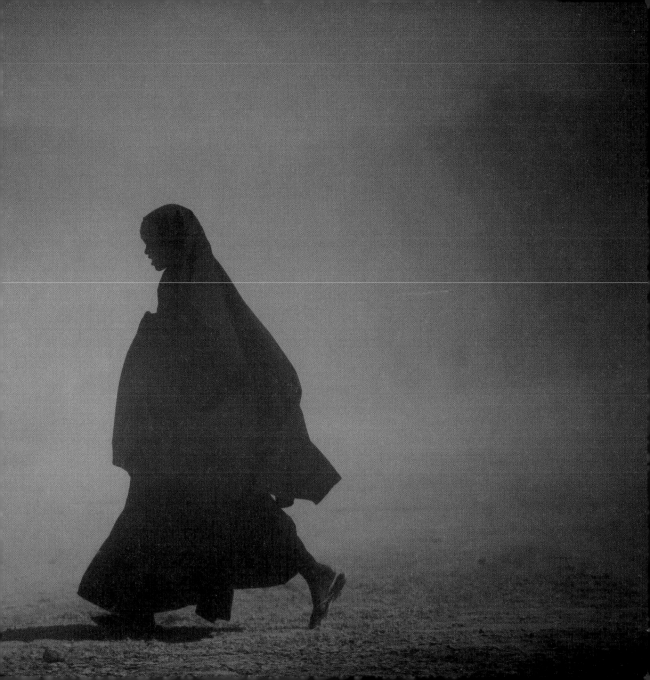

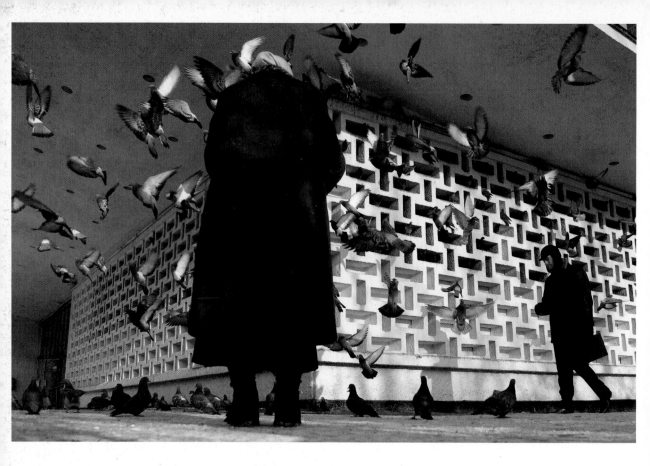

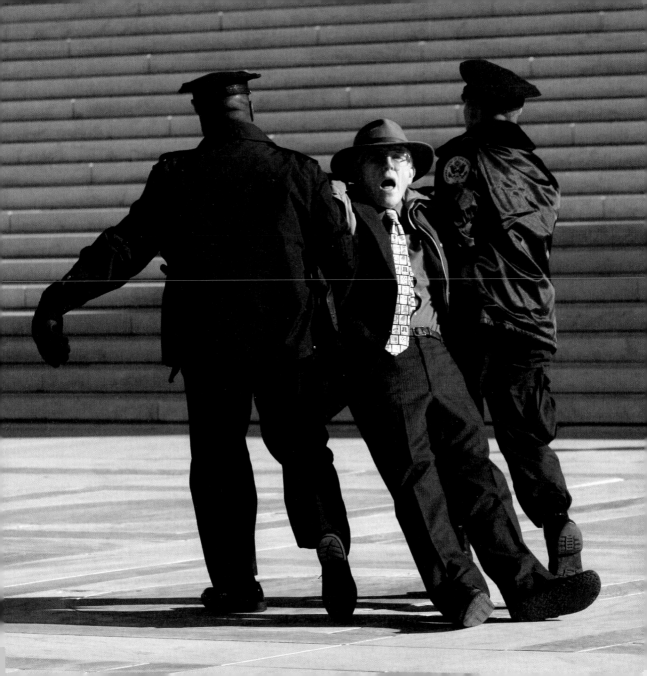

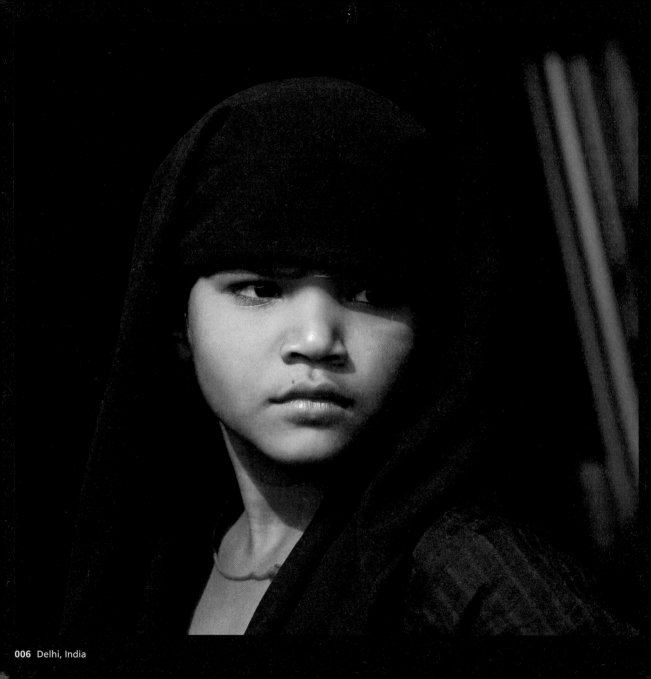

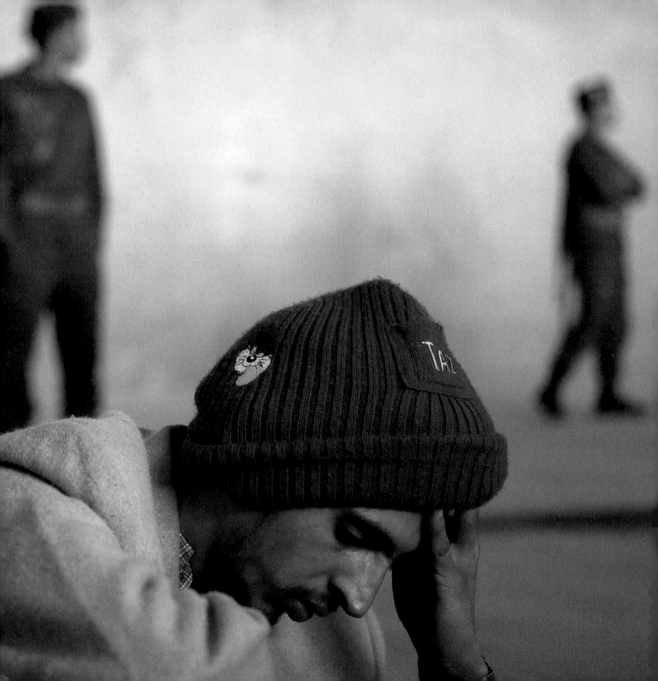

010 [OPPOSITE] Nouadhibou, Mauritania

011 Chenguetti, Mauritania

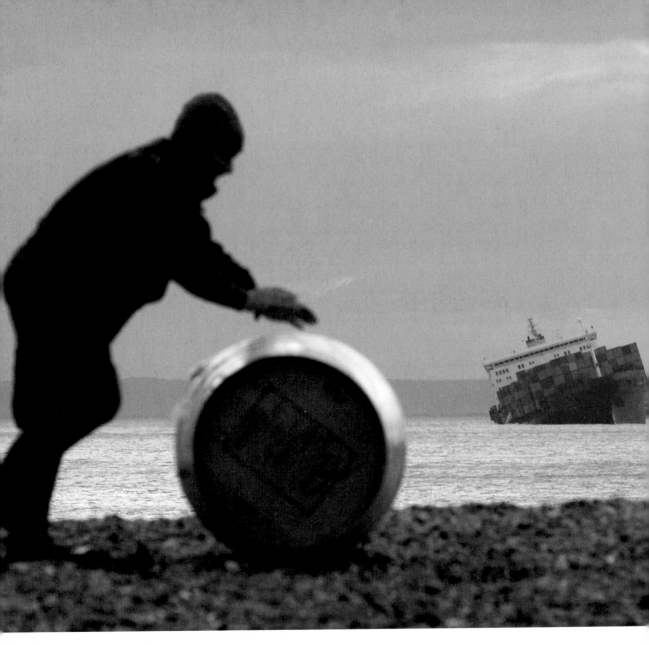

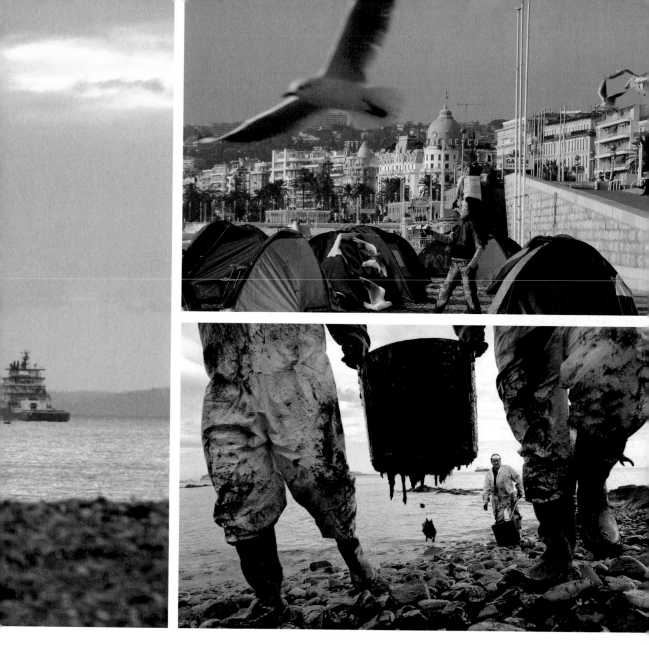

013 [TOP] Nice, France **014** [ABOVE] Algeciras, Spain

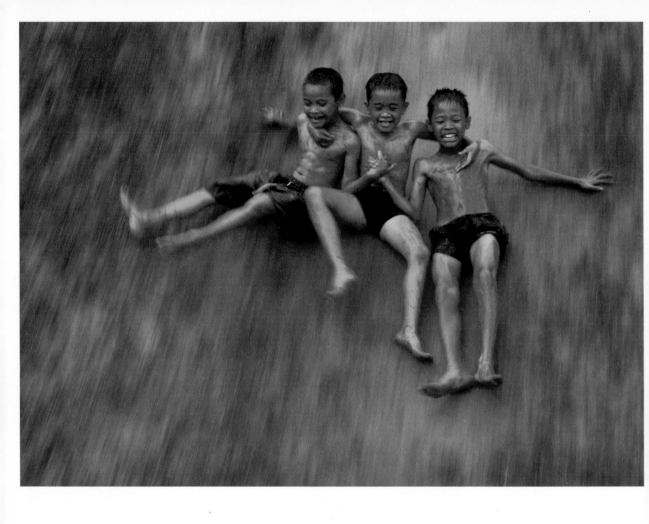

015 Serpong, Indonesia

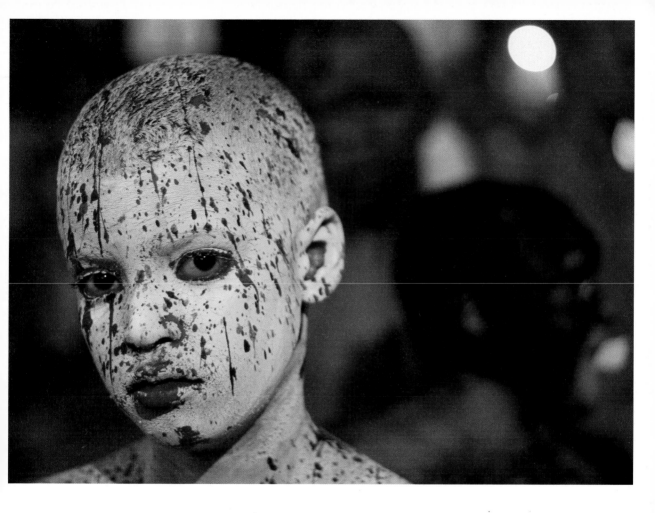

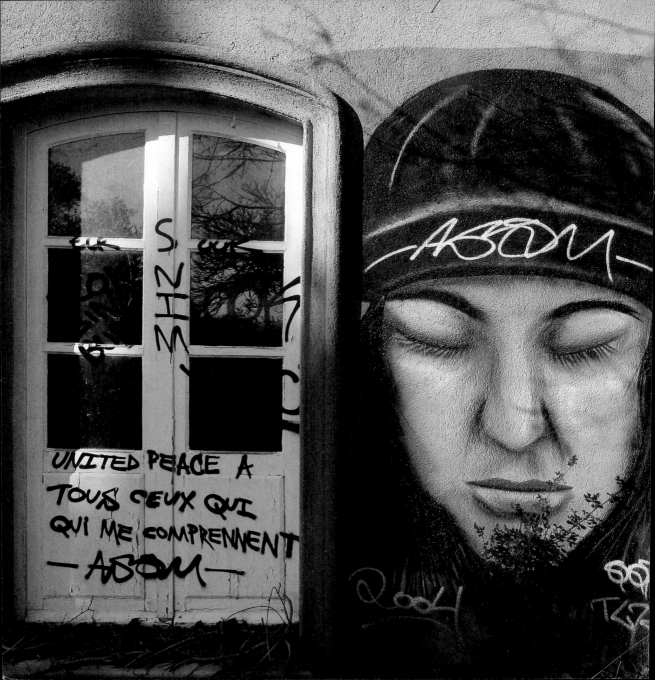

UNITED PEACE A
TOUS CEUX QUI
QUI ME COMPRENNENT
— ASOM —

001 Somali refugees run from the dust at Ifo refugee camp near Dadaab in northeastern Kenya, on the border with Somalia. 8 January 2007. Dadaab, Kenya. Radu Sigheti.

002 A woman feeds pigeons outside a Moscow metro station. 26 January 2007. Moscow, Russia. Thomas Peter.

003 Protester Jack Payden-Travers from the group 'Virginians for Alternatives to the Death Penalty' is dragged away by police following his arrest on the steps of the U.S. Supreme Court. 17 January 2007. Washington, DC, United States. Jason Reed.

004 A riot policeman holds a shield onto which a protester has thrown paint during a rally outside the Greek parliament building against government plans to reform higher education and introduce private universities. 10 January 2007. Athens, Greece. Yiorgos Karahalis.

005 A young Hindu devotee takes a shower before starting his pilgrimage to the sacred Batu Caves temple in Kuala Lumpur during Thaipusam festival. Hindus comprise over 8 percent of Malaysia's 26 million population. 31 January 2007. Kuala Lumpur, Malaysia. Bazuki Muhammad.

006 In Delhi's old quarter, a Shi'ite Muslim girl watches a procession on the final day of the week-long Ashura mourning rite, the highpoint of the Shi'ite religious calendar. 30 January 2007. Delhi, India. Desmond Boylan.

007 A man stands in front of a banner in Tehran during the Shi'ite Ashura festival. 30 January 2007. Tehran, Iran. Morteza Nikoubazl.

008 An Indian Shi'ite Muslim flagellates himself during a procession on the final day of the Ashura mourning rite. 30 January 2007. Delhi, India. Desmond Boylan.

009 The shadow of Afghan Shi'ite Muslims holding chains falls on a bloody street during an Ashura procession in Kabul. 29 January 2007. Kabul, Afghanistan. Ahmad Masood.

010 A would-be migrant to Europe rests at the port of Nouadhibou in northern Mauritania. Up to 400 migrants disembarked from a battered freighter intercepted by the Spanish coastguard, witnesses said. 12 February 2007. Nouadhibou, Mauritania. Juan Medina.

011 Prints left by Mauritanian voters' fingers marked with indelible ink stain the doorway of a polling station in the remote, ancient desert town of Chenguetti. 11 March 2007. Chenguetti, Mauritania. Finbarr O'Reilly.

012 A man pushes a barrel along a south Devon beach. Scores of people flocked to the site of a shipwreck to scavenge among beached containers for cargo that included a BMW motorcycle, shoes and barrels of wine. 22 January 2007. Branscombe, Britain. Stephen Hird.

013 Tents for homeless people, erected by the housing campaign group 'Enfants de Don Quichotte' (Children of Don Quixote), line the beach in Nice. 9 January 2007. Nice, France. Eric Gallard.

014 Men clean up engine fuel from a refrigerator ship that ran aground on the southern Spanish coast, spilling fuel over protected coasts near Gibraltar. 30 January 2007. Algeciras, Spain. Anton Meres.

015 Children play in a flooded rice field near Jakarta. Floods in the Indonesian capital in the first weeks of 2007 killed dozens and displaced thousands of people. 4 February 2007. Serpong, Indonesia. Beawiharta.

016 A reveller takes part in Santo Domingo's annual carnival. 4 March 2007. Santo Domingo, Dominican Republic. Eduardo Munoz.

017 Graffiti adorns an empty villa in the south of France that formerly belonged to Saddam Hussein's half-brother and intelligence chief Barzan al-Tikriti. 11 January 2007. Grasse, France. Eric Gaillard.

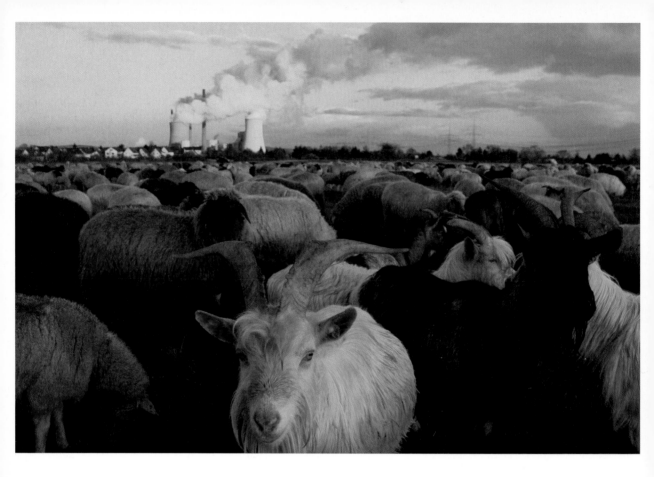

018 Grosskrotzenburg, Germany

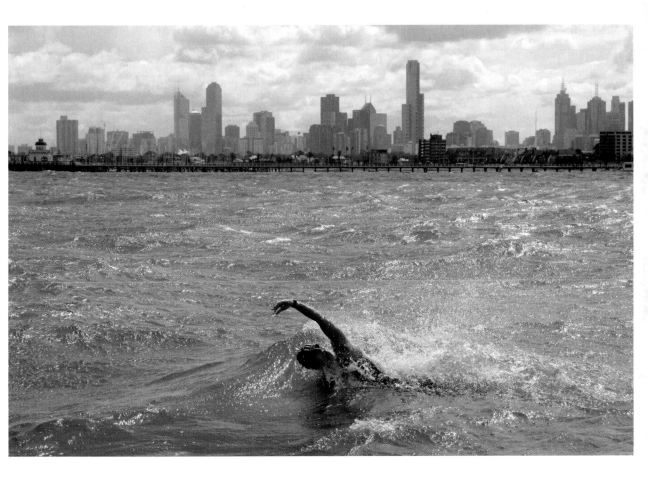

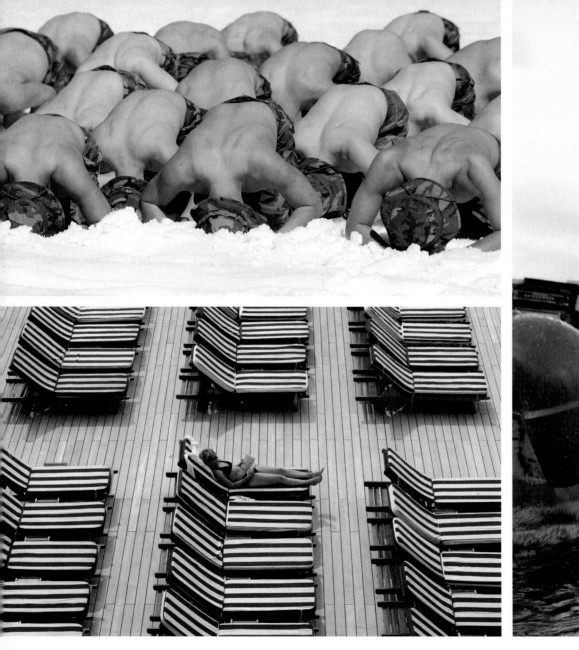

020 [TOP] Pyongchang, South Korea **021** [ABOVE] Hong Kong, China

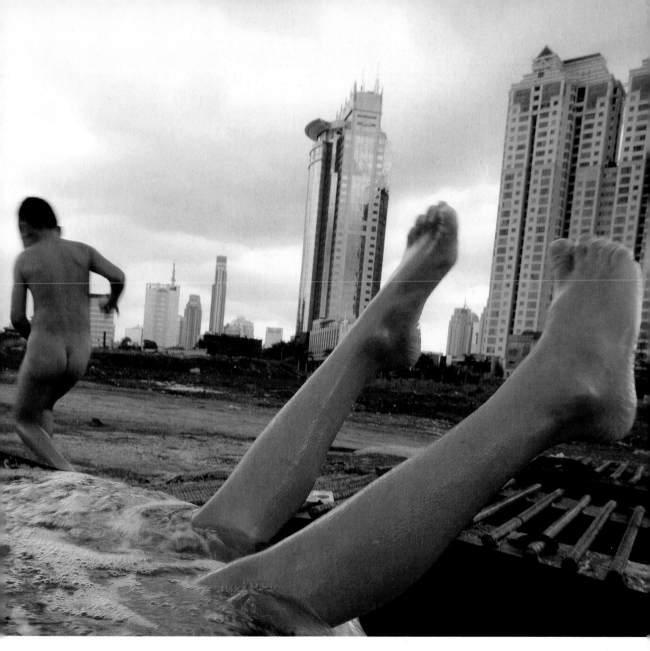

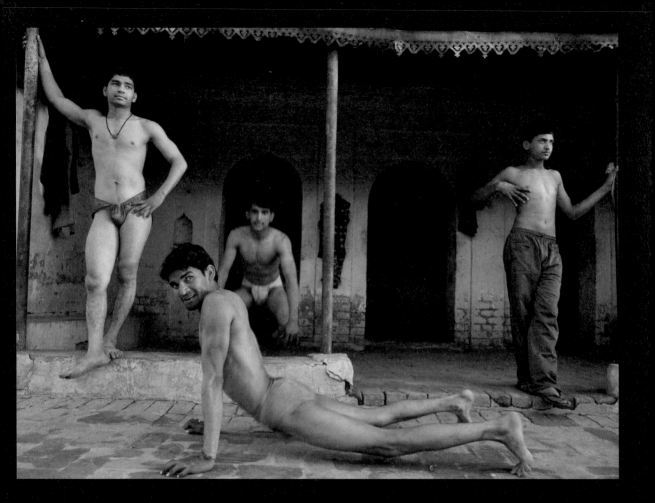

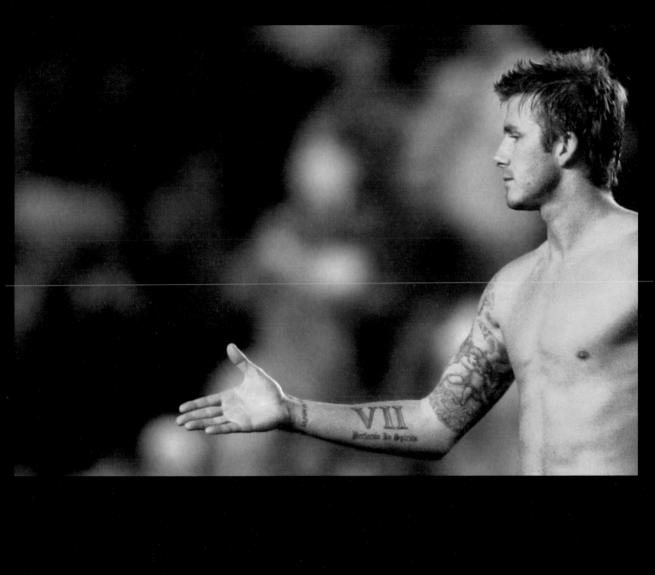

025 [TOP] Jinan, China **026** [ABOVE] London, Britain

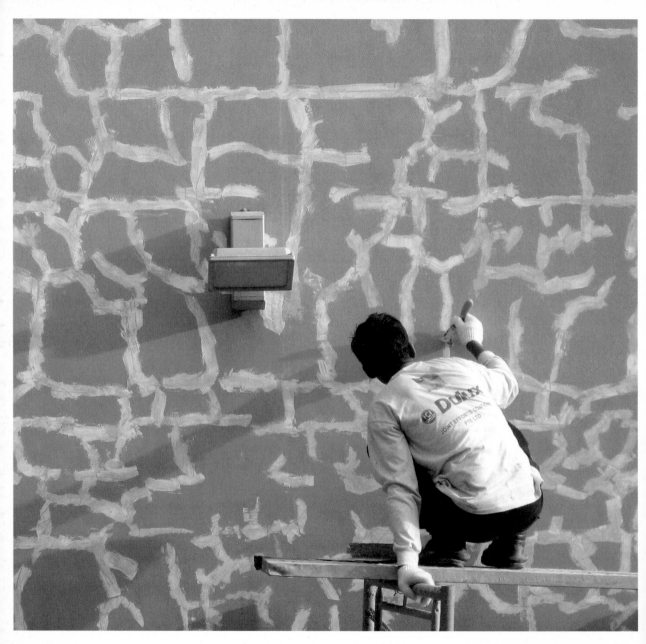

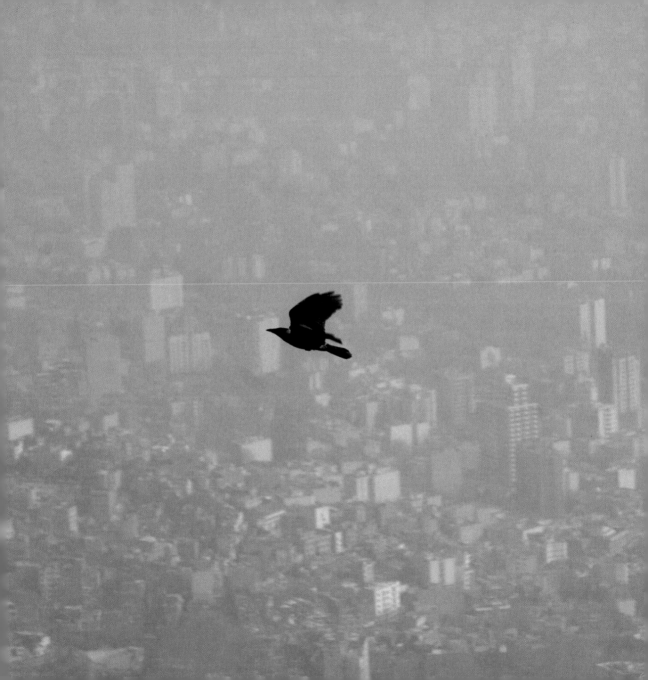

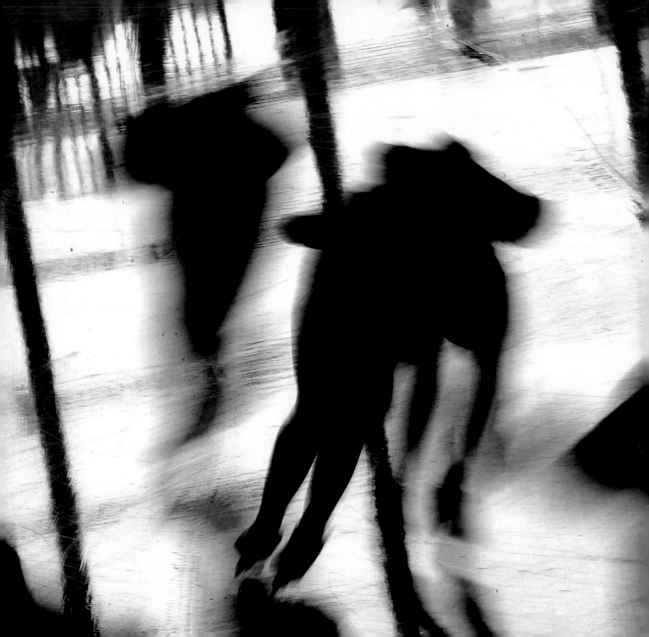

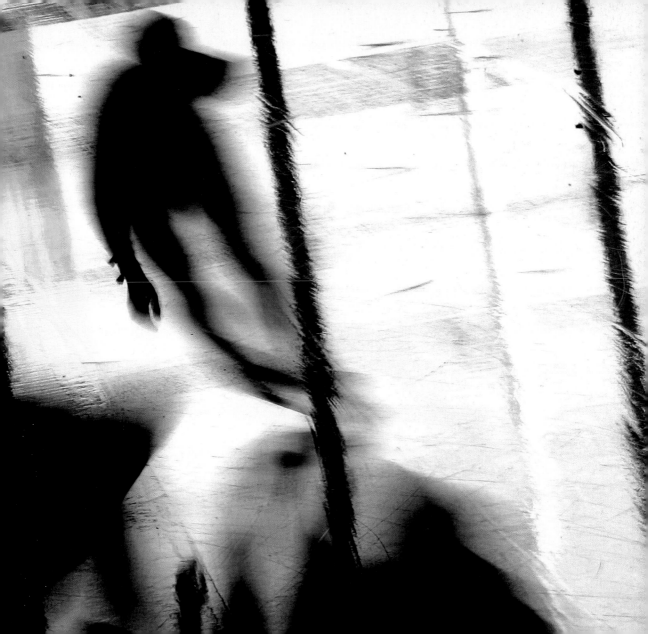

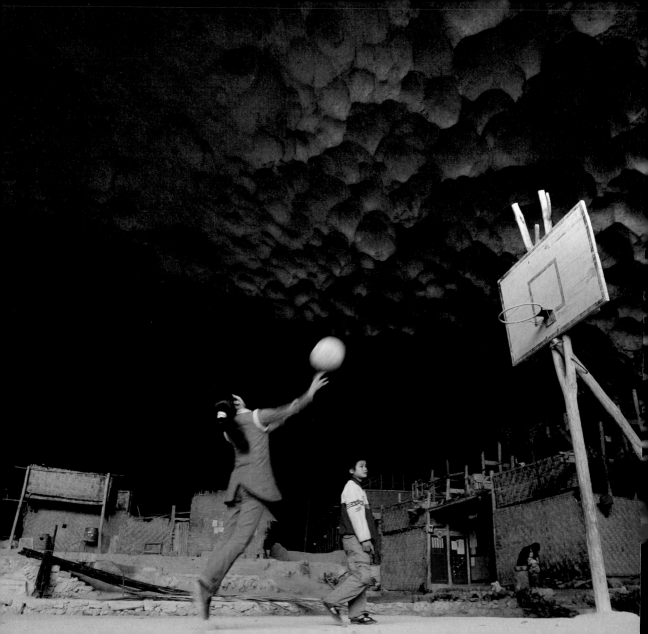

018 Sheep and goats gather in a field in front of the German RWE AG energy company's Staudinger coal power plant, as water vapour rises from its cooling tower. 21 March 2007. Grosskrotzenburg, Germany. Kai Pfaffenbach.

019 Germany's Britta Kamrau-Corestein fights against waves as she swims in front of the Melbourne skyline during the women's 25 km open water race at the World Aquatic Championships. 24 March 2007. Melbourne, Australia. Wolfgang Rattay.

020 Members of the South Korean Marine Corps honour their parents for Lunar New Year's Day during an annual winter season drill in Pyongchang, about 180 km (110 miles) east of Seoul. 14 February 2007. Pyongchang, South Korea. Jo Yong-Hak.

021 A woman sunbathes on the deck of the *Queen Mary 2*, the world's largest ocean liner, as it arrives at Kwai Chung port in Hong Kong. 28 February 2007. Hong Kong, China. Paul Yeung.

022 Indonesian children take a bath near a construction site in Jakarta. 25 January 2007. Jakarta, Indonesia. Beawiharta.

023 Wrestlers exercise in the northern Indian city of Mathura. 5 March 2007. Mathura, India. Adeel Halim.

024 Real Madrid's David Beckham gestures after his team's Spanish First Division soccer match against Deportivo Coruña at Riazor stadium. 7 January 2007. La Coruña, Spain. Miguel Vidal.

025 A woman passes a shop window in Jinan, in east China's Shandong province. 9 March 2007. Jinan, China. Pan Bing.

026 Christie's employee Zoe Schoon walks past British artist Damien Hirst's painting *Untitled* at a preview of Christie's Post-War and Contemporary Art sale in London. 2 February 2007. London, Britain. Toby Melville.

027 A girl looks at her mobile phone outside Tokyo's Harajuku Station. 15 March 2007. Tokyo, Japan. Kevin Coombs.

028 A worker in Singapore fills cracks in a wall in the evening sunshine. 14 February 2007. Singapore. Russell Boyce.

029 A bird flies through the polluted sky above Tehran. 25 January 2007. Tehran, Iran. Morteza Nikoubazl.

030 Skaters train for the Essent ISU Speed Skating World Cup at Turin's Oval Lingotto arena. 4 February 2007. Turin, Italy. Max Rossi.

031 Two ethnic Miao children play basketball at a school playground inside a huge cave at a remote Miao village in Ziyun county, in southwest China's Guizhou province. The village of Zhongdong, which literally means 'middle cave', is built in a natural cave the size of an aircraft hangar. 12 February 2007. Zhongdong, China. Jason Lee.

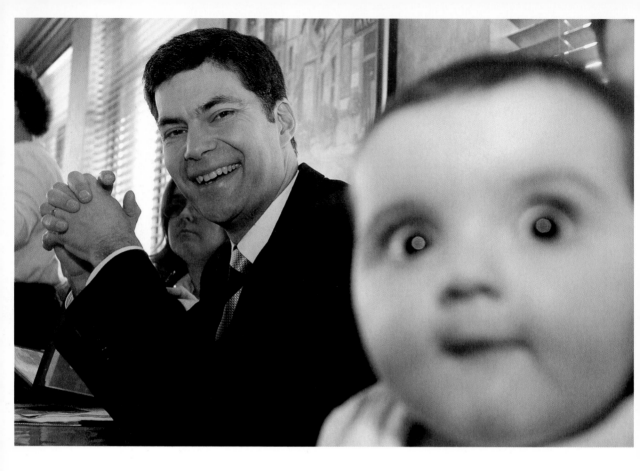

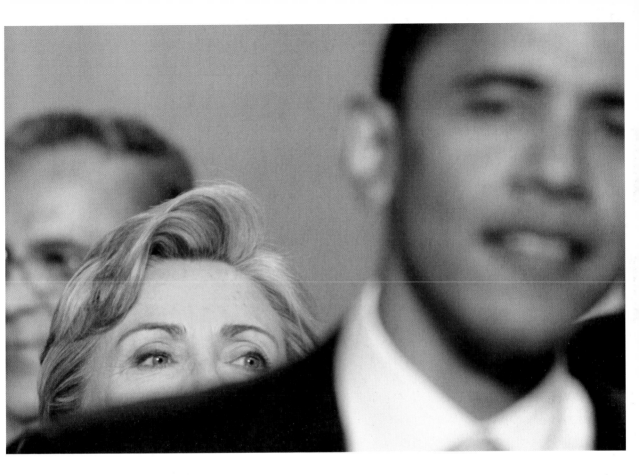

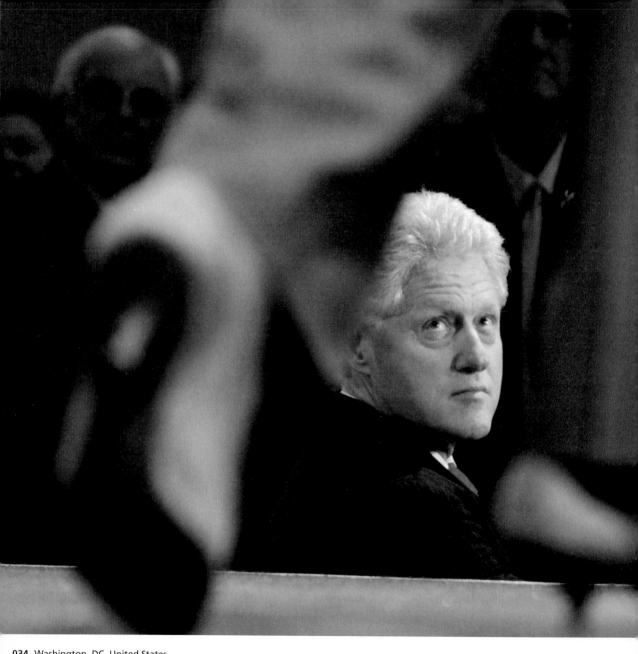

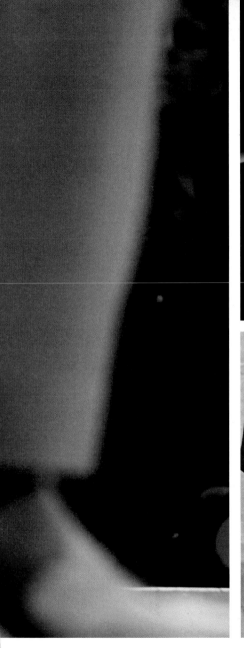

035 [TOP] Rabat, Morocco 036 [ABOVE] Washington, DC, United States

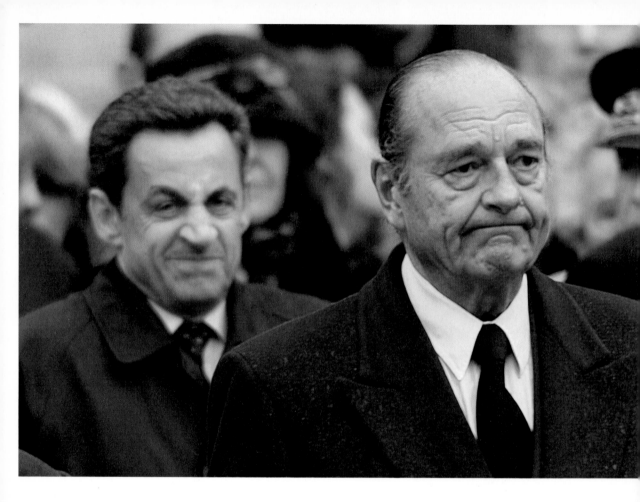

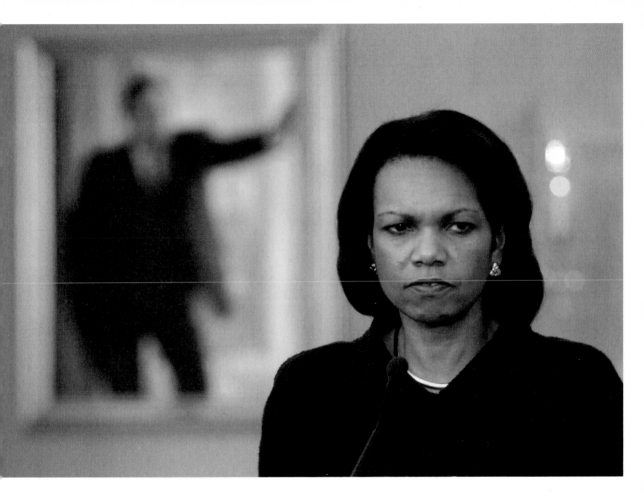

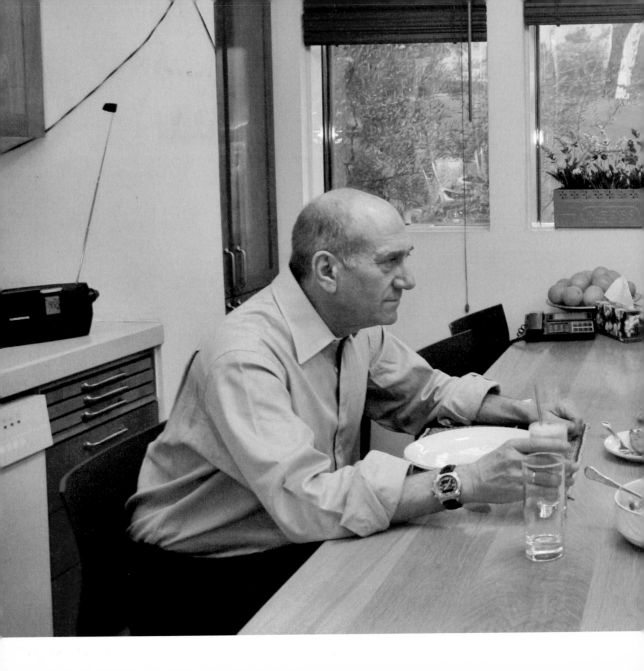

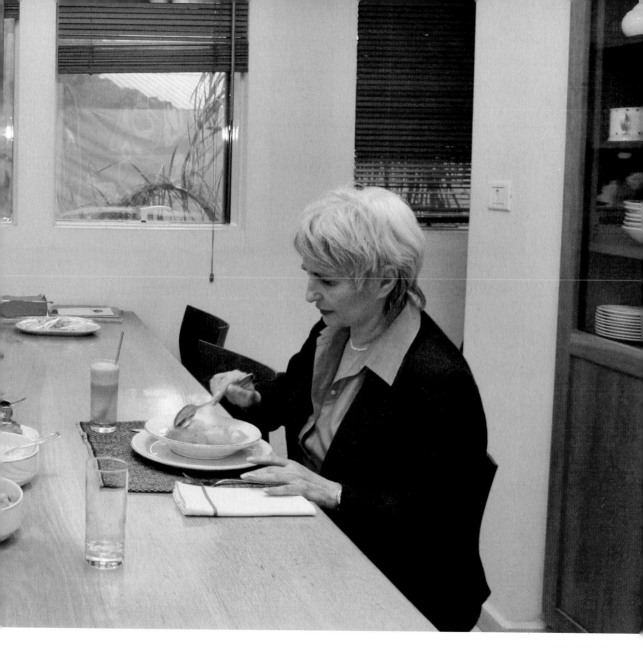

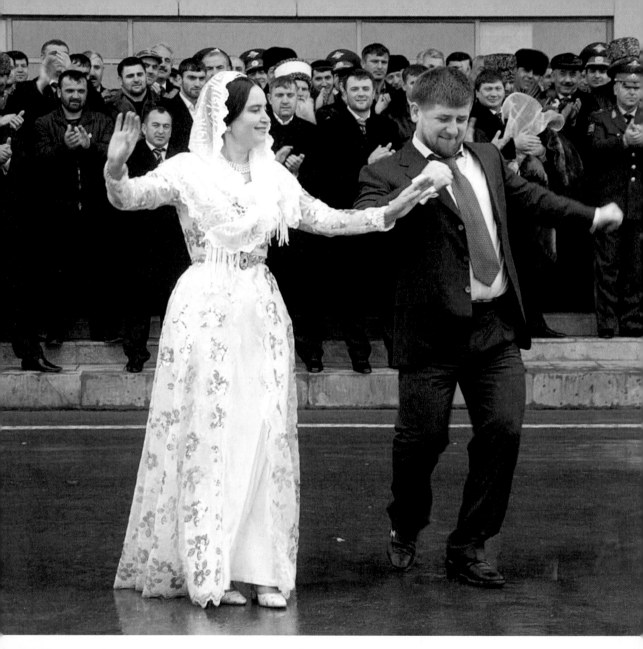

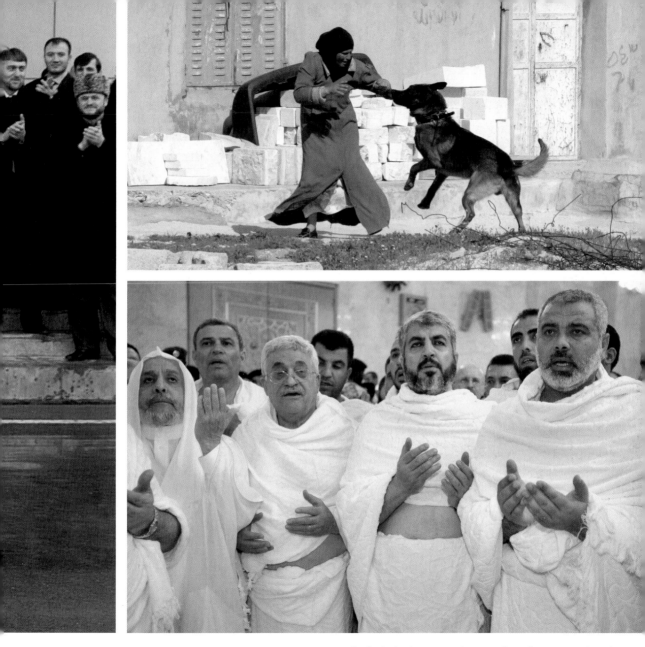

041 [TOP] Obadiyah, West Bank　　**042** [ABOVE] Mecca, Saudi Arabia

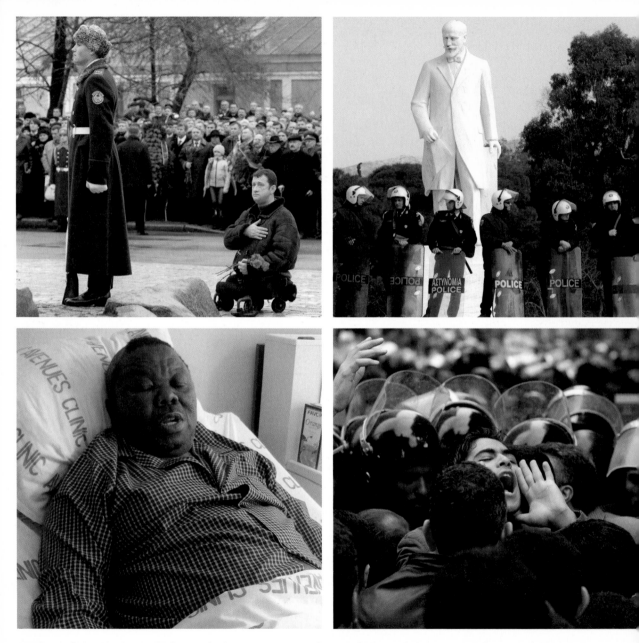

043 [TOP LEFT] Kiev, Ukraine **044** [TOP RIGHT] Athens, Greece **045** [ABOVE LEFT] Harare, Zimbabwe **046** [ABOVE RIGHT] Cairo, Egypt

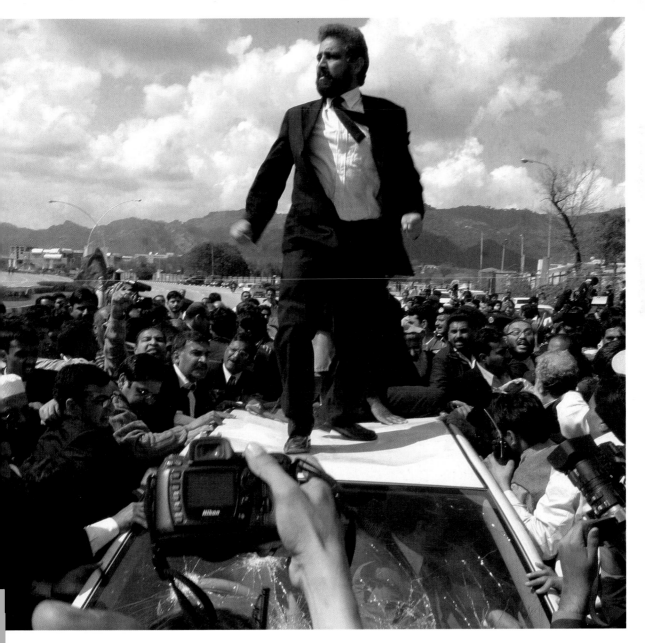

047 Islamabad, Pakistan

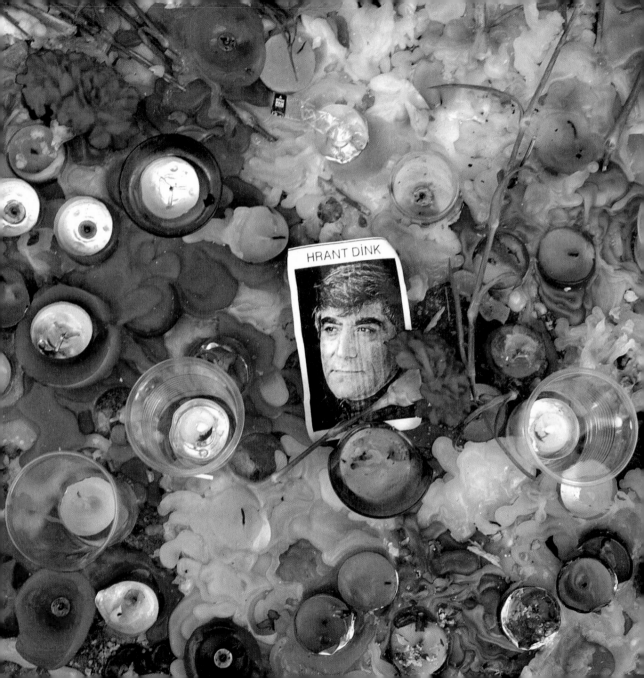

HRANT DİNK

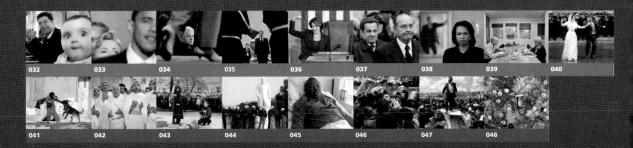

032 033 034 035 036 037 038 039 040

041 042 043 044 045 046 047 048

032 **Action Democratique du Quebec leader Mario Dumont attends a luncheon during campaigning ahead of provincial elections.** 15 March 2007. Delson, Canada. Christinne Muschi.

033 **Senator Barack Obama stands in front of Senator Hillary Clinton as they arrive for U.S. President George W. Bush's annual State of the Union Speech to Congress.** 23 January 2007. Washington, DC, United States. Larry Downing.

034 **Former U.S. President Bill Clinton listens to his wife, Democratic presidential candidate Hillary Clinton, speak at a campaign fundraiser.** 20 March 2007. Washington, DC, United States. Jim Young.

035 **Spain's Prime Minister José Luis Rodríguez Zapatero (centre) reviews a guard of honour in Rabat.** 5 March 2007. Rabat, Morocco. Rafael Marchante.

036 **Nancy Pelosi takes the podium after her election as the first female Speaker of the U.S. House of Representatives.** Washington, DC, United States. 4 January 2007. Larry Downing.

037 **France's former President Jacques Chirac (right) and former Interior Minister and UMP party presidential candidate Nicolas Sarkozy attend a ceremony to honour Lucie Aubrac, one of France's greatest wartime resistance heroes.** 21 March 2007. Paris, France. Charles Platiau.

038 **U.S. Secretary of State Condoleezza Rice listens to a question during a news conference at the State Department in Washington.** 14 March 2007. Washington, DC, United States. Jonathan Ernst.

039 **Israel's Prime Minister Ehud Olmert and his wife, Aliza, eat lunch together in their official residence.** 26 February 2007. Jerusalem. Ronen Zvulun.

040 **Chechnya's President Ramzan Kadyrov (right) dances during celebrations to mark the reopening of Grozny's civilian airport, presented as evidence of the war-ravaged region's recovery under its pro-Moscow government.** 8 March 2007. Grozny, Russia. Said Tsarnayev.

041 **An Israeli army dog attacks Palestinian Yusra Rabayaa during a raid in the West Bank village of Obadiyah, near Bethlehem.** 21 March 2007. Obadiyah, West Bank. Nayef Hashlamoun.

042 **Palestinian President Mahmoud Abbas, Hamas leader Khaled Meshaal and then Palestinian Prime Minister Ismail Haniyeh (front row, second left to right) pray inside the Grand Mosque in Mecca.** 9 February 2007. Mecca, Saudi Arabia. Suhaib Salem.

043 **A ceremony is held in Kiev to mark the 18th anniversary of the Soviet Union's withdrawal from Afghanistan.** 15 February 2007. Kiev, Ukraine. Gleb Garanich.

044 **Riot police stand guard by the Greek parliament during a march by students and striking workers.** 28 March 2007. Athens, Greece. Yannis Behrakis.

045 **Zimbabwe's Morgan Tsvangirai of the Movement for Democratic Change lies in hospital after a police beating following his arrest during a protest against President Robert Mugabe's government.** 14 March 2007. Harare, Zimbabwe.

046 **A member of the banned Muslim Brotherhood shouts amid Egyptian riot police in Cairo during a protest against Israeli excavations near Jerusalem's most sacred Muslim shrine.** 9 February 2007. Cairo, Egypt. Amr Dalsh.

047 **A lawyer stands on the roof of a car surrounded by fellow supporters of suspended Chief Justice Iftikhar Chaudhry as Chaudhry was driven for his appearance before Pakistan's Supreme Judicial Council.** 13 March 2007. Islamabad, Pakistan. Faisal Mahmood.

048 **A portrait of Turkish-Armenian writer Hrant Dink lies at the spot where he was gunned down on 19 January 2007 by a 17-year-old ultra-nationalist.** 21 January 2007. Istanbul, Turkey. Ahmet Ada.

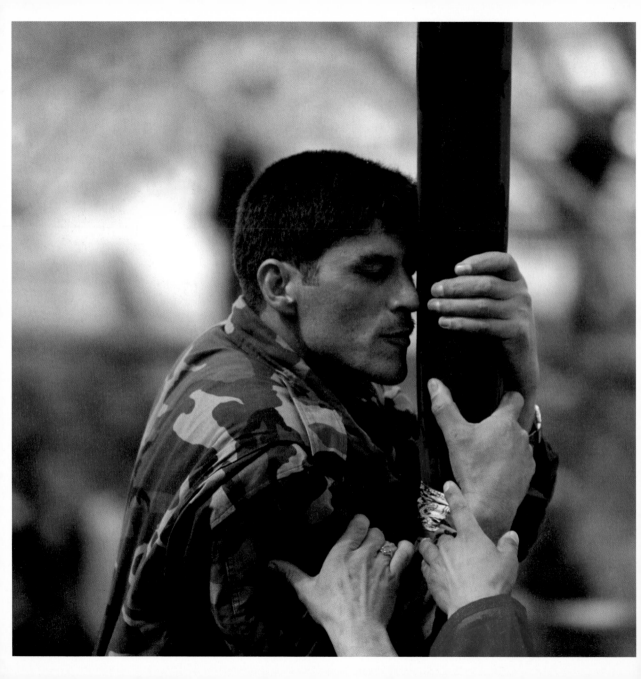

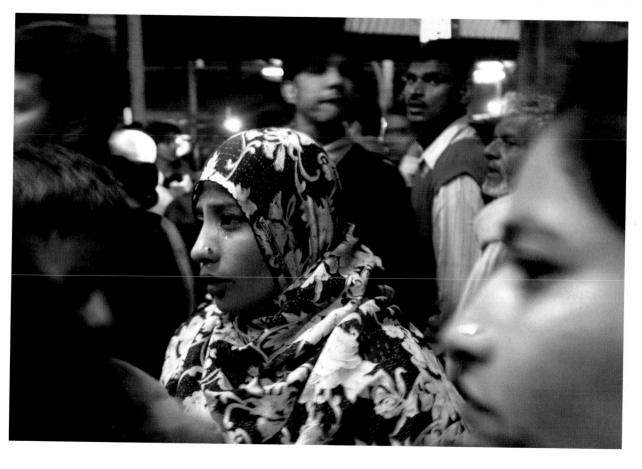

049 [OPPOSITE] Kabul, Afghanistan

050 Delhi, India

051 [TOP] **052** [ABOVE] Jerusalem

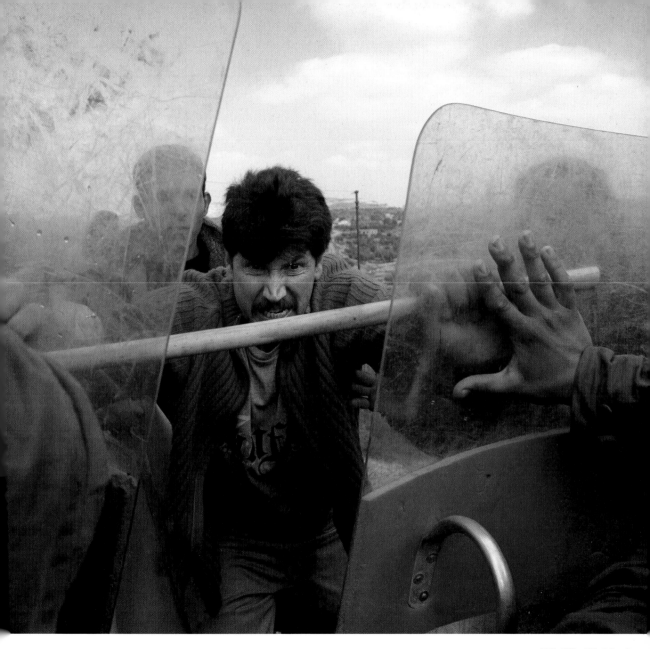

053 Bilin, West Bank

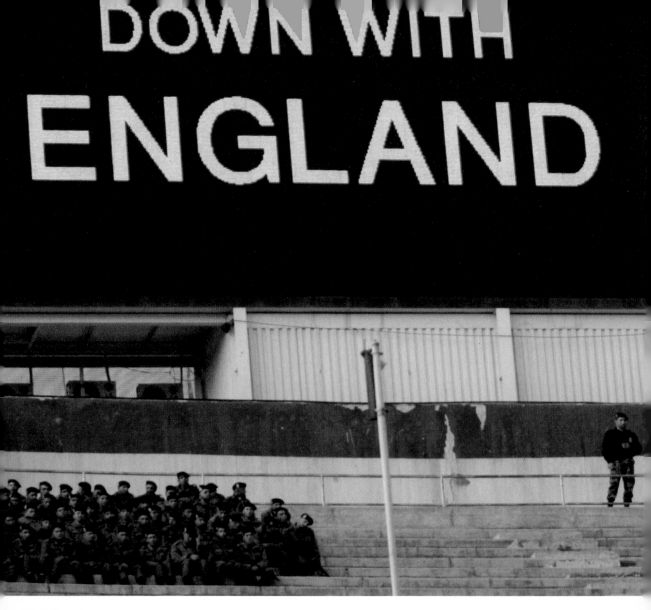

DOWN WITH
ENGLAND

055 [TOP] 056 [ABOVE] Tehran, Iran

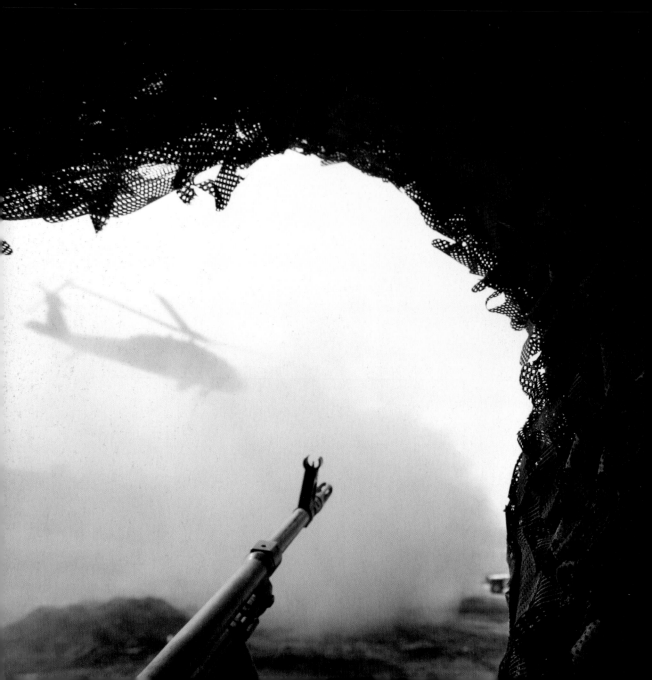

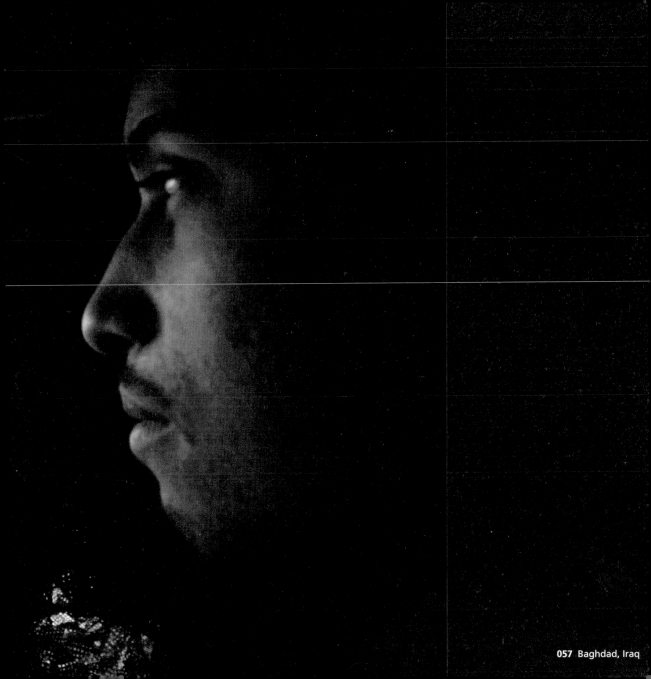

057 Baghdad, Iraq

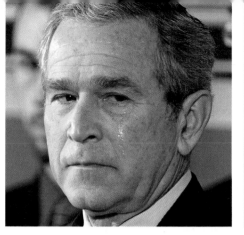

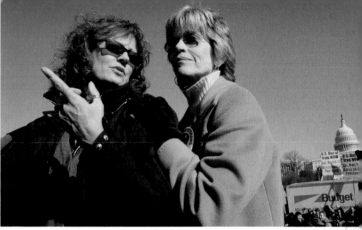

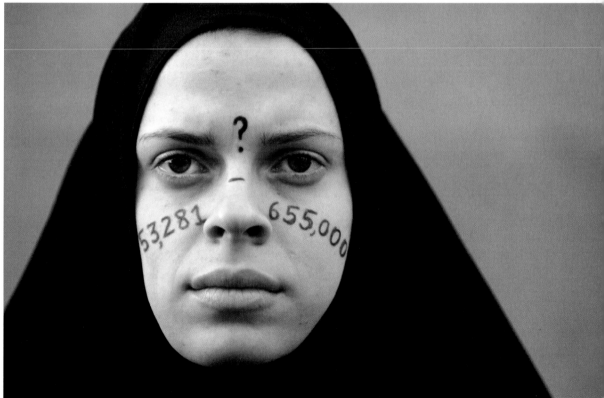

059 [TOP LEFT] **060** [TOP RIGHT] Washington, DC, United States **061** [ABOVE] Boston, United States

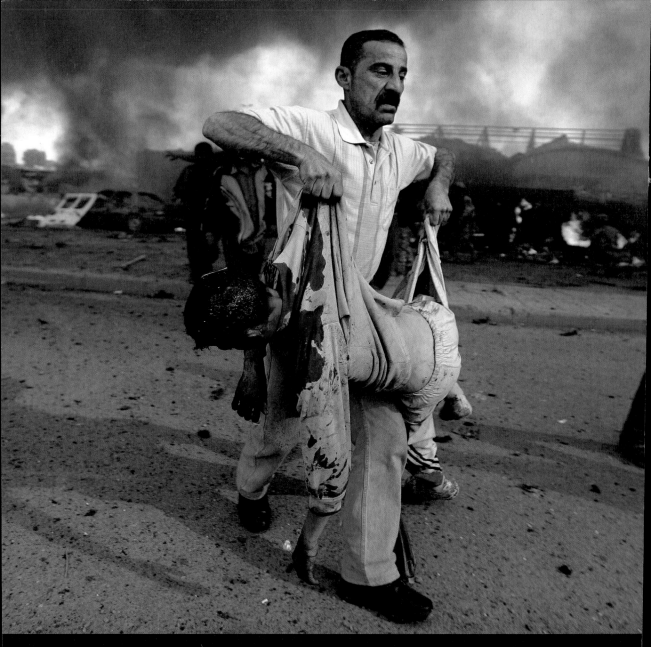

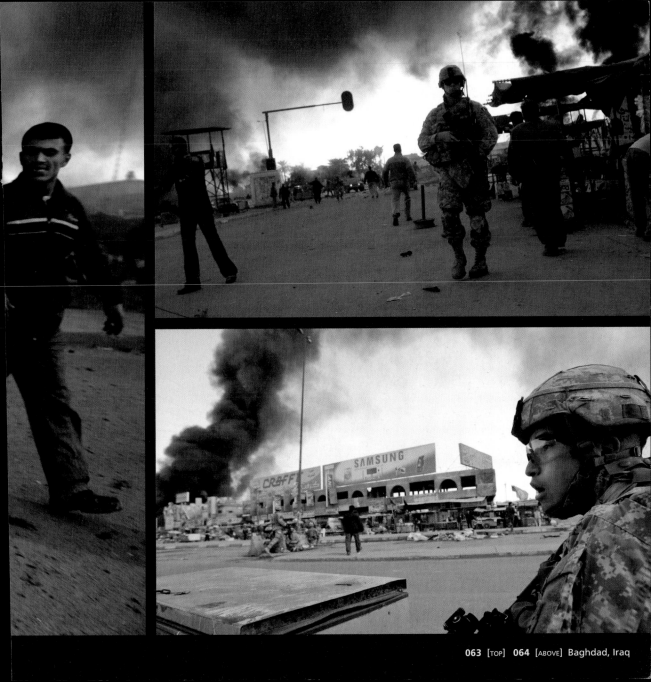

049 **A man kisses a flagpole bearing a religious banner during Naw Ruz, the Afghan New Year.** 21 March 2007. Kabul, Afghanistan. Ahmad Masood.

050 **A girl cries after bidding farewell to relatives who boarded the Samjhauta Express train between Delhi, India, and Lahore, Pakistan, for the first journey on the route since 68 people were killed when a train was bombed on 19 February 2007.** 21 February 2007. Delhi, India. Adnan Abidi.

051 **A Palestinian girl shouts in front of Israeli border police during a protest against Israeli excavations in Jerusalem's Old City, close to the Dome of the Rock and al-Aqsa mosque. The excavation work near Jerusalem's most sensitive shrine and Islam's third holiest site angered Muslims and threatened a Gaza ceasefire deal.** 8 February 2007. Jerusalem. Ammar Awad.

052 **Ultra-orthodox Jews gather to watch a house demolition in Jerusalem. According to the Israeli authorities, the house was demolished due to a lack of permits.** 31 January 2007. Jerusalem. Yonathan Weitzman.

053 **A Palestinian demonstrator confronts Israeli border police during a protest against Israel's controversial separation barrier.** 9 March 2007. Bilin, West Bank. Yonathan Weitzman.

054 **Anti-riot police sit under a scoreboard bearing an anti-English slogan during a soccer match at the Azadi stadium in Tehran. Fifteen British naval personnel were detained by Iranian forces on 23 March 2007, leading to a two-week standoff.** 30 March 2007. Tehran, Iran. Chavosh Homavandi.

055 **Flight attendant Lucy Nichols leaves business class where 15 released British military personnel are seated on their return flight to London.** 5 April 2007. Tehran, Iran. Caren Firouz.

056 **Two released British military personnel await their departure flight to London.** 5 April 2007. Tehran, Iran. Mohammad Babaei.

057 **An Iraqi policeman watches a U.S. Black Hawk helicopter leaving an Iraqi police base southeast of Baghdad.** 14 February 2007. Baghdad, Iraq. Carlos Barria.

058 **A sign at the 'Arlington West' memorial in Santa Monica records the 3,000th U.S. soldier killed in Iraq.** 31 December 2006. Santa Monica, United States. Max Morse.

059 **U.S. President George W. Bush weeps during a ceremony to honour Marine Corporal Jason Dunham at the White House. Corporal Dunham was killed in Iraq when he jumped on a grenade in order to save other members of his patrol.** 11 January 2007. Washington, DC, United States. Jim Bourg.

060 **Actresses and anti-war campaigners Susan Sarandon and Jane Fonda stand together after addressing thousands of protesters in Washington, DC, against the war in Iraq.** 27 January 2007. Washington, DC, United States. Joshua Roberts.

061 **U.S. protester Alicia Casilio, dressed as an Iraqi civilian, attends an anti-Iraq war demonstration. The figures on her face represent the range of estimates of the number of Iraqi civilians killed in the Iraq war.** 11 January 2007. Boston, United States. Brian Snyder.

062 **An Iraqi man carries the body of a boy after double car bomb explosions at a busy market in the neighbourhood of New Baghdad, southeast of Baghdad.** 18 February 2007. Baghdad, Iraq. Carlos Barria.

063 **A U.S. soldier patrols the site of a double car bomb explosion in New Baghdad. Sixty people were killed and scores wounded.** 18 February 2007. Baghdad, Iraq. Carlos Barria.

064 **A U.S. soldier patrols the site of a double car bomb explosion in New Baghdad.** 18 February 2007. Baghdad, Iraq. Carlos Barria.

065 **An Iraqi child watches U.S. soldiers leave the area after a double car bomb explosion in New Baghdad.** 18 February 2007. Baghdad, Iraq. Carlos Barria.

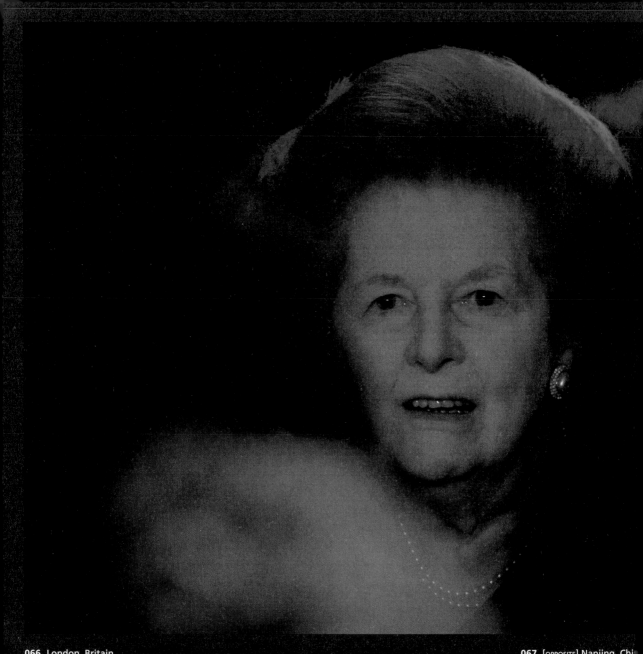

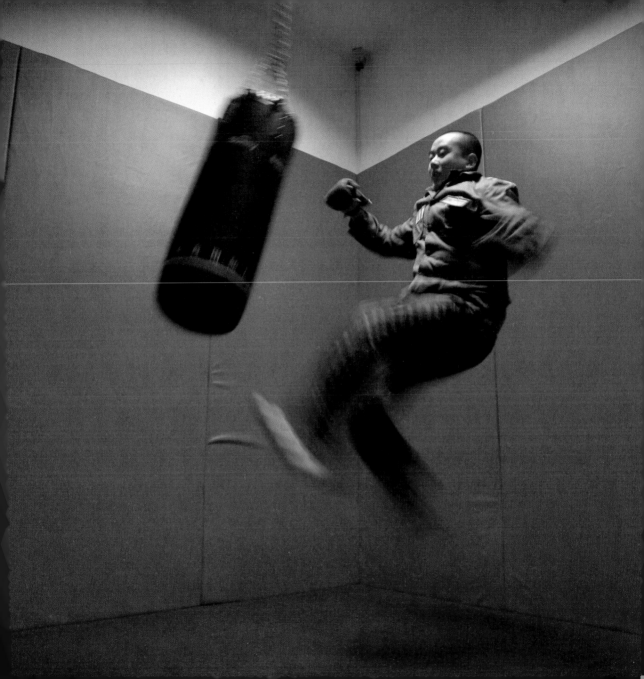

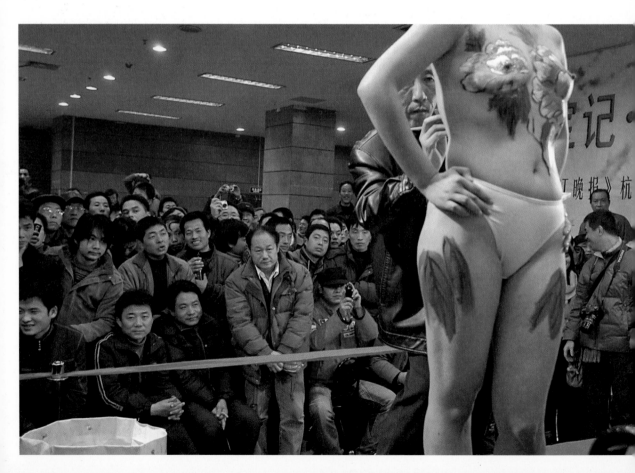

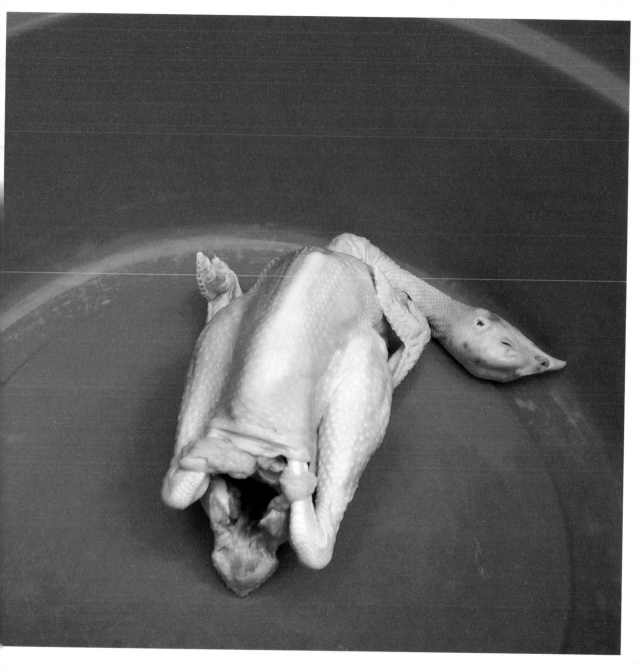

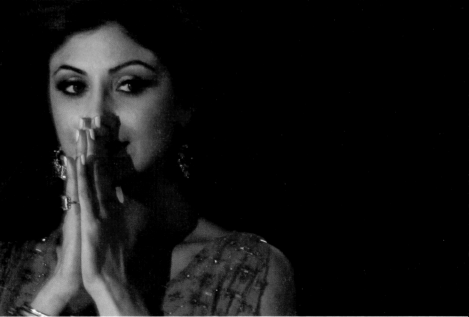

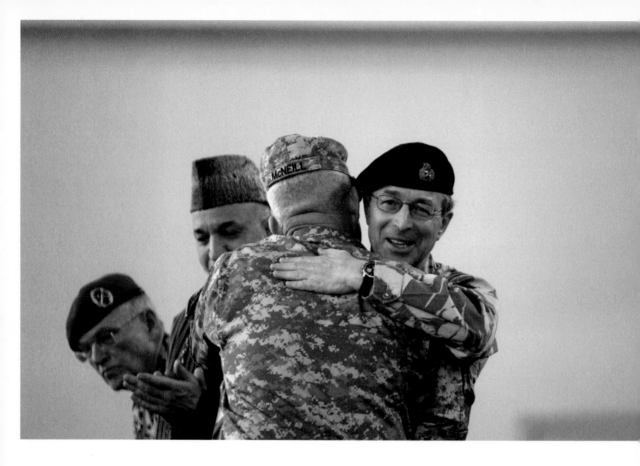

073 Kabul, Afghanistan

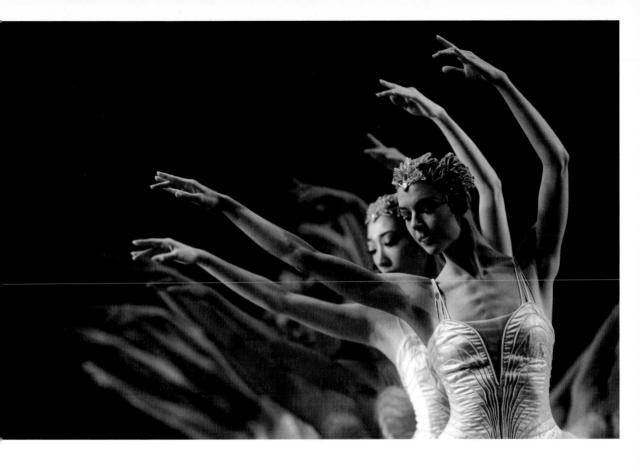

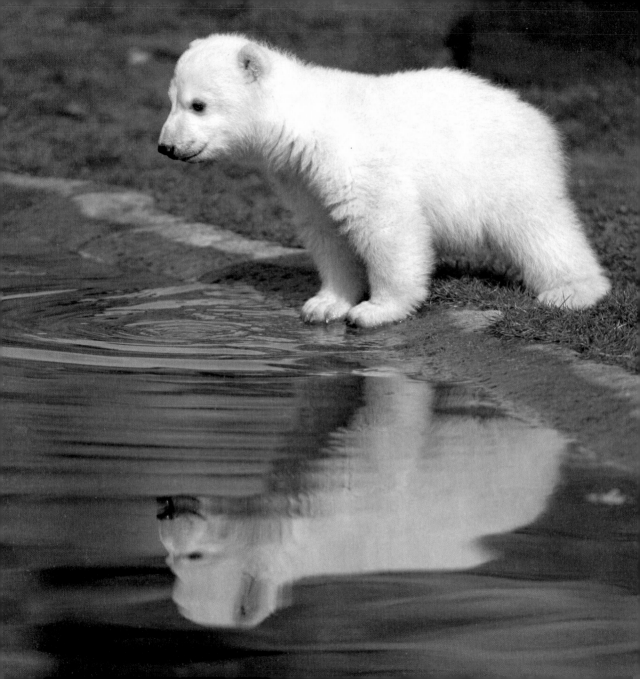

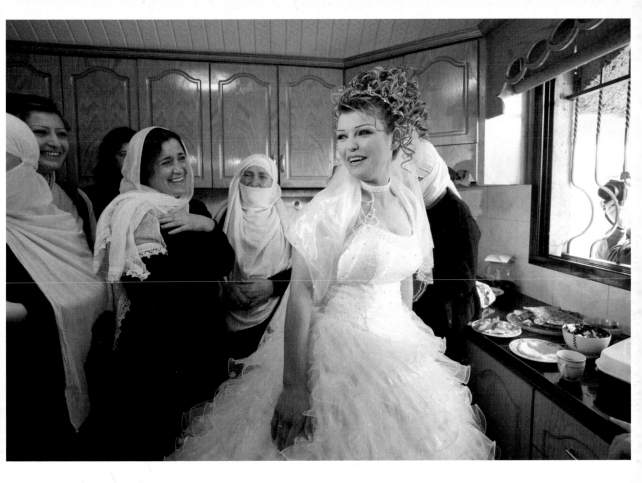

075 [OPPOSITE] Berlin, Germany

076 Buqata, Golan Heights

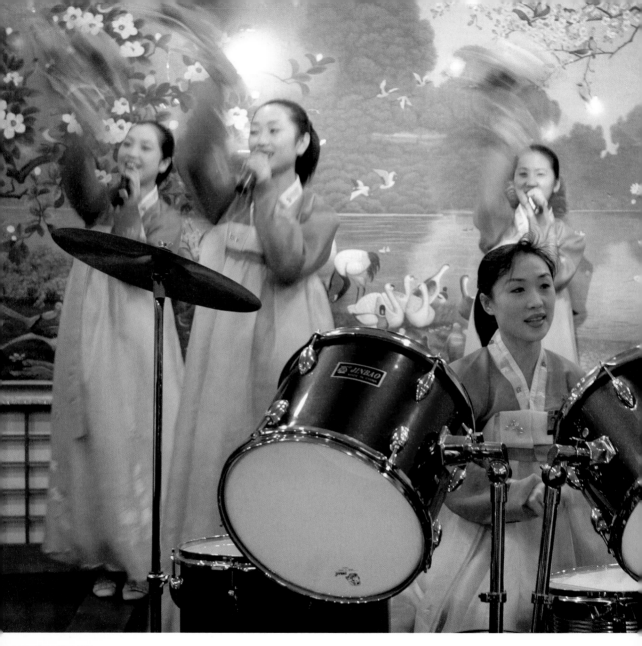

077 Shanghai, China

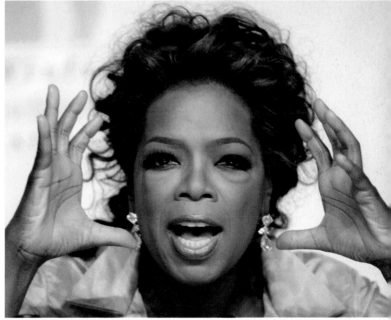

078 [TOP] Melbourne, Australia **079** [ABOVE] Meyerton, South Africa

066 Former British Prime Minister Margaret Thatcher attends a reception in London to celebrate the 90th birthday of Dame Vera Lynn, the singer whose popularity during World War Two made her 'the Forces' Sweetheart'. 20 March 2007. London, Britain. Kieran Doherty.

067 A prison inmate in Nanjing, in east China's Jiangsu province, kicks a sandbag to unleash pent-up anger during a psychological treatment. 15 March 2007. Nanjing, China. Sean Yong.

068 An artist paints on a model during a body painting performance in Hangzhou, in east China's Zhejiang province. 23 January 2007. Hangzhou, China. China Daily.

069 A chicken lies in a plastic basin in a Jakarta market. 24 January 2007. Jakarta, Indonesia. Beawiharta.

070 Models display Cartier High Jewellery during a private gala dinner in Shanghai at which the total value of goods presented was over $32 million. The dinner was followed by a private sale. 26 January 2007. Shanghai, China. Nir Elias.

071 Renoir's *Les Deux Soeurs* is viewed by Sotheby's auctioneers in London ahead of an Impressionist and Modern Art auction at which the work sold for £6,852,000. 31 January 2007. London, Britain. Stephen Hird.

072 Bollywood star Shilpa Shetty reacts after winning the UK's 'Celebrity Big Brother'. 28 January 2007. London, Britain. Luke MacGregor.

073 Outgoing NATO commander in Afghanistan British General David Richards (right) hugs his successor, U.S. General Dan McNeill, during NATO's change of command ceremony. Second from left is Afghan President Hamid Karzai and left is German General Egon Ramms, Commander of NATO Joint Force Command Brunssum. 4 February 2007. Kabul, Afghanistan. Ahmad Masood.

074 Dancers of the Royal Ballet perform a scene from the new production of *Swan Lake* at the Royal Opera House in Covent Garden, London. 2 February 2007. London, Britain. Kieran Doherty.

075 Polar bear cub Knut ventures out at Berlin zoo. Knut had to be hand-fed every four hours after its mother Tosca rejected her baby. 23 March 2007. Berlin, Germany. Tobias Schwarz.

076 Israeli Druze Arwad Abu Shahin, 25, stands in the kitchen with relatives before her wedding in the northern Druze village of Buqata in the Golan Heights. Shahin parted permanently from her family before passing through the Kuneitra crossing from Israel into Syria to wed her Syrian fiancé. 12 March 2007. Buqata, Golan Heights. Sharon Perry.

077 North Korean women perform in a Korean restaurant at a hotel in Shanghai. 18 March 2007. Shanghai, China. Aly Song.

078 Synchronized swimmer Natalia Ischenko of Russia prepares to perform in the World Aquatics Championships staged in Melbourne's Rod Laver Arena. 18 March 2007. Melbourne, Australia. Laszlo Balogh.

079 U.S. talk show host and businesswoman Oprah Winfrey addresses journalists before the opening of the Oprah Winfrey Leadership Academy for Girls in Meyerton, outside Johannesburg. The private boarding school founded by Winfrey is for girls who show outstanding promise despite coming from disadvantaged backgrounds. 2 January 2007. Meyerton, South Africa. Siphiwe Sibeko.

080 A Sadhu or holy man holds a poster of Indian cricketers and shouts good luck slogans at Sangam, the confluence of the Ganges, Yamuna and Saraswati Rivers, in the northern Indian city of Allahabad. 12 March 2007. Allahabad, India. Jitendra Prakash.

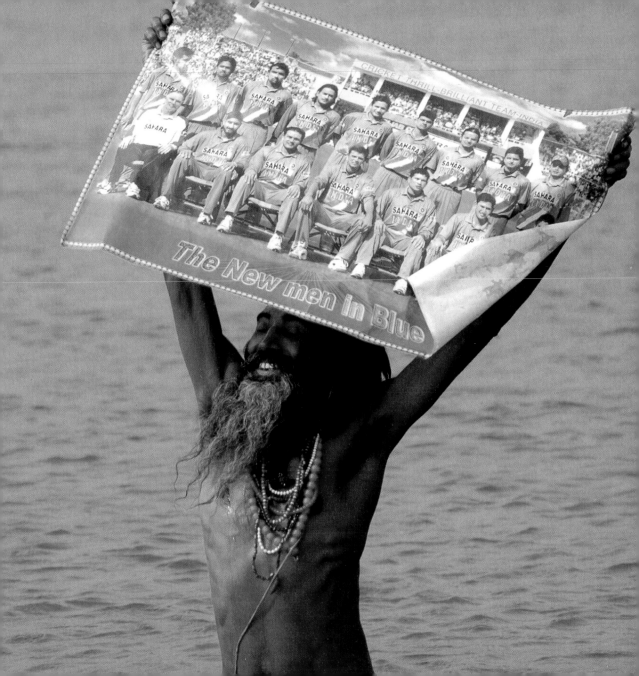

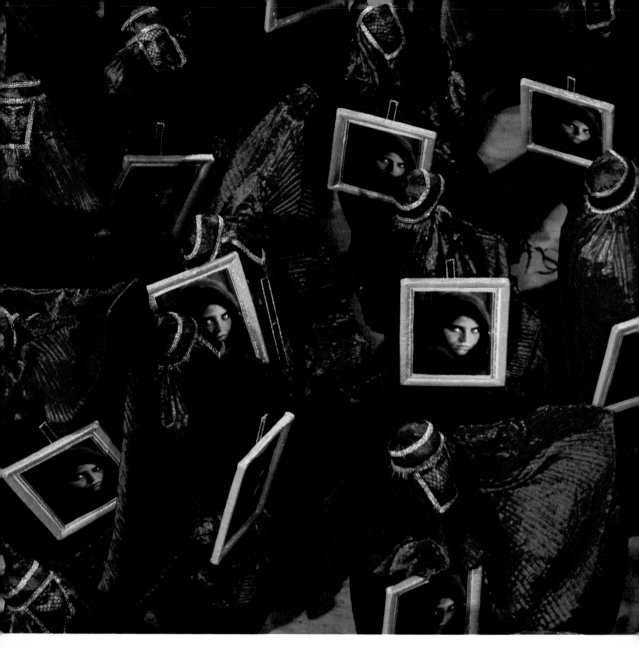

081 Rio de Janeiro, Brazil

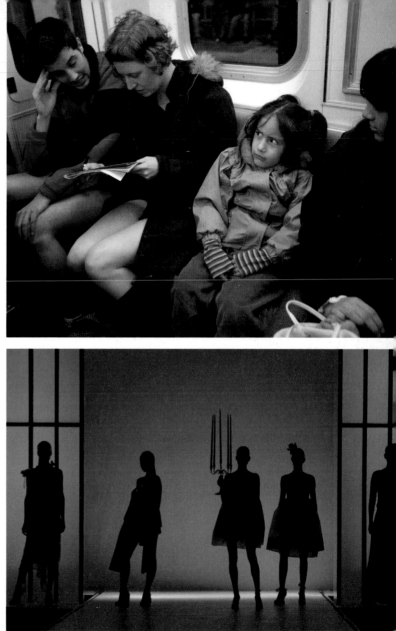

082 [TOP] New York, United States 083 [ABOVE] Hong Kong, China

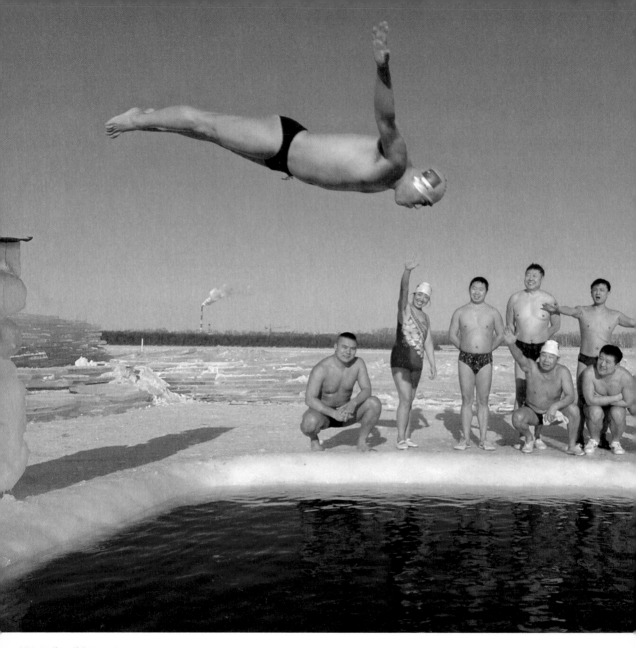

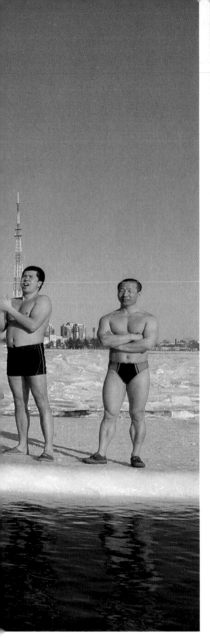

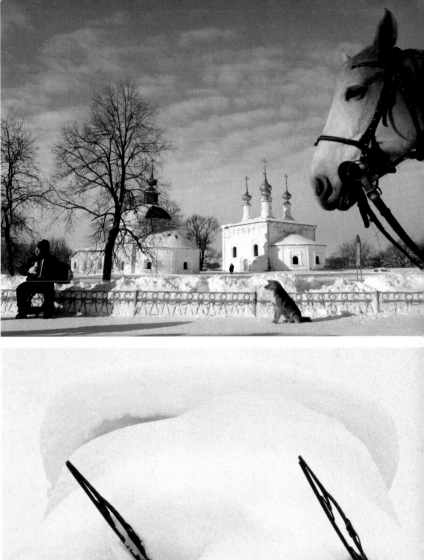

085 [TOP] Suzdal, Russia **086** [ABOVE] Pajares, Spain

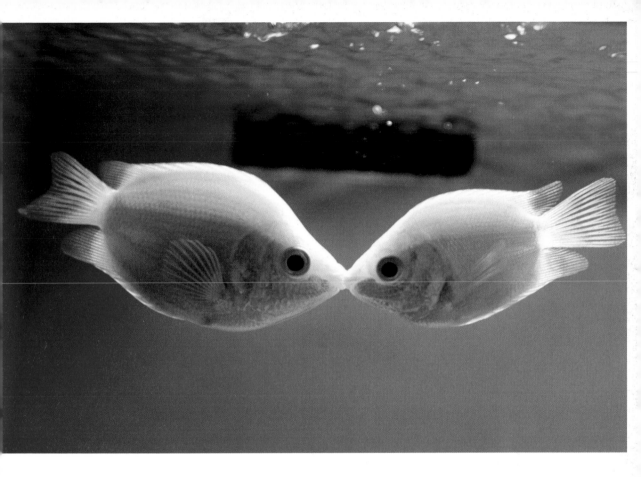

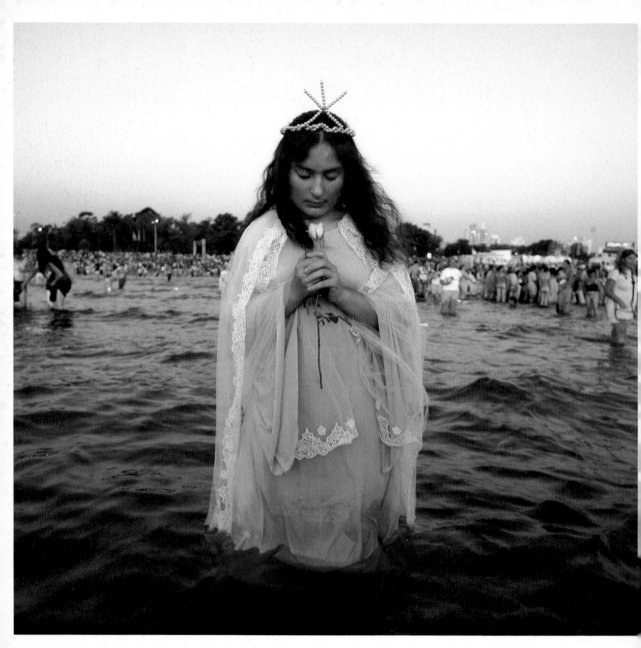

089 Montevideo, Uruguay

090 [OPPOSITE] Jakarta, Indonesia

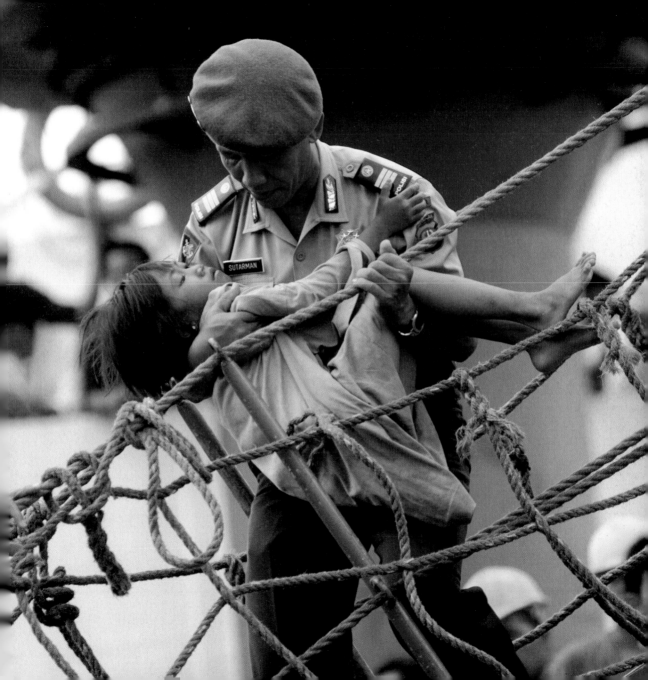

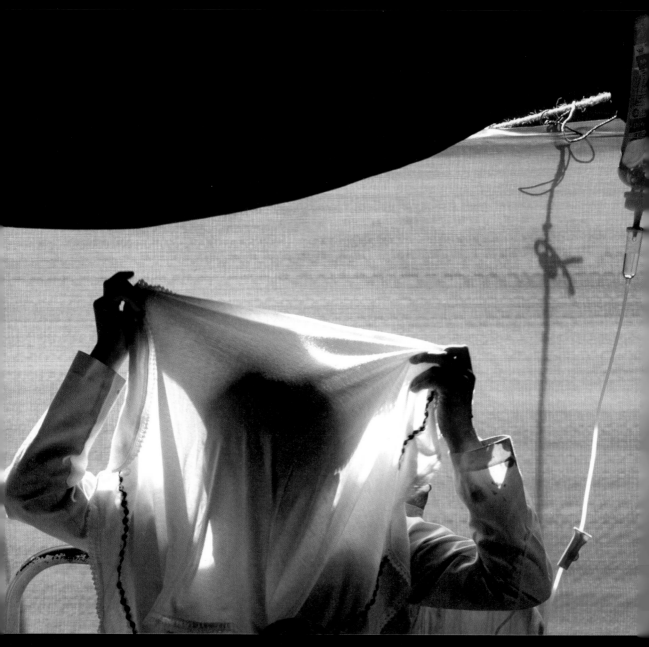

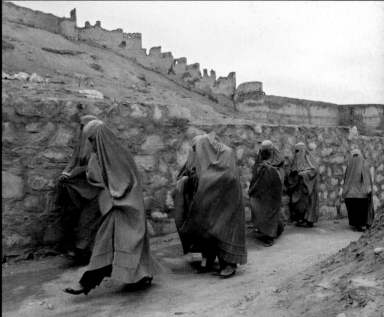

092 [TOP] Agra, India **093** [ABOVE] Kabul, Afghanistan

081 **Carnival revellers of the Unidos da Tijuca samba school parade during the second night of competition between the premier league of samba schools in Rio de Janeiro.** 19 February 2007. Rio de Janeiro, Brazil. Jorge Silva.

082 **A girl reacts to participants in the annual 'No Pants Subway Ride' in New York. The event is run by the group Improv Everywhere, and is intended to make people laugh and give them an interesting New York experience. When asked, participants are not supposed to reveal the purpose, but to respond with something such as 'I forgot my pants today'.** 13 January 2007. New York, United States. Eric Thayer.

083 **Models present creations by Hong Kong designer Andy Ho during Hong Kong Fashion Week.** 17 January 2007. Hong Kong, China. Bobby Yip.

084 **A winter swimmer dives into a river in Heihe, in northeast China's Heilongjiang province.** 24 January 2007. Heihe, China. China Daily.

085 **A man plays an accordion during celebrations of 'Maslenitsa' in Russia's ancient town of Suzdal. The festival marks the end of winter, and has been accommodated by the Orthodox Church as a week of feasting before Lent.** 17 February 2007. Suzdal, Russia. Denis Sinyakov.

086 **Windshield wipers are visible through a thick layer of snow on a car in Pajares, in the northern Spanish region of Asturias.** 24 January 2007. Pajares, Spain. Eloy Alonso.

087 **Canada's synchronized divers Alexandre Despatie and Arturo Miranda dive into the water to win the 3-metre springboard synchro silver medal at the World Aquatics Championships in Melbourne.** 19 March 2007. Melbourne, Australia. Wolfgang Rattay.

088 **A pair of Kissing Gourami fish pictured on Valentine's Day at the Shanghai Ocean Aquarium.** 14 February 2007. Shanghai, China. Nir Elias.

089 **Followers of Afro-American goddess Iemanjá pay tribute during the Feast of Iemanjá on Montevideo's Ramirez Beach.** 2 February 2007. Montevideo, Uruguay. Andres Stapff.

090 **A policeman carries an injured girl off a burning ferry at the Tanjung Priok port in Jakarta. Many passengers hurled themselves off the packed vessel into the sea to escape the flames and searing heat. About 50 people died.** 22 February 2007. Jakarta, Indonesia. Supri.

091 **A survivor of an earthquake that struck West Sumatra on 6 March 2007 puts on her headscarf in a tent at the Bukit Tinggi hospital as thousands began to pick up the pieces of their lives and to rebuild their quake-flattened homes.** 8 March 2007. West Sumatra, Indonesia. Beawiharta.

092 **A group of women visit the Taj Mahal in the northern Indian city of Agra.** 14 January 2007. Agra, India. Ahmad Masood.

093 **Afghan women clad in burqas walk along a hillside.** 8 March 2007. Kabul, Afghanistan. Ahmad Masood.

094 **A Hindu devotee holds clothes to dry during the Ardh Kumbh Mela, or Half Pitcher Festival, in Allahabad city. Nearly half a million Hindus washed away their sins in the icy waters of the Ganges on the first day of the six-week festival.** 5 January 2007. Allahabad, India. Ahmad Masood.

April / May / June

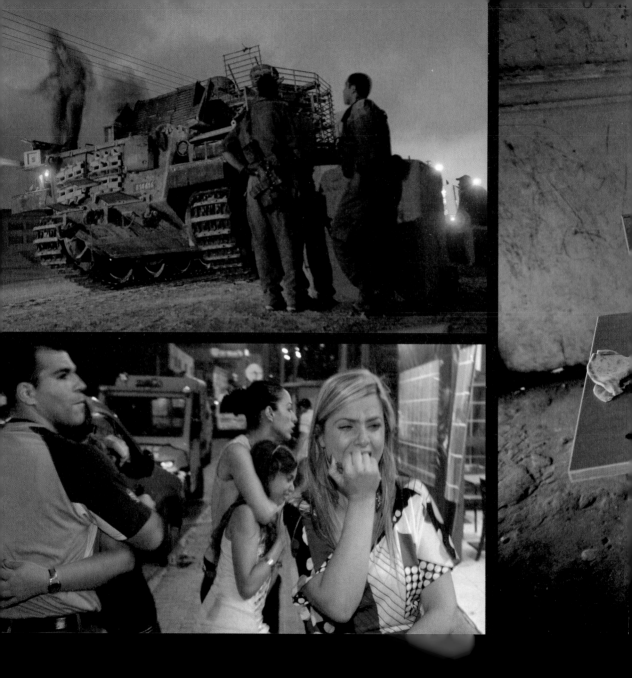

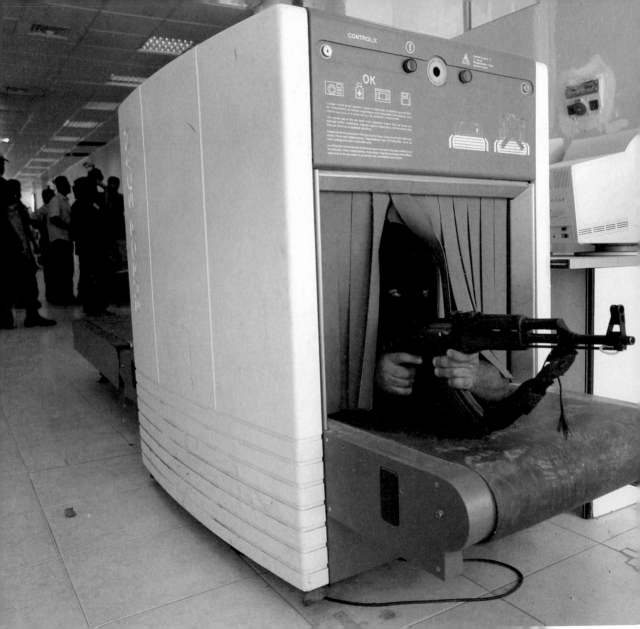

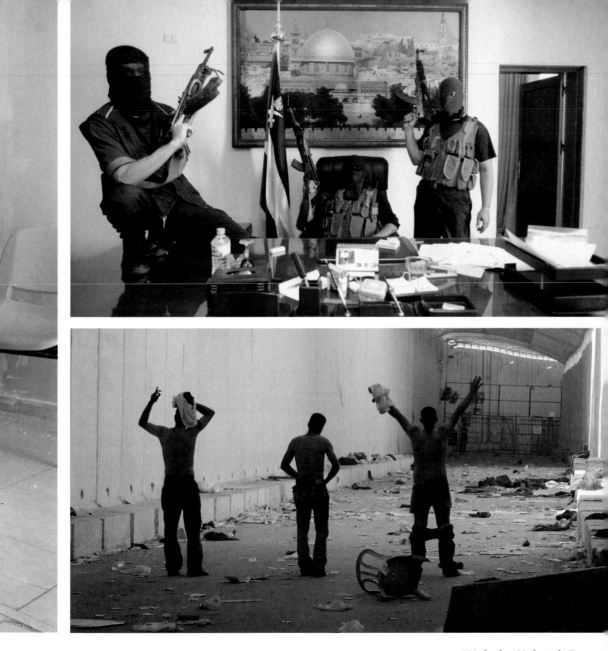

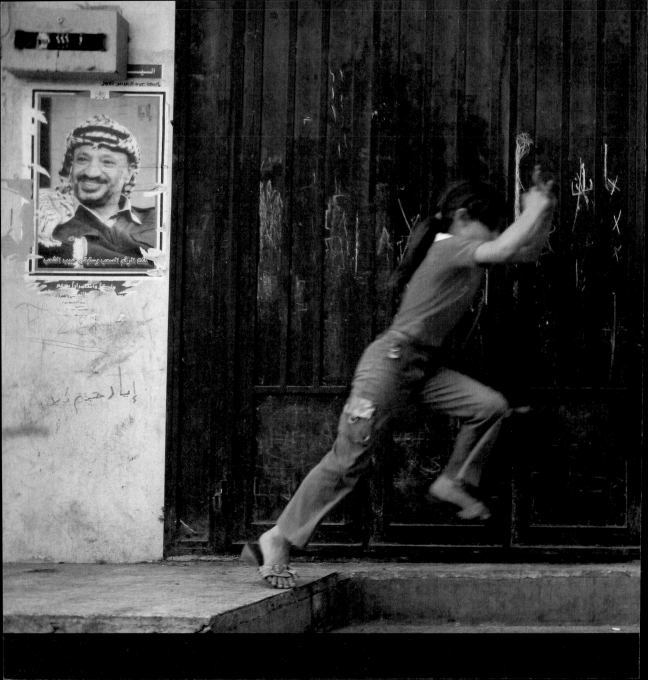

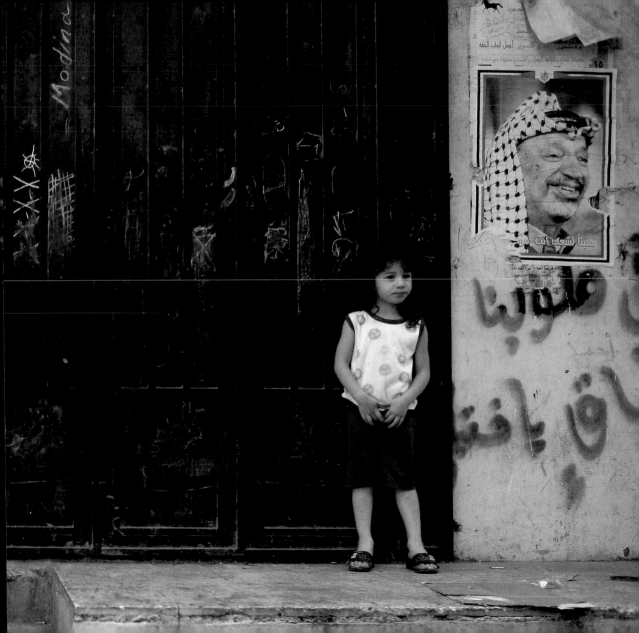

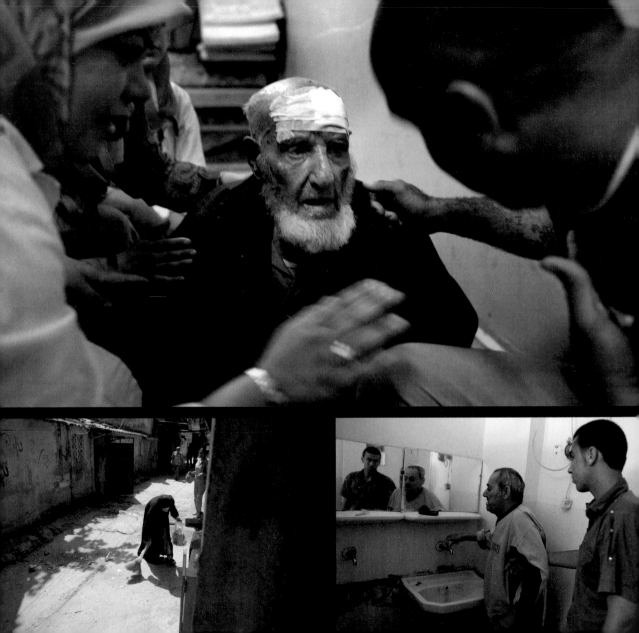

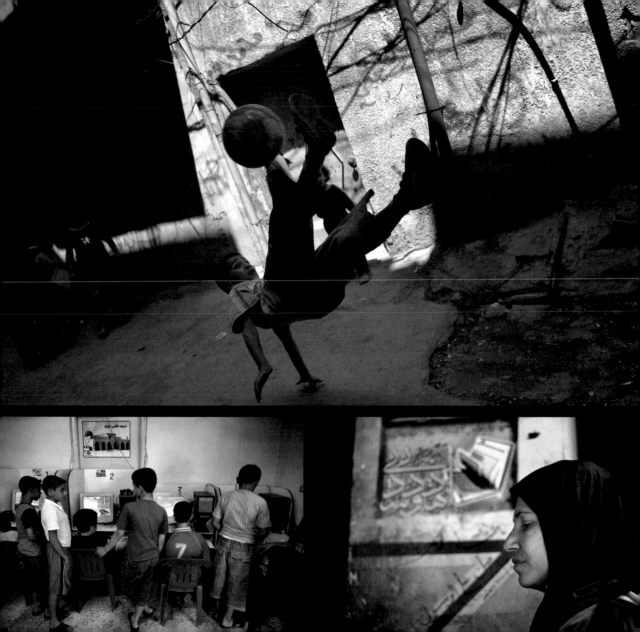

095 096 097 098 099 100 101 102 103

104 105 106 107 108

095 Israeli soldiers stand next to an
armoured personnel carrier at a
temporary military base near Kibbutz
Zikkim, just outside the Gaza Strip.
30 May 2007. Kibbutz Zikkim, Israel.
Amir Cohen.

096 People react following a rocket attack
by Palestinian militants in Gaza on
the southern Israeli town of Sderot.
21 May 2007. Sderot, Israel. Yonathan
Weitzman.

097 Palestinian children who have fled
violence at the Nahr al-Bared refugee
camp sit in a school converted into a
shelter for refugees in the Beddawi
refugee camp in northern Lebanon.
29 May 2007. Beddawi, Lebanon. Jerry Lampen.

098 A Hamas fighter takes position inside
a scanning machine in the customs hall
of the Rafah border crossing between
Egypt and the southern Gaza Strip,
after its capture by Hamas forces.
15 June 2007. Gaza. Ibraheem Abu Mustafa.

099 Hamas fighters pose in Palestinian
President Mahmoud Abbas's personal
office after the Islamist group's
gunmen routed Abbas's last forces
in Gaza and seized effective control.
15 June 2007. Gaza. Suhaib Salem.

100 Palestinians hold up their hands
before approaching Israeli soldiers
at the Erez crossing while trying to
flee from Gaza. Dozens were trapped
at the border crossing for days after
Hamas Islamists routed Fatah forces
in the Gaza Strip. 19 June 2007. Gaza.
Oleg Popov.

101 Palestinian girls play in the Beddawi
refugee camp. 28 May 2007. Beddawi,
Lebanon. Jerry Lampen.

102 Injured Palestinian Mahmoud Taha,
85, who fled violence between Islamist
militants and the Lebanese army
at the Nahr al-Bared refugee camp,
waits to receive medical treatment
at a school converted into a shelter
in the Beddawi refugee camp. 29 May
2007. Beddawi, Lebanon. Jerry Lampen.

103 A Palestinian woman sweeps a
street in the Beddawi refugee camp.
28 May 2007. Beddawi, Lebanon. Jerry Lampen.

104 An elderly Palestinian man is assisted
by a younger relative to wash his
face inside a school converted into a
shelter at the Beddawi refugee camp.
25 May 2007. Beddawi, Lebanon. Jerry Lampen.

105 A Palestinian boy plays soccer in
the Beddawi refugee camp. 28 May
2007. Beddawi, Lebanon. Jerry Lampen.

106 Palestinian boys play in a computer
game shop in the Beddawi refugee
camp. 28 May 2007. Beddawi, Lebanon.
Jerry Lampen.

107 A Palestinian woman waits for her
order in a bakery in the Beddawi
refugee camp. 28 May 2007. Beddawi,
Lebanon. Jerry Lampen.a

108 Israel's Vice Premier Shimon
Peres speaks on the phone before
a Kadima party meeting. Peres, a
former prime minister and Labour
leader who now belongs to Kadima,
was sworn in as Israel's president on
15 July 2007. 11 June 2007. Jerusalem.
Yonathan Weitzman.

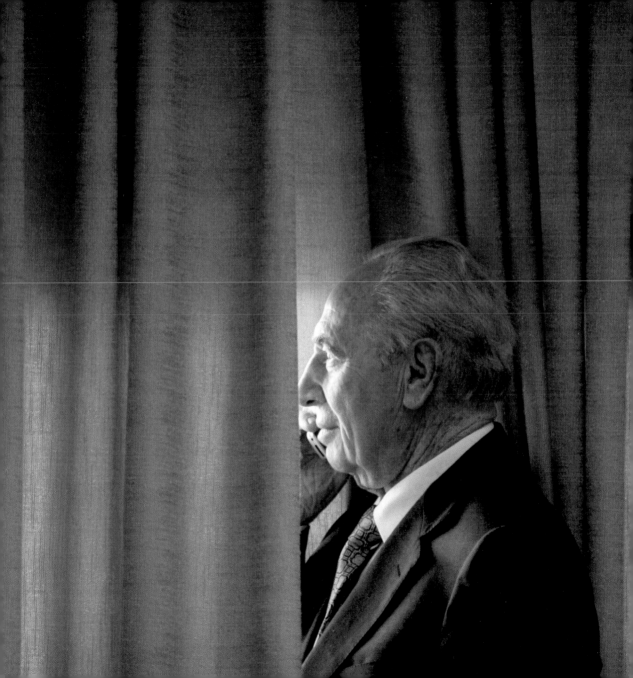

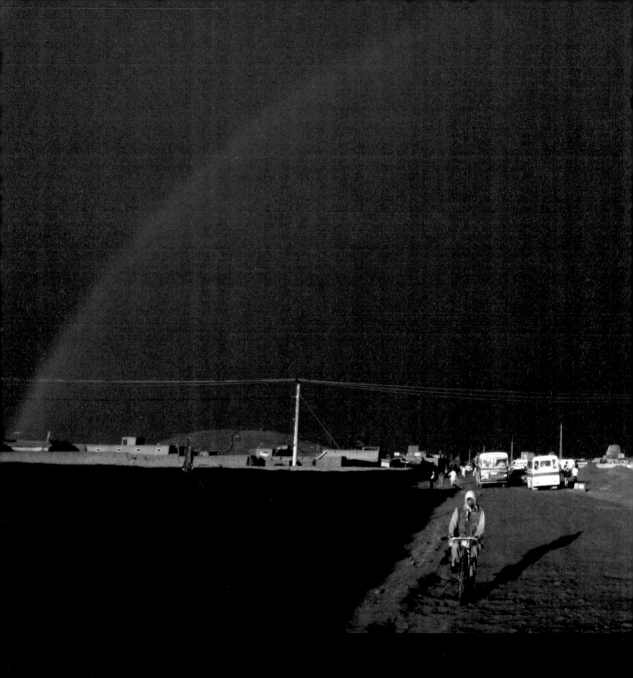

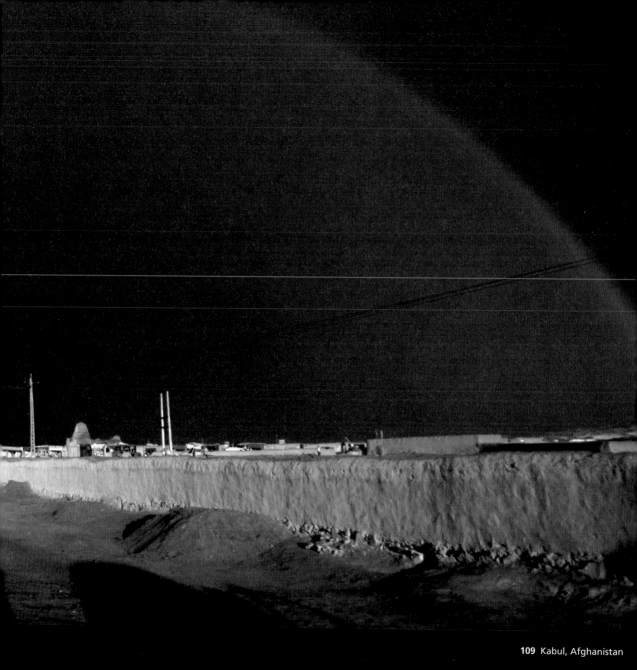

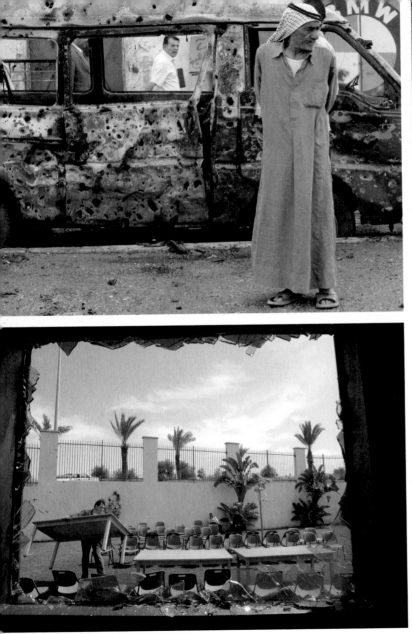

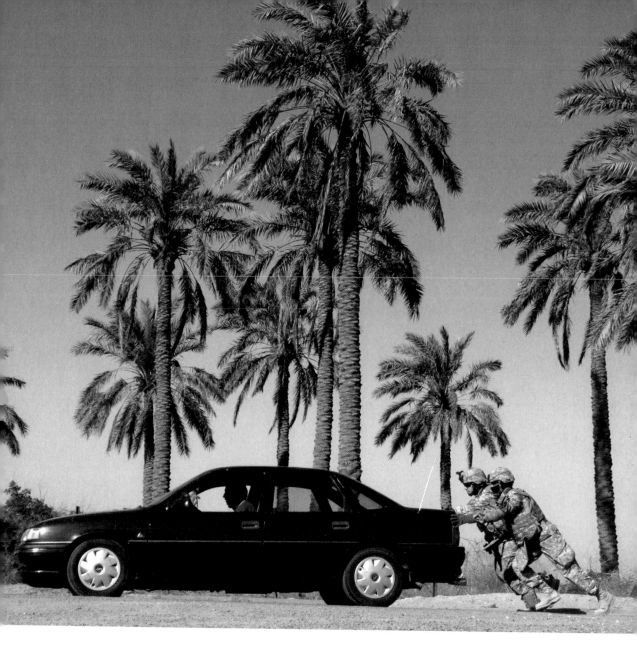

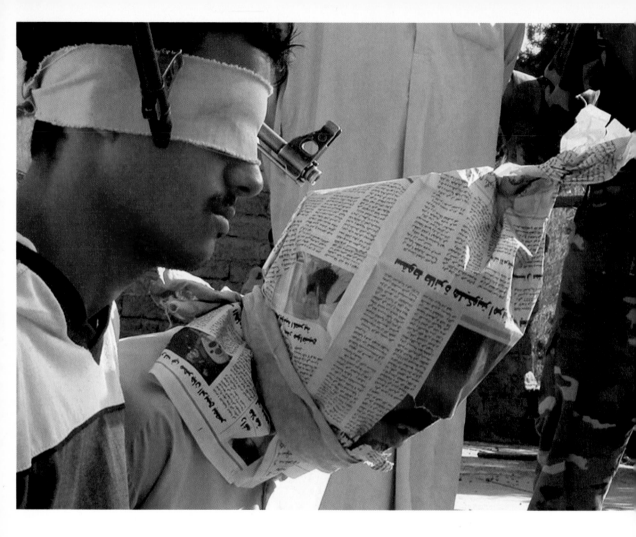

113 Baquba, Iraq

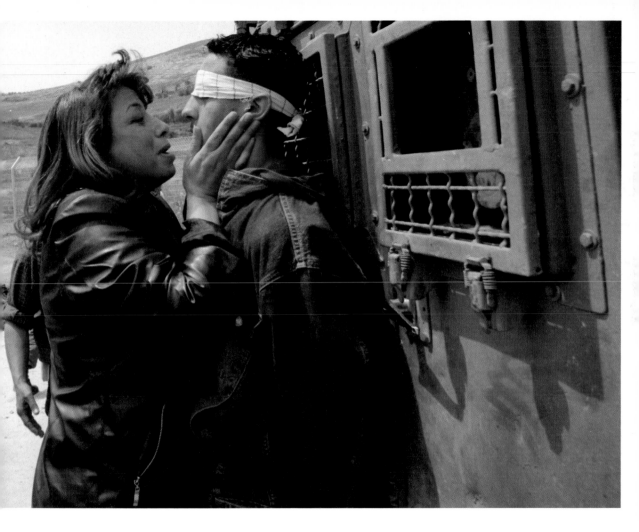

114 Nablus, West Bank

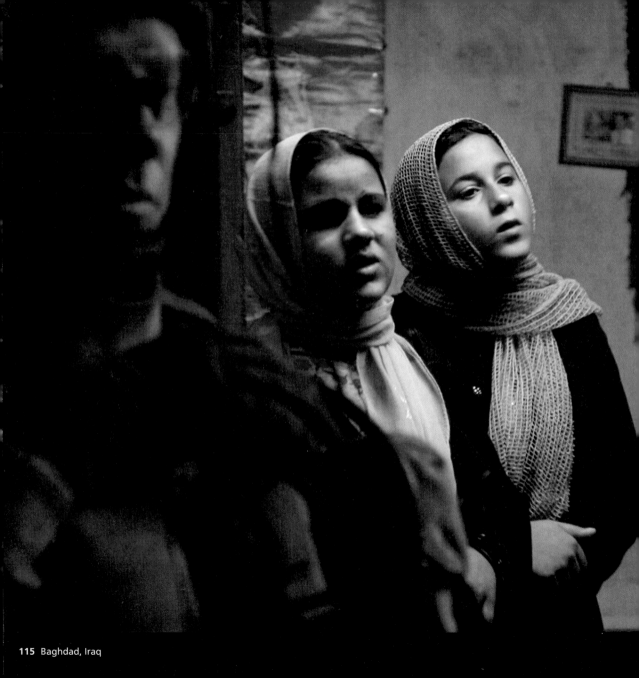

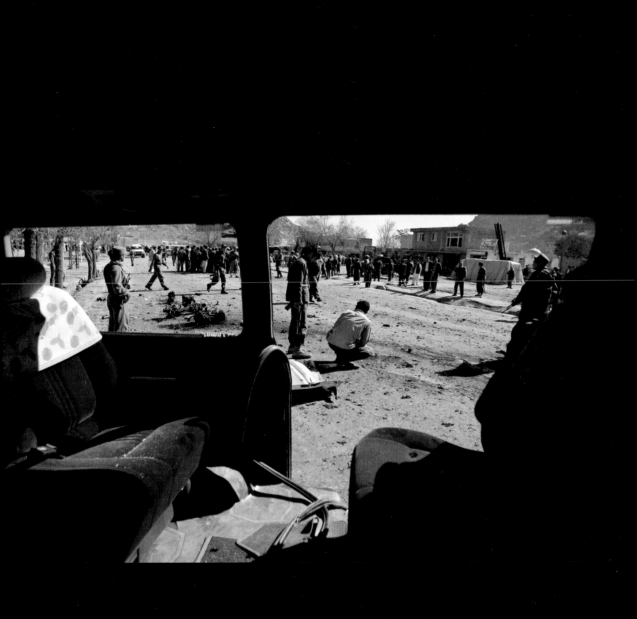

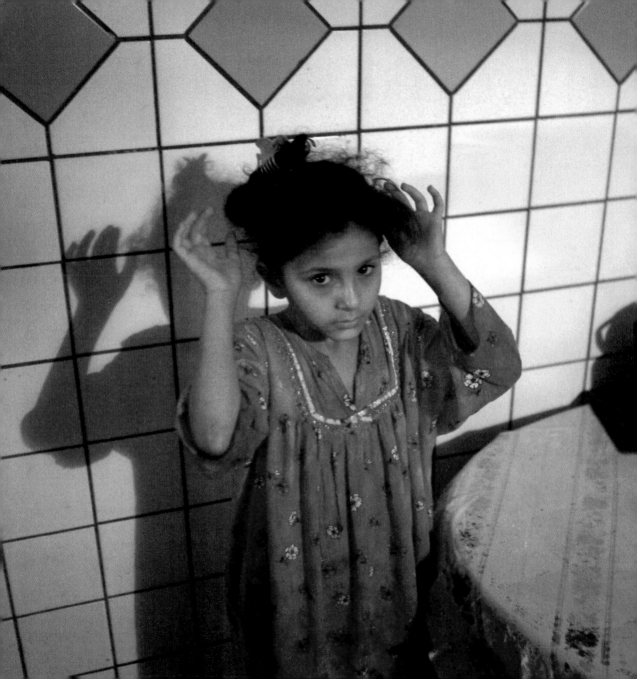

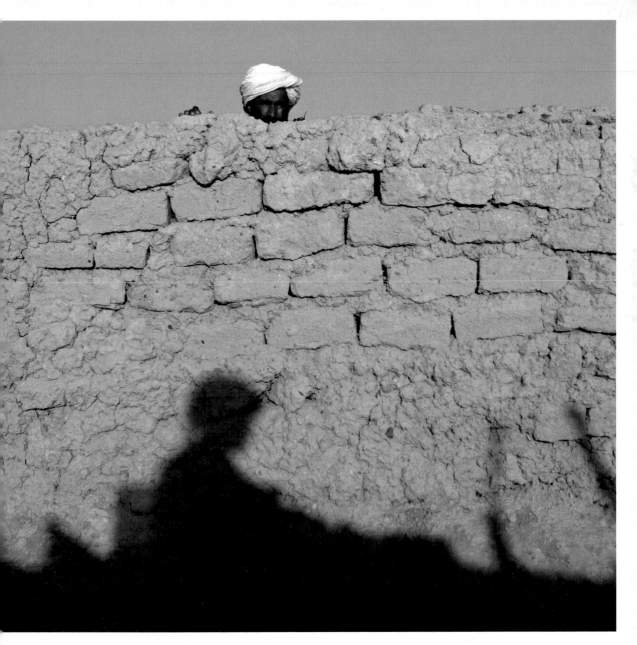

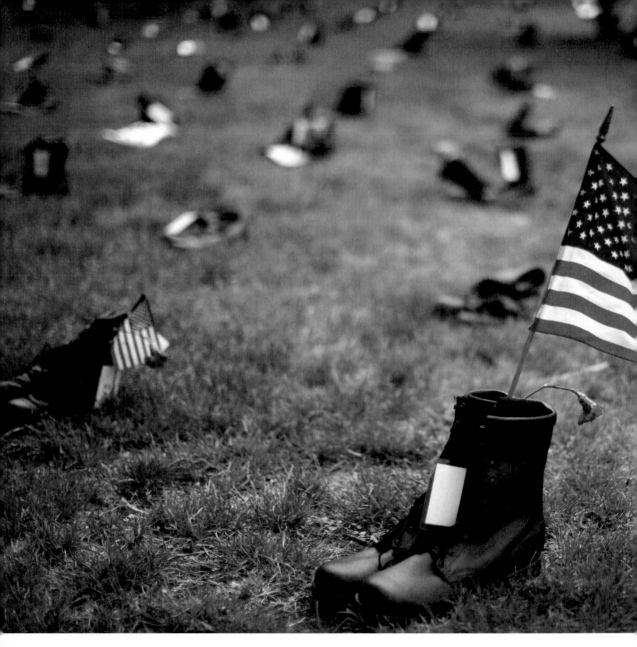

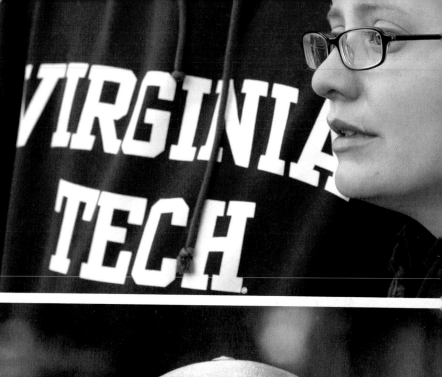

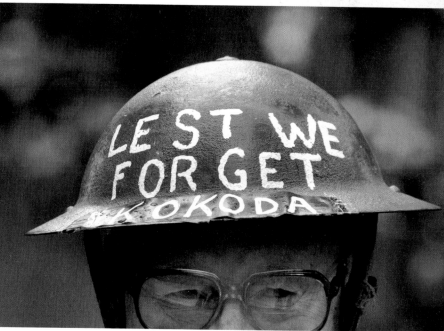

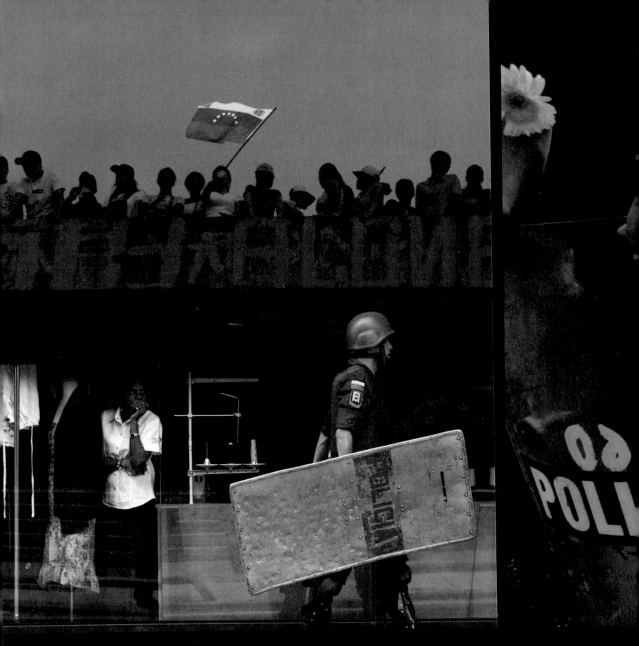

Caracas, Venezuela

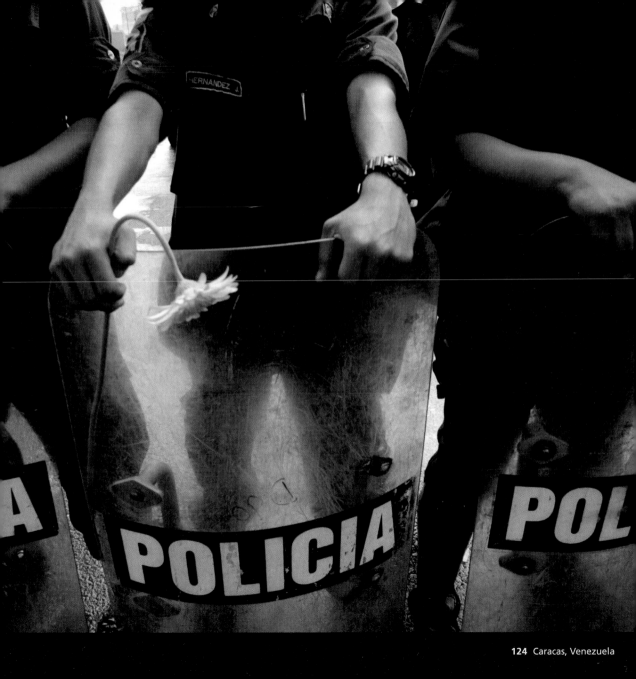

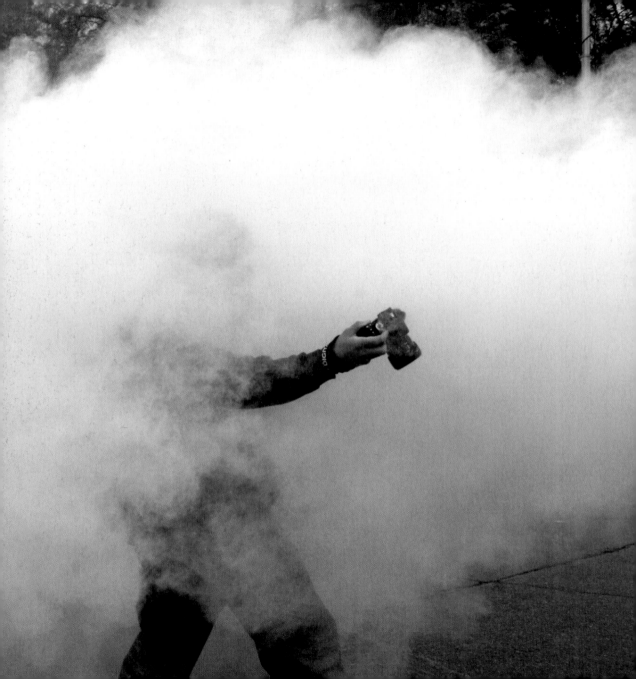

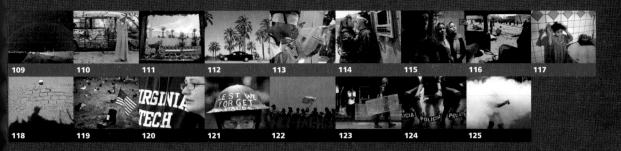

A man cycles in front of a rainbow in Kabul. 29 April 2007. Kabul, Afghanistan. Goran Tomasevic.

A man stands at the scene of a car bomb attack in Baghdad. 2 April 2007. Baghdad, Iraq. Ceerwan Aziz.

A Palestinian man clears furniture at the American International School in Gaza after the building was partially blown up by Palestinian militants, causing damage but no injuries, security sources and witnesses said. 21 April 2007. Gaza. Mohammed Salem.

U.S. soldiers push the car of an Iraqi man to start the engine at a checkpoint in north Baghdad. 13 June 2007. Baghdad, Iraq. Goran Tomasevic.

Iraqi soldiers guard blindfolded detainees arrested during a raid in Baquba. An Iraqi army officer said 18 suspected insurgents were arrested and assorted weapons confiscated. 30 June 2007. Baquba, Iraq. Helmiy al-Azawi.

Palestinian Najat al-Nadi touches the face of her son Raed after he was detained by Israeli soldiers at the Hawara checkpoint. An Israeli army spokesman said three pipe bombs and a mortar shell were found in his possession. 2 May 2007. Nablus, West Bank. Abed Omar Qusini.

115 Iraqi girls watch as their brother is questioned by U.S. soldiers on suspicion of attempting to hide an illegal machine gun. 4 April 2007. Baghdad, Iraq. Bob Strong.

116 Crime scene investigators inspect the site of a suicide bomb blast near Afghanistan's parliament building. 6 April 2007. Kabul, Afghanistan. Ahmad Masood.

117 An Iraqi girl holds her hands up while U.S. and Iraqi soldiers search her home. 30 June 2007. Baquba, Iraq. Goran Tomasevic.

118 An Afghan man watches over the wall of his house in the Mukhtar district of Helmand province as a British military patrol passes by. 11 June 2007. Mukhtar, Afghanistan. Ahmad Masood.

119 More than 3,400 pairs of combat boots, one pair for every U.S. soldier killed to date in the Iraq war, are displayed as part of 'Eyes Wide Open: An Exhibition on the Human Cost of the Iraq War'. 25 May 2007. Chicago, United States. John Gress.

120 A Virginia Tech student cries as she looks at Norris Hall, scene of 30 of the 32 killings that occurred on 16 April 2007 when Cho Seung-Hui opened fire on fellow students and staff in an apparently premeditated massacre. 17 April 2007. Blacksburg, United States. Kevin Lamarque.

121 War veteran Pat Lee wears his old World War Two helmet during the annual Anzac (Australian and New Zealand Army Corps) Day march in Sydney to commemorate all those who have lost their lives in war. 25 April 2007. Sydney, Australia. David Gray.

122 A supporter of Radio Caracas Television (RCTV) waves a Venezuelan flag during a protest against President Hugo Chavez's decision not to renew the broadcaster's licence because of accusations that it participated in a bungled 2002 coup attempt, incited violent demonstrations and aired immoral programming. It was to be replaced by a state-run channel promoting the president's socialist programmes. 27 May 2007. Caracas, Venezuela. Francesco Spotorno.

123 A police officer in riot gear walks past a shop during a protest by supporters of RCTV. 28 May 2007. Caracas, Venezuela. Francesco Spotorno.

124 Riot police stand in line with flowers placed on their shields by supporters of RCTV. 29 May 2007. Caracas, Venezuela. Francesco Spotorno.

125 A photographer is surrounded by teargas released by Chilean riot police during a May Day demonstration in Santiago. 1 May 2007. Santiago, Chile. Patricio Valenzuela Hohmann.

127 [TOP] Mount Meron, Israel **128** [ABOVE] Cervia, Italy

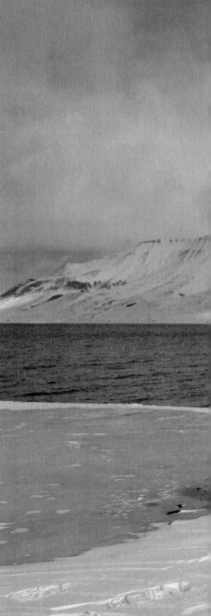

129 [TOP] Jammu, India **130** [ABOVE] Shenyang, China

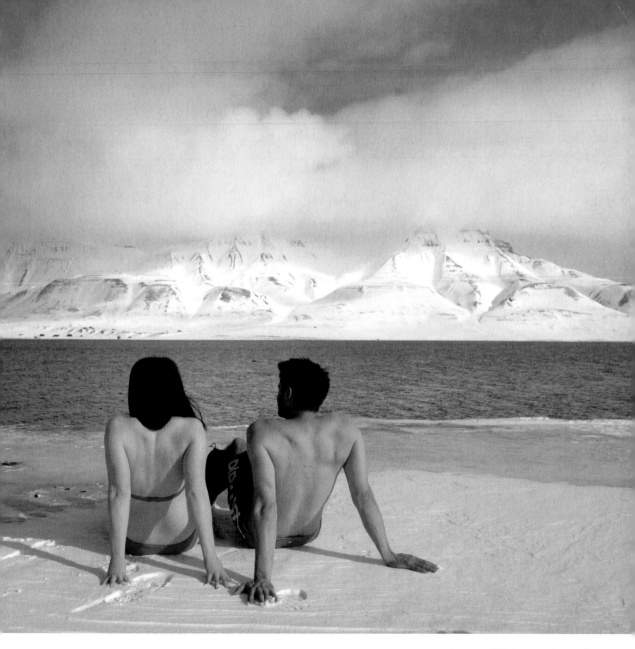

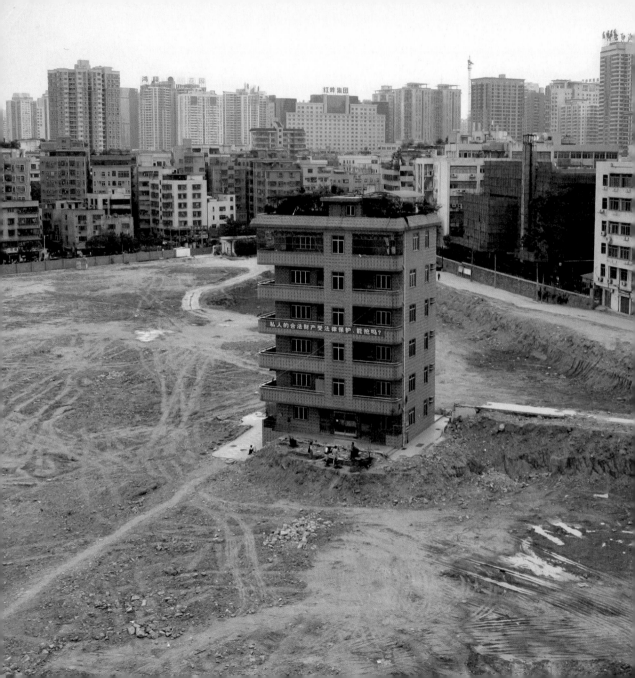

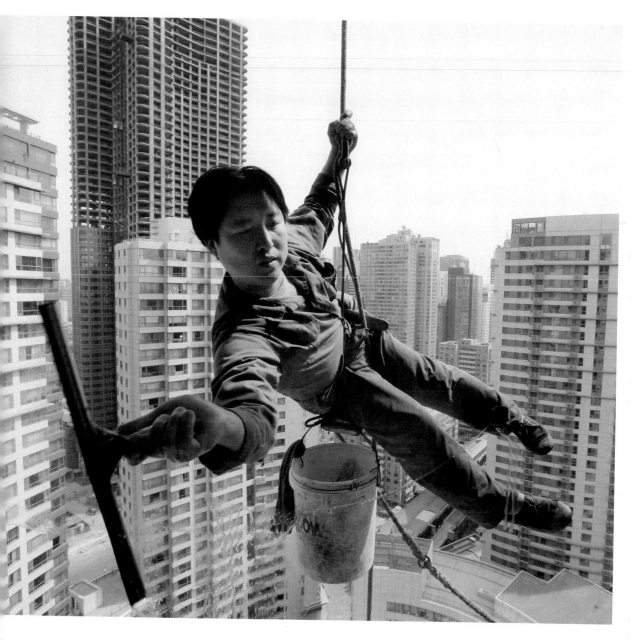

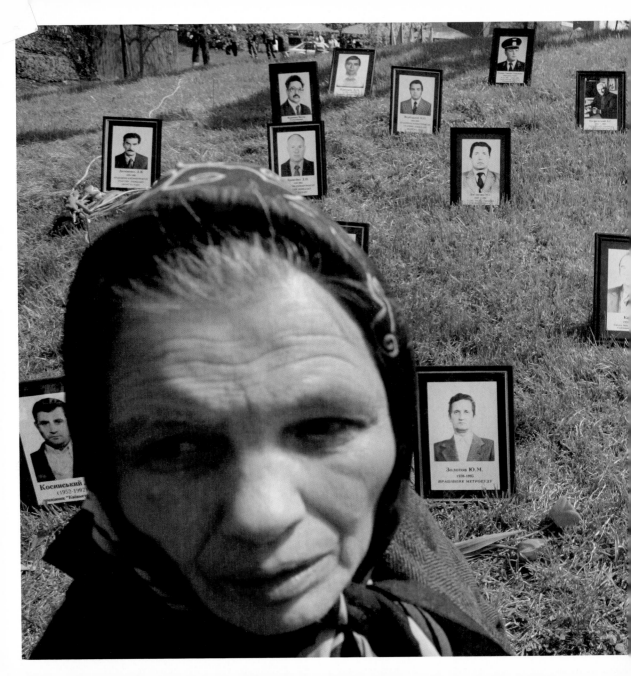

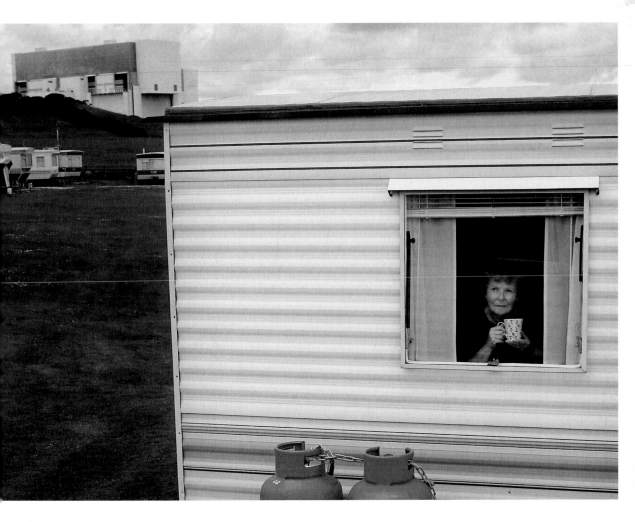

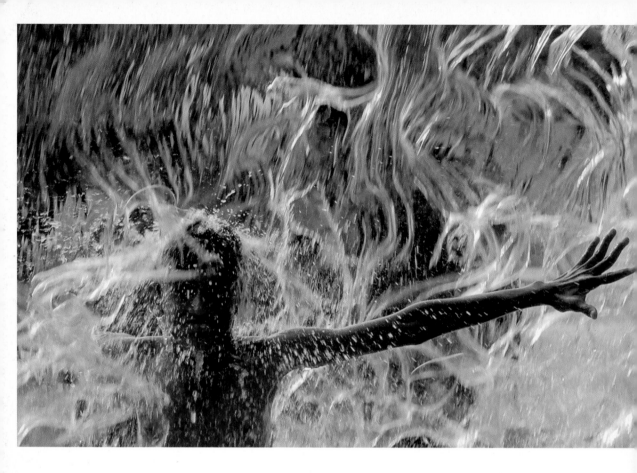

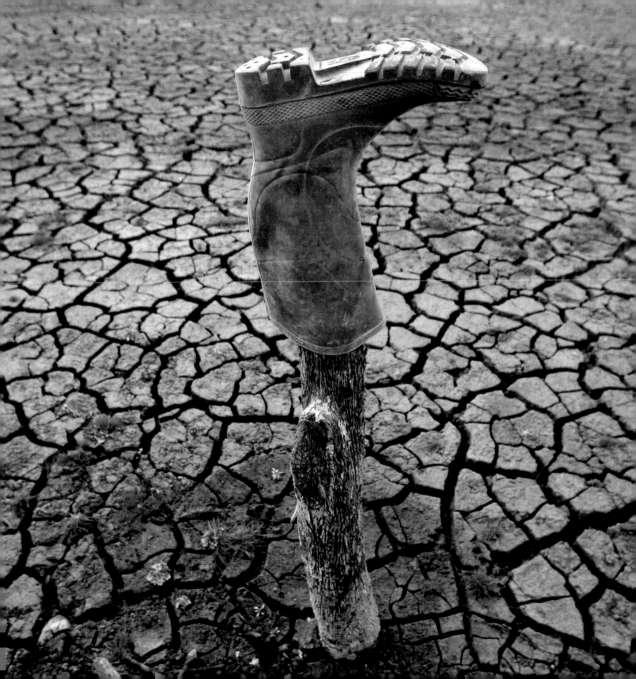

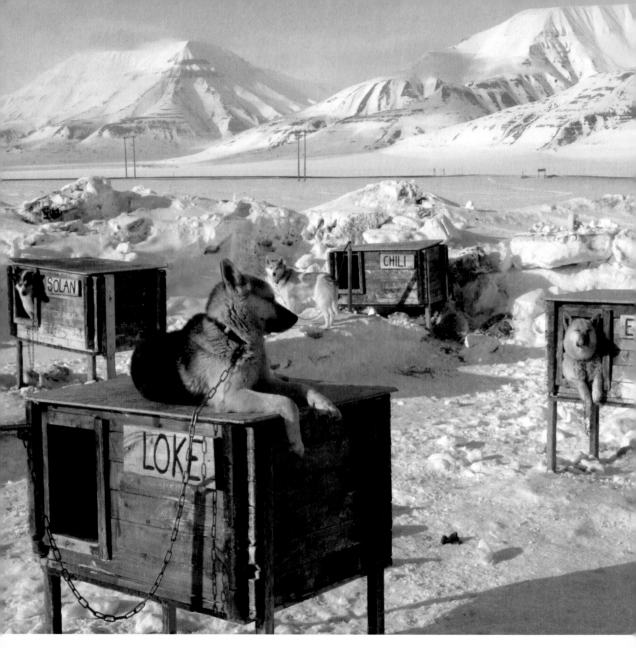

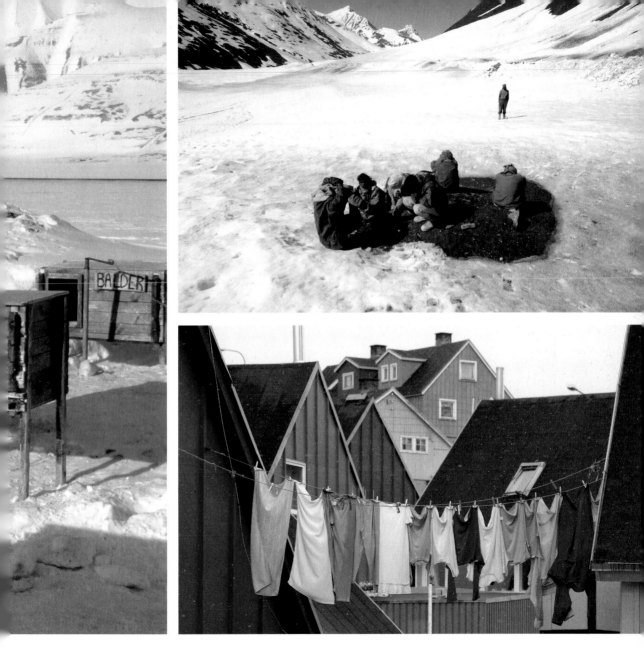

139 [TOP] Zojila Pass, India **140** [ABOVE] Ilulissat, Greenland

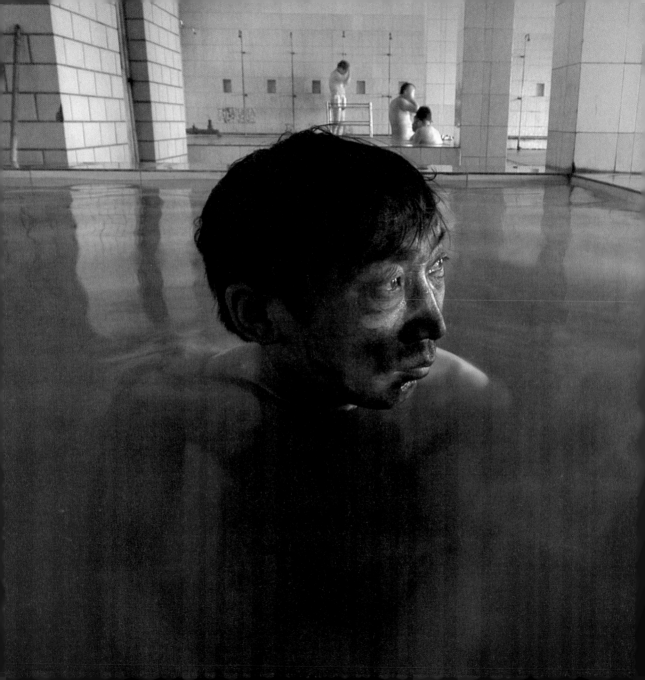

126 **An Airbus A380, the world's largest passenger aircraft, prepares to land at Mumbai airport.** 8 May 2007. Mumbai, India. Arko Datta.

127 **Ultra-Orthodox Jews take part in celebrations for the Jewish holiday of Lag Ba-Omer on Mount Meron in northern Israel. Lag Ba-Omer marks the end of a plague in ancient times that killed thousands of disciples of a revered rabbi.** 6 May 2007. Mount Meron, Israel. Yonathan Weitzman.

128 **A competitor holds his kite at the end of an international kite festival in Cervia, northeast Italy.** 30 April 2007. Cervia, Italy. Alessandro Bianchi.

129 **A boy swims in a pond on the outskirts of Jammu, in Indian Kashmir.** 5 June 2007. Jammu, India. Amit Gupta.

130 **A motorcyclist wears a scarf to protect herself against dust as she rides on a windy day in Shenyang, capital of Liaoning province. Northern China experiences duststorms and sandstorms almost every spring due to drought, overuse of agricultural land and topographical peculiarities.** 7 May 2007. Shenyang, China. Sheng Li.

131 **Climate change activists Lesley Butler and Rob Bell 'sunbathe' on the edge of a frozen fjord in the Norwegian Arctic town of Longyearbyen. The activists warned that global warming could thaw the Arctic and make the sea warm enough to swim in.** 25 April 2007. Longyearbyen, Norway. Francois Lenoir.

132 **A six-floor villa stands intact in the middle of a cleared construction site in the central business district of Shenzhen. The villa's owners had refused to accept the compensation offered by the developer.** 17 April 2007. Shenzhen, China. Paul Yeung.

133 **A worker cleans the windows of an apartment block in Beijing's central business district.** 4 April 2007. Beijing, China. Reinhard Krause.

134 **A woman attends a memorial ceremony on the 21st anniversary of the Chernobyl tragedy, the world's worst civil nuclear accident. The explosion sent radioactive clouds into the air, poisoning vast areas in Ukraine, Belarus and Russia, and contaminating much of Europe.** 26 April 2007. Kiev, Ukraine. Gleb Garanich.

135 **Margaret Stewart sits at the window of her caravan holiday home in East Lothian, Scotland, with Torness nuclear power station in the background.** 23 May 2007. Torness, Britain. David Moir.

136 **A boy plays in a water fountain in Hyderabad.** 2 April 2007. Hyderabad, India. Krishnendu Halder.

137 **A gumboot sits atop a fencepost on the site of the submerged town of Old Adaminaby. Prolonged drought is causing the town to re-emerge out of the vanishing waters of Lake Eucumbene, one of Australia's largest manmade lakes.** 5 June 2007. Old Adaminaby, Australia. David Gray.

138 **Dogs wait to be harnessed to pull sleds across snows covering the Arctic island of Spitsbergen.** 26 April 2007. Spitsbergen, Norway. Francois Lenoir.

139 **Labourers working for India's Border Roads Organization rest at Zojila Pass in Indian Kashmir. Lying 3,530 metres (11,580 feet) above sea level, the pass had been snowbound for the previous six months.** 1 May 2007. Zojila Pass, India. Fayaz Kabli.

140 **Clothes hang out to dry in western Greenland.** 14 May 2007. Ilulissat, Greenland. Bob Strong.

141 **A miner washes himself in the bathhouse of a coal mine in Changzhi, in north China's Shanxi province.** 16 April 2007. Changzhi, China. Bai Gang.

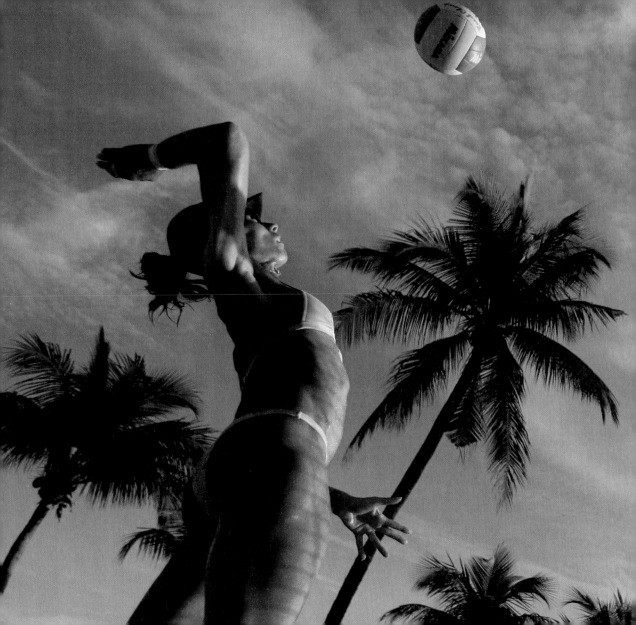

143 [TOP] Ternje, Serbia **144** [ABOVE] Lima, Peru

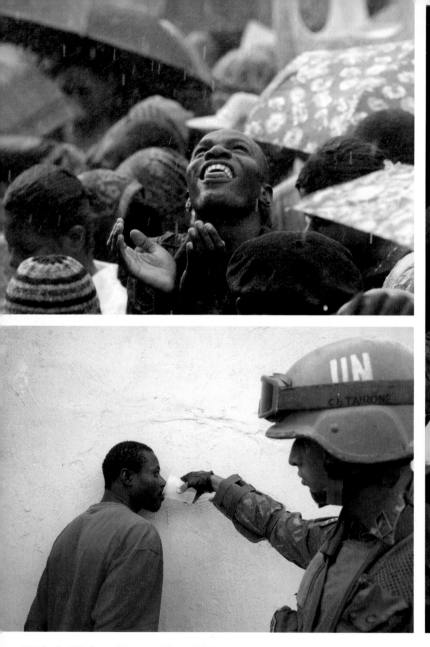

147 [TOP] **148** [ABOVE] Port-au-Prince, Haiti

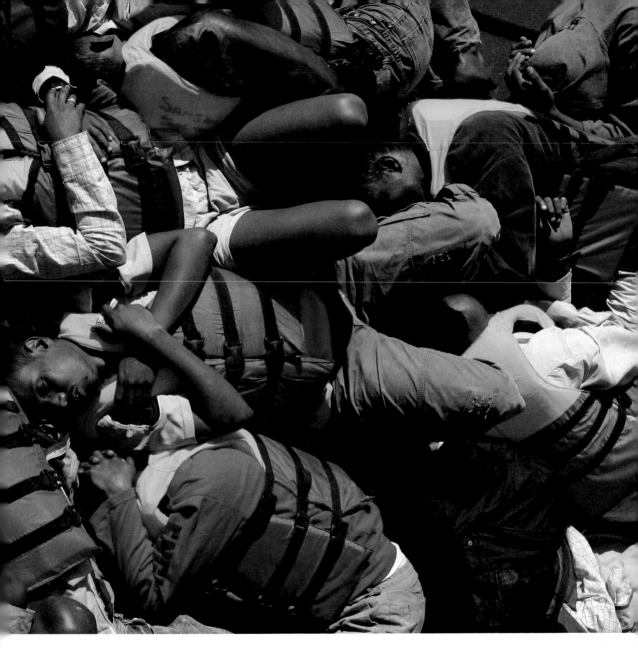

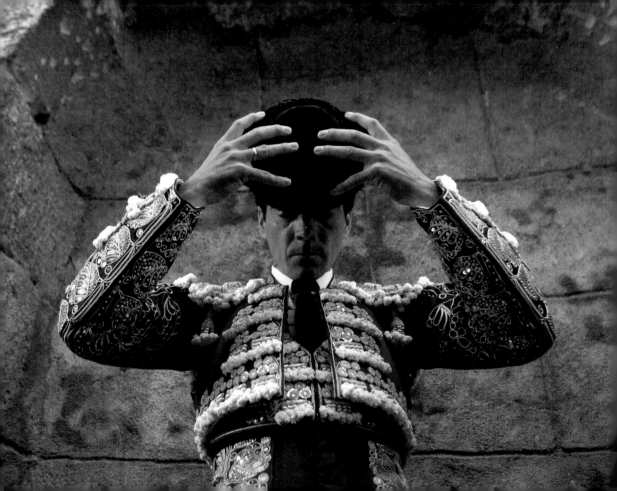

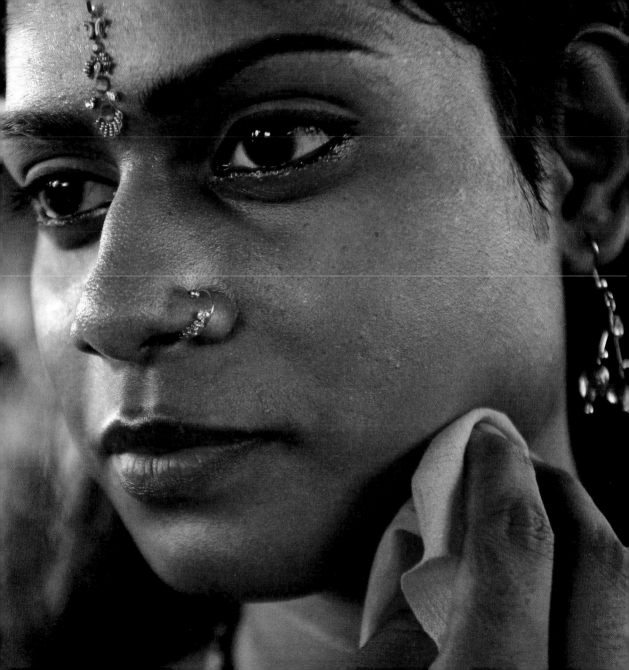

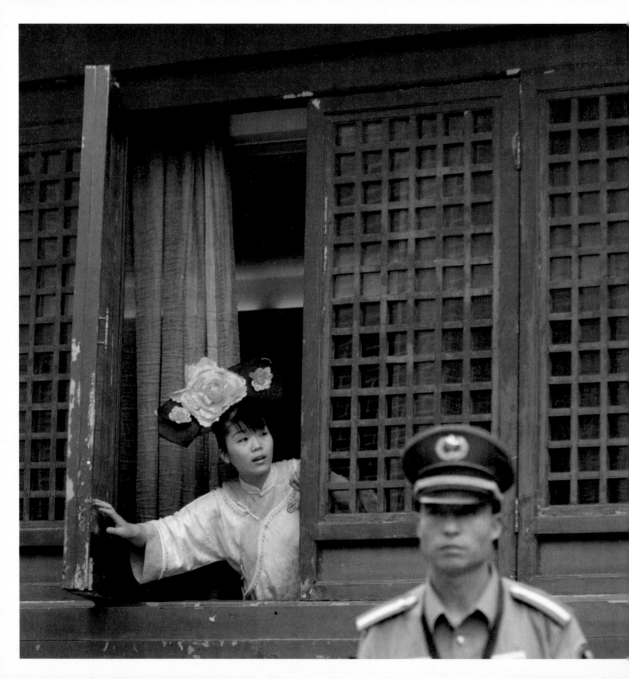

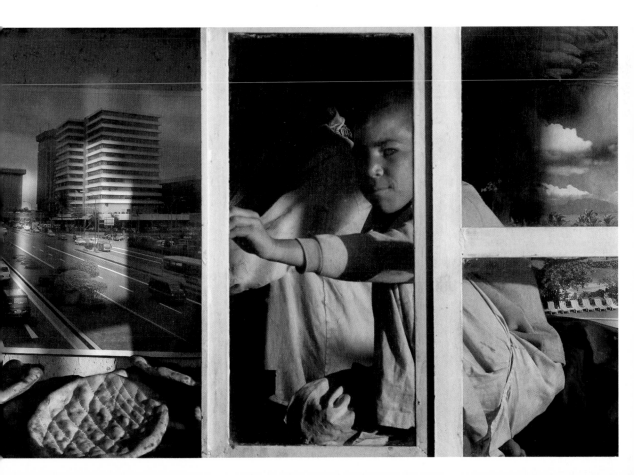

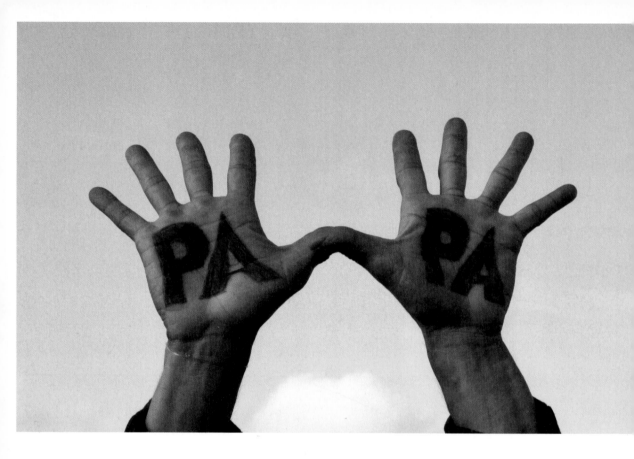

154 São Paulo, Brazil

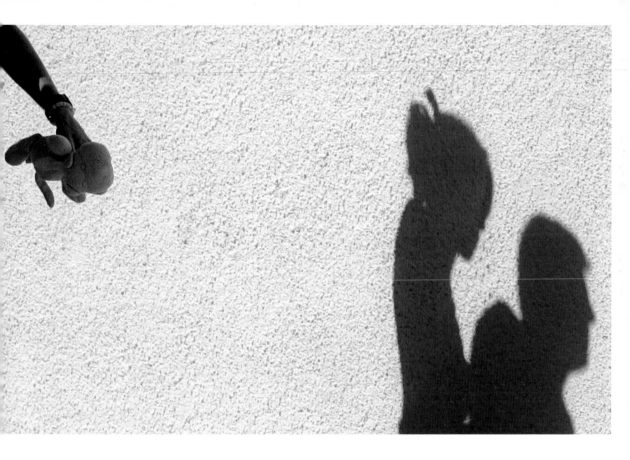

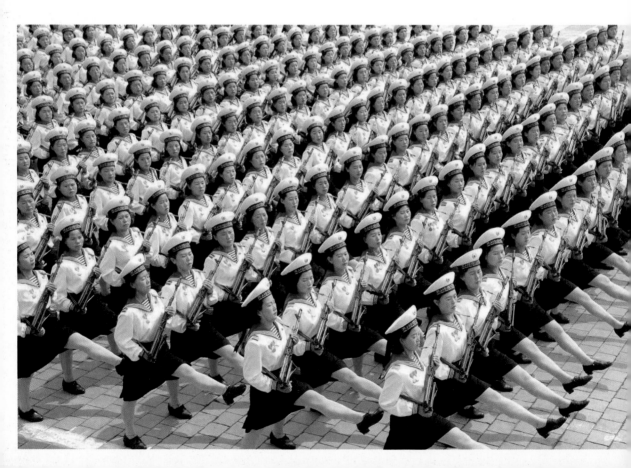

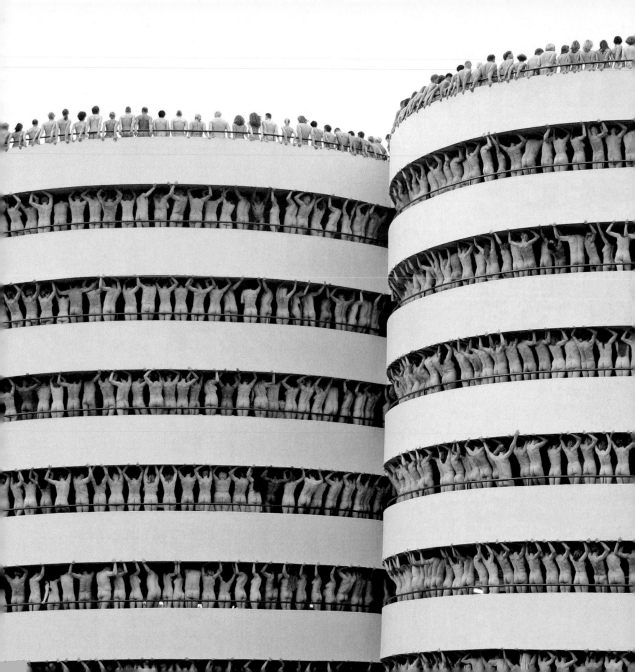

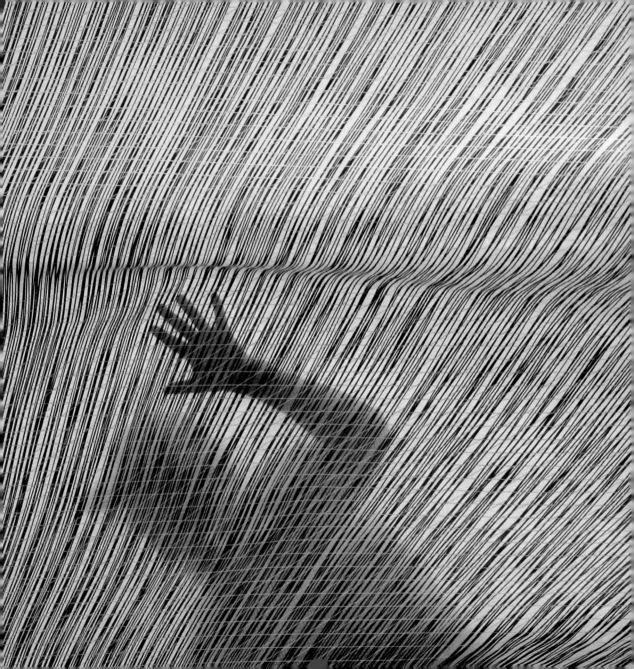

Ana Paula Connelly of Brazil hits a shot during a practice session ahead of the FIVB Women's Beach Volleyball Singapore Open. 23 May 2007. Singapore. Nicky Loh.

Kosovo Albanian children in traditional dress perform a dance during the opening of a school, built with the help of funds raised by German NATO soldiers, in the village of Ternje, 80 km (50 miles) west of the Kosovan capital Pristina. 7 May 2007. Ternje, Serbia. Hazir Reka.

A mother-to-be sings to her unborn baby during a workshop in Lima's maternity hospital. 10 May 2007. Lima, Peru. Enrique Castro-Mendivil.

Two elderly women exercise in Havana as a girl sits beside them. 23 April 2007. Havana, Cuba. Claudia Daut.

A woman cools off in a swimming pool on a hot day in the Senegalese capital Dakar. 22 June 2007. Dakar, Senegal. Finbarr O'Reilly.

A Haitian drinks rainwater during Mass. 27 June 2007. Port-au-Prince, Haiti. Kena Betancur.

148 A Brazilian soldier gives water to a suspected gang member in Cité Soleil, a volatile neighbourhood in the Haitian capital Port-au-Prince. Brazil has control of the U.N. peacekeeping mission in the troubled Caribbean country. 16 May 2007. Port-au-Prince, Haiti. Kena Betancur.

149 Would-be immigrants to Europe, believed to be from Somalia, sleep on the deck of an Armed Forces of Malta ship after being transferred from a Sicilian trawler that rescued them when their boat capsized. 31 May 2007. Malta. Darrin Zammit Lupi.

150 Matador Manuel Jesús 'El Cid' adjusts his *montera* before a bullfight in Seville's Maestranza bullring. 25 April 2007. Seville, Spain. Jon Nazca.

151 Bobby, an Indian 'launda' transvestite dancer, waits for his turn to perform during a street play as part of a campaign for AIDS awareness. 7 June 2007. Kolkata, India. Jayanta Shaw.

152 A waitress dressed as a Qing Dynasty lady-in-waiting looks out from a window as a security guard stands nearby at the Beijing Jun Wang Fu hotel, built in Qing Dynasty style. 30 May 2007. Beijing, China. Jason Lee.

153 A boy sits in a bakery in the outskirts of Kabul. 5 April 2007. Kabul, Afghanistan. Goran Tomasevic.

154 A Catholic faithful in São Paulo holds up his hands bearing the word 'Papa' (Pope) while awaiting the arrival of Pope Benedict to celebrate Mass. 11 May 2007. São Paulo, Brazil. Jamil Bittar.

155 Kate McCann, mother of missing four-year-old British girl Madeleine McCann, holds a soft toy in her hand as shadow silhouettes of her and her husband Gerry are seen on a wall. Madeleine McCann disappeared from an apartment in the Algarve resort of Praia da Luz on 3 May 2007. 17 May 2007. Lagos, Portugal. Nacho Doce.

156 Female sailors parade in central Pyongyang as North Korea celebrates the 75th birthday of its army. 25 April 2007. Pyongyang, North Korea. Korea News Service.

157 Naked volunteers pose for U.S. photographer Spencer Tunick in the Europarking building in Amsterdam. 3 June 2007. Amsterdam, Netherlands. Koen van Weel.

158 A crew member of the Italian Luna Rossa Challenge team is silhouetted through the jib as he works on the bow before their semi-final Race 6 at the Louis Vuitton Cup in Valencia. 20 May 2007. Valencia, Spain. Victor Fraile.

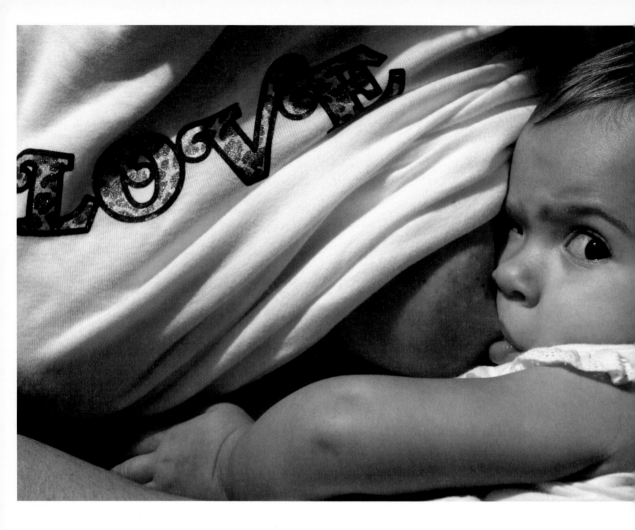

159 Malaga, Spain

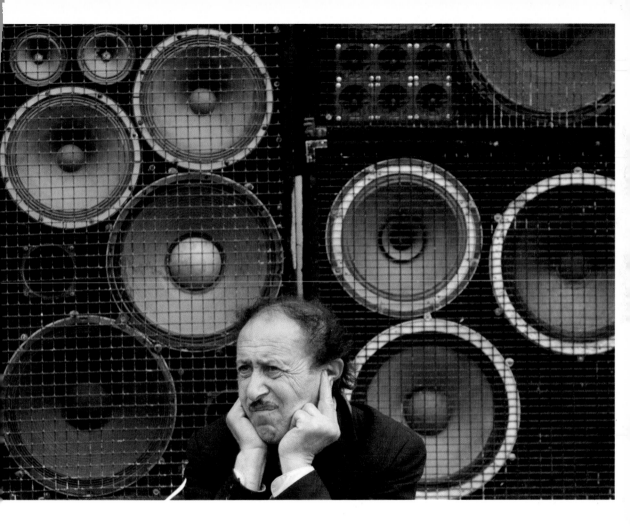

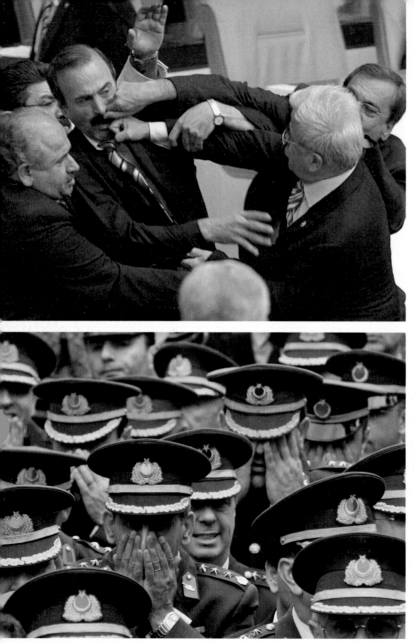

161 [TOP] Ankara, Turkey **162** [ABOVE] Istanbul, Turkey

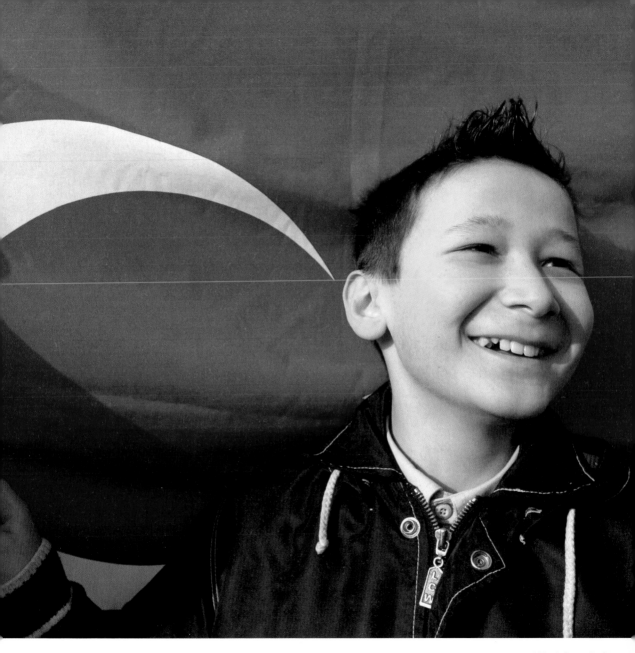

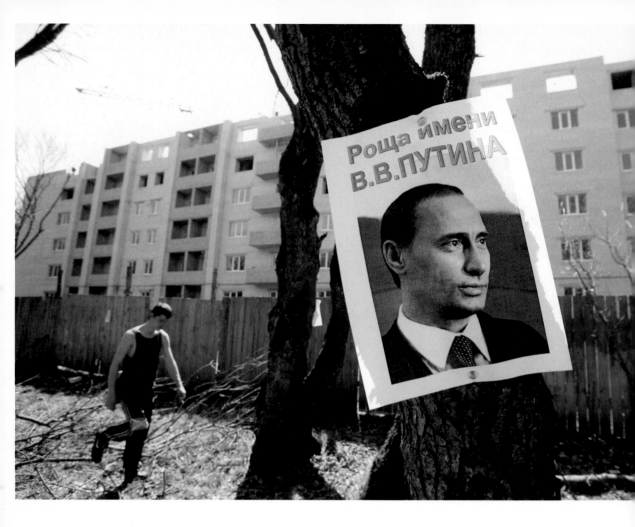

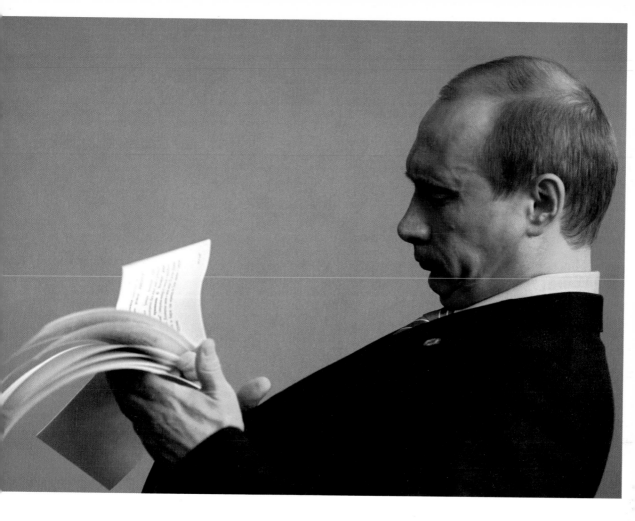

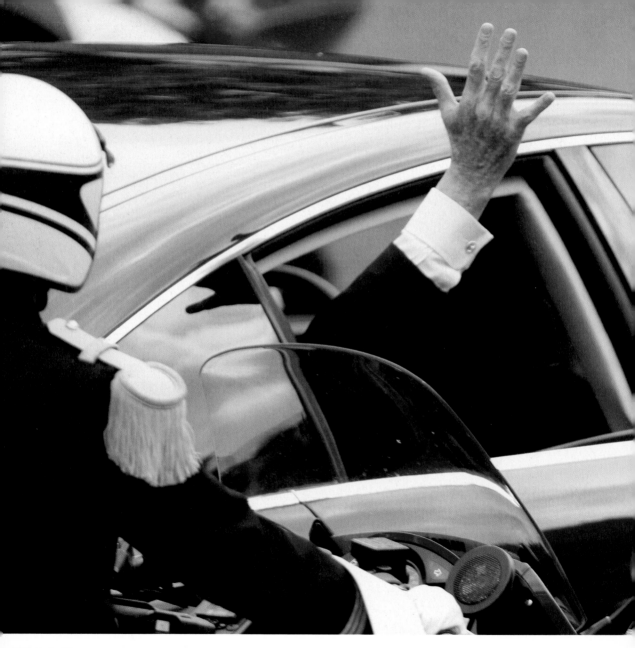

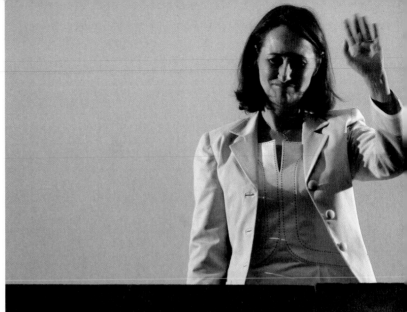

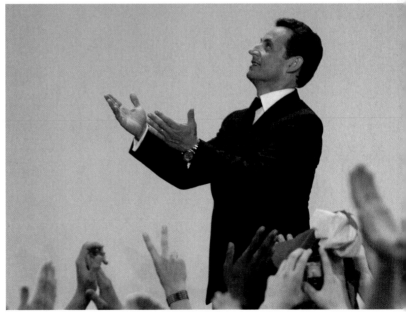

167 [TOP] **168** [ABOVE] Paris, France

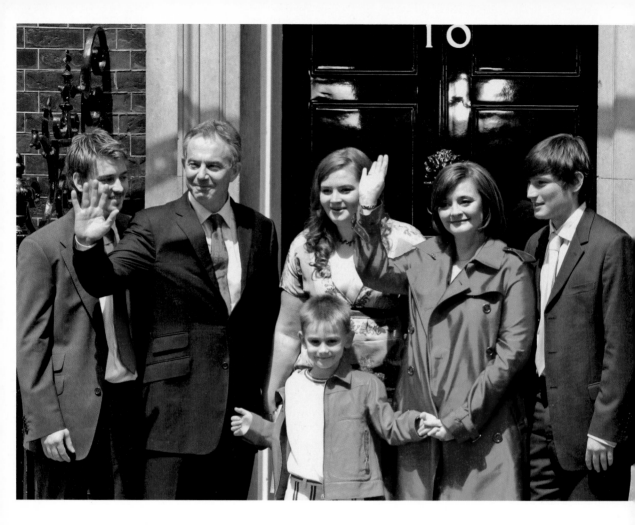

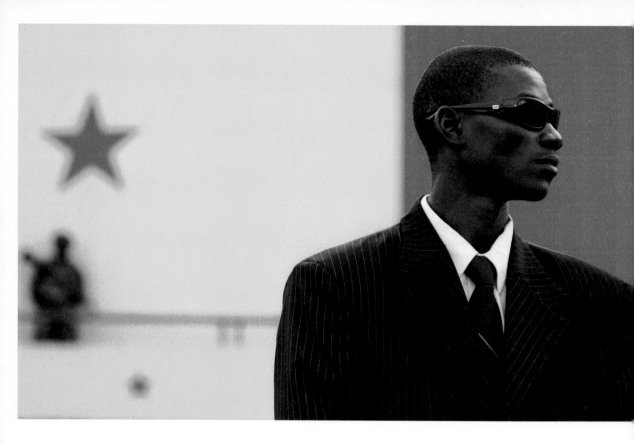

171 Dakar, Senegal

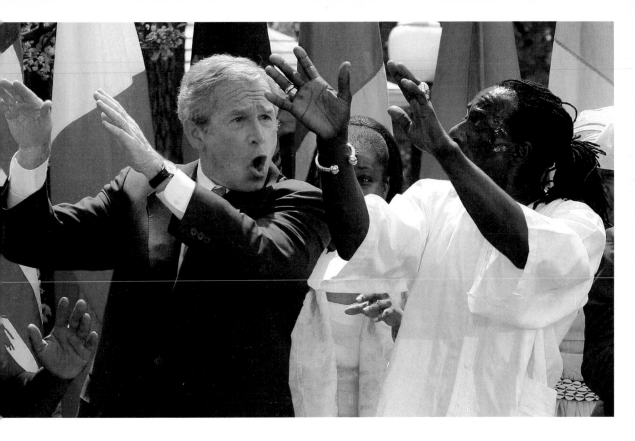

159 A woman nurses her baby during a demonstration in a Malaga shopping centre to protest against an incident in which a mother was prohibited from breastfeeding in public. 30 June 2007. Malaga, Spain. Jon Nazca.

160 A man protects his ears as he sits in front of loudspeakers during an opposition rally ahead of Armenia's parliamentary elections. 13 May 2007. Yerevan, Armenia. David Mdzinarishvili.

161 MPs from Turkey's main opposition Republican People's Party hit Turkey's ruling AK Party MP Alim Tunc (second left) as others try to stop the fight during a debate in the Turkish parliament. 28 May 2007. Ankara, Turkey. Nuri Kaynar, Anatolian.

162 Turkish military officers join prayers during the funeral ceremony of Emrah Kayadelen, 21, one of seven Turkish soldiers killed in an attack in the southeast of the country by the banned Kurdistan Workers Party. 6 June 2007. Istanbul, Turkey. Fatih Saribas.

163 A child waves a Turkish flag during a ceremony to mark National Sovereignty and Child's Day at the mausoleum of Mustafa Kemal Ataturk, founder of modern Turkey. 23 April 2007. Ankara, Turkey. Umit Bektas.

164 A man walks past a tree bearing a portrait of Russian President Vladimir Putin near an expanding housing development in the southern Russian city of Stavropol. Local residents named the grove after Putin and put up his portraits to save the trees from a construction company's axe, Russian media reported. 11 April 2007. Stavropol, Russia. Eduard Korniyenko.

165 Russian President Vladimir Putin checks his notes before meeting his Serbian counterpart Boris Tadić in Zagreb during the Energy Summit of Southeast European Countries. 24 June 2007. Zagreb, Croatia. Damir Sagolj.

166 French President Jacques Chirac waves on the Champs Elysées as he departs ceremonies marking the 62nd anniversary of the end of World War Two. 8 May 2007. Paris, France. Charles Platiau.

167 Ségolène Royal, France's Socialist Party presidential candidate, waves to the crowd from her election headquarters after the announcement of the results. Conservative UMP party candidate Nicolas Sarkozy was elected as president in the runoff vote. 6 May 2007. Paris, France. Christian Hartmann.

168 France's newly elected president, Nicolas Sarkozy, speaks to supporters after the election results are announced. 6 May 2007. Paris, France. Philippe Wojazer.

169 British Prime Minister Tony Blair departs 10 Downing Street with his family after a decade in power. 27 June 2007. London, Britain. Kieran Doherty.

170 Britain's new prime minister, Gordon Brown, and his wife Sarah arrive at 10 Downing Street. 27 June 2007. London, Britain. Kieran Doherty.

171 Security agents stand guard during the inauguration of Senegal's President Abdoulaye Wade. 3 April 2007. Dakar, Senegal. Finbarr O'Reilly.

172 U.S. President George W. Bush dances with Senegalese performers from the West African Dance Company during an event to mark World Malaria Awareness Day in the Rose Garden of the White House. 25 April 2007. Washington, DC, United States. Jason Reed.

173 Shadows are cast on a wall at a polling centre during vote counting in central Lagos. Nigerians were voting for state governors, with presidential and national assembly elections scheduled a week later in Africa's most populous nation. 14 April 2007. Lagos, Nigeria. Finbarr O'Reilly.

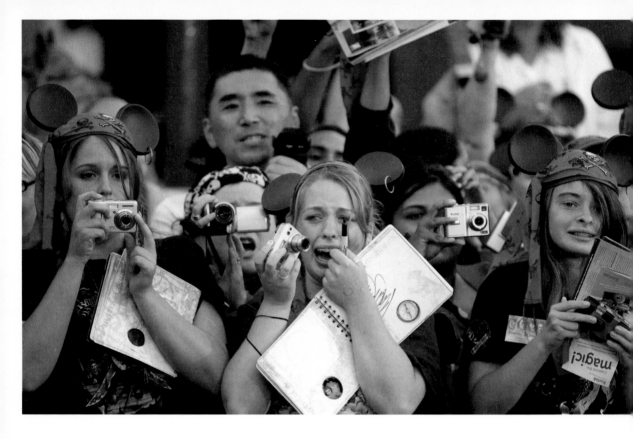

177 Anaheim, United States

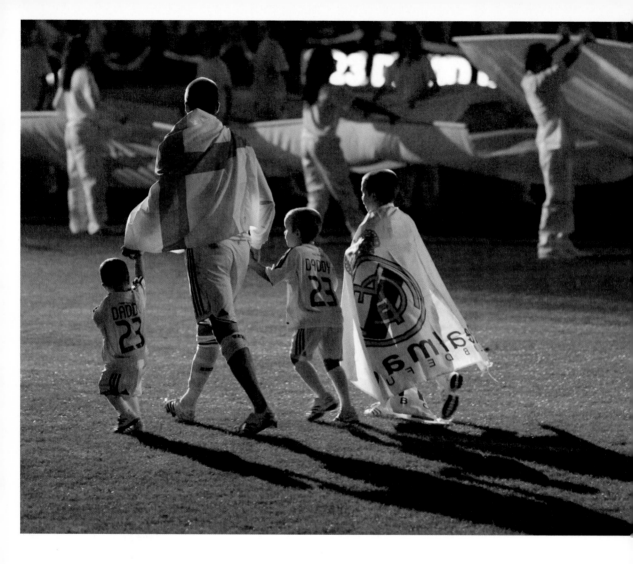

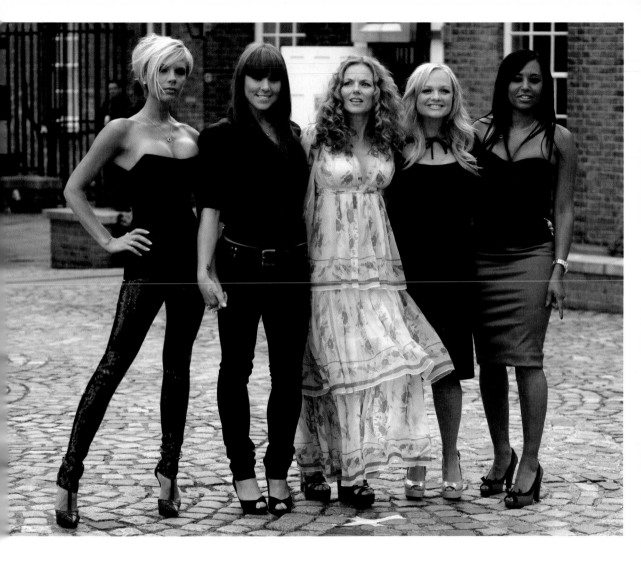

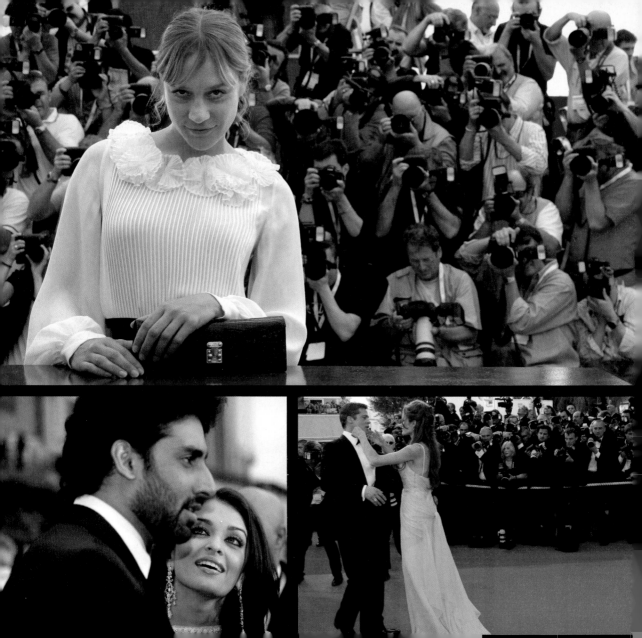

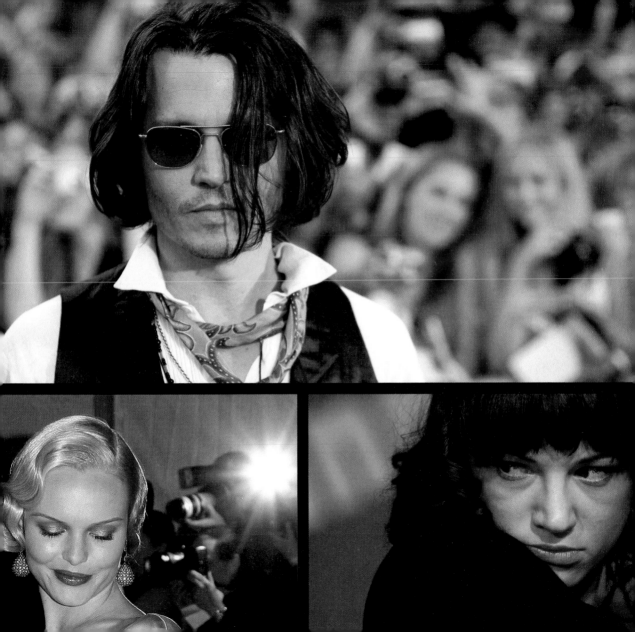

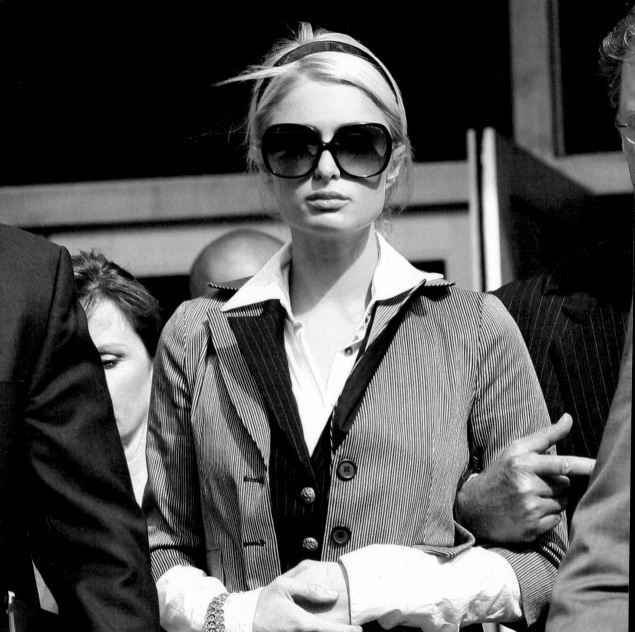

174 | 175 | 176 | 177 | 178 | 179 | 180 | 181 | 182

183 | 184 | 185 | 186 | 187

174 **Models wear clothes made from recycled materials during Phnom Penh's Recycled Fashion Show.** 18 May 2007. Phnom Penh, Cambodia. Chor Sokunthea.

75 **A participant has her hair styled before the Daspu spring/summer 2007–8 fashion show. Daspu is a Brazilian fashion house founded and run by prostitutes. Its designs have become the talk of Brazil's fashion industry.** 22 May 2007. Rio de Janeiro, Brazil. Bruno Domingos.

76 **British model Kate Moss displays clothes from her Kate Moss collection in a window of the Topshop flagship store in central London.** 30 April 2007. London, Britain. Toby Melville.

77 **Fans wait to see cast member Orlando Bloom at the premiere of *Pirates of the Caribbean: At World's End* at Disneyland in Anaheim, California.** 19 May 2007. Anaheim, United States. Mario Anzuoni.

78 **Nuns react to the arrival of Pope Benedict in St Peter's Square to lead his weekly general audience.** 25 April 2007. Vatican City. Max Rossi.

179 **Real Madrid's David Beckham walks with his sons Cruz, Romeo and Brooklyn (left to right) at Madrid's Santiago Bernabeu stadium.** 17 June 2007. Madrid, Spain. Victor Fraile.

180 **The Spice Girls pose for the media in London ahead of announcing their reunion tour.** 28 June 2007. London, Britain. Dylan Martinez.

181 **Cast member Chloe Sevigny poses during a photocall for U.S. director David Fincher's in-competition film *Zodiac* at the 60th Cannes Film Festival.** 17 May 2007. Cannes, France. Eric Gaillard.

182 **Bollywood actor Abhishek Bachchan arrives in Sheffield with his wife Aishwarya Rai for the Indian International Academy Awards.** 9 June 2007. Sheffield, Britain. David Moir.

183 **Brad Pitt and Angelina Jolie arrive for the world premiere of U.S. director Steven Soderbergh's film *Ocean's Thirteen* at the 60th Cannes Film Festival.** 24 May 2007. Cannes, France. Jean-Paul Pelissier.

184 **Cast member Johnny Depp attends the premiere of *Pirates of the Caribbean: At World's End*.** 19 May 2007. Anaheim, United States. Mario Anzuoni.

185 **Actress Kate Bosworth arrives for a Metropolitan Museum of Art Costume Institute Benefit Gala.** 7 May 2007. New York, United States. Lucas Jackson.

186 **Cast member Asia Argento attends a news conference for U.S. director Abel Ferrara's film *Go Go Tales* at the 60th Cannes Film Festival.** 23 May 2007. Cannes, France. Jean-Paul Pelissier.

187 **Paris Hilton leaves the Los Angeles Municipal Court where she was ordered to spend 45 days in jail for violating the terms of her probation for alcohol-related reckless driving.** 4 May 2007. Los Angeles, United States. Mario Anzuoni.

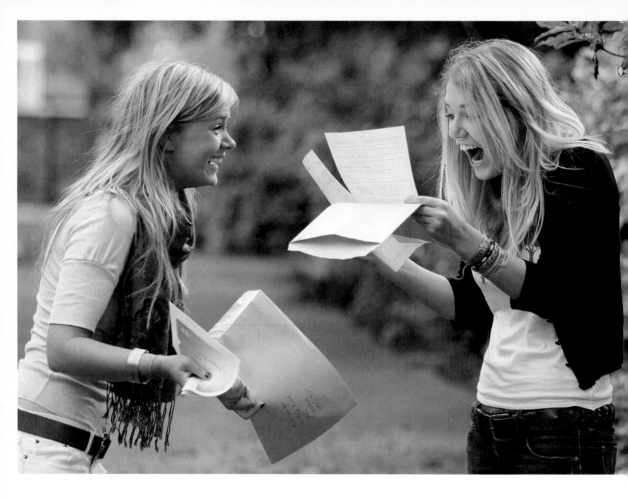

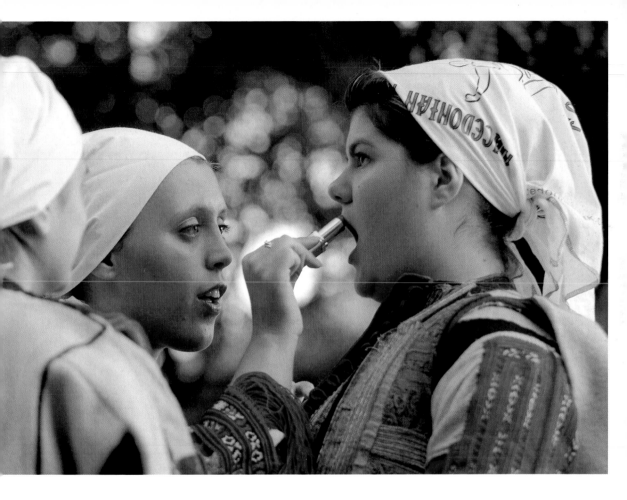

190 [TOP] Pamplona, Spain **191** [ABOVE] Barquisimeto, Venezuela

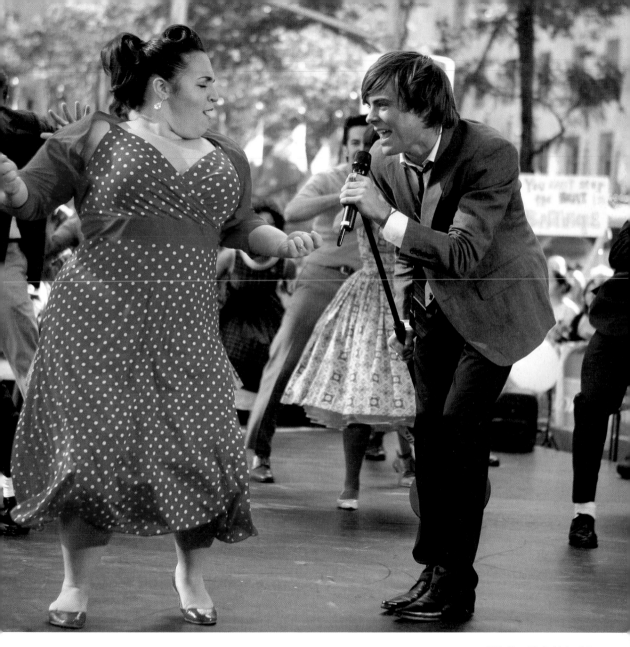

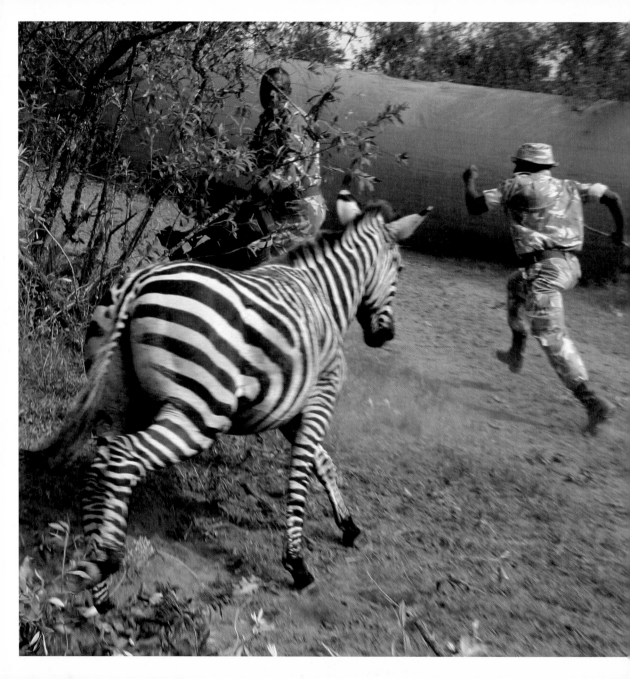

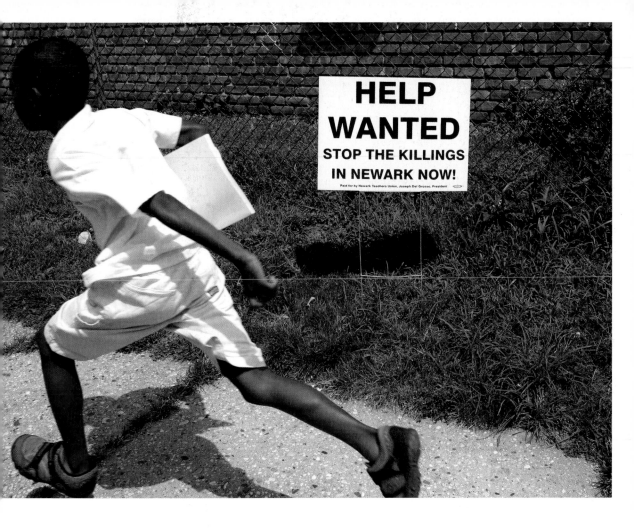

The sign in the image reads:

HELP WANTED
STOP THE KILLINGS
IN NEWARK NOW!

Paid for by Newark Teachers Union, Joseph Del Grosso, President

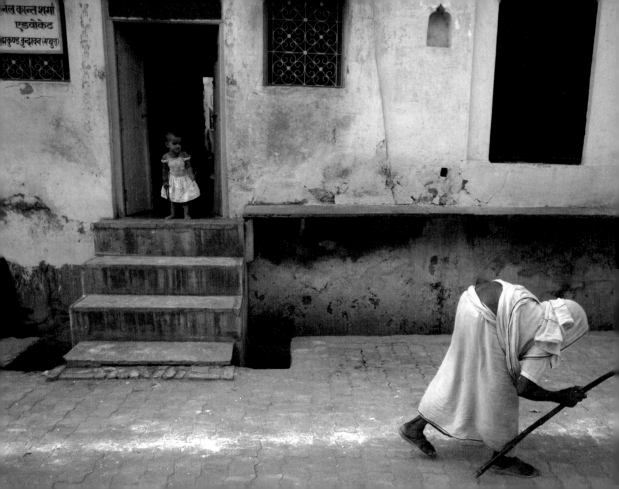

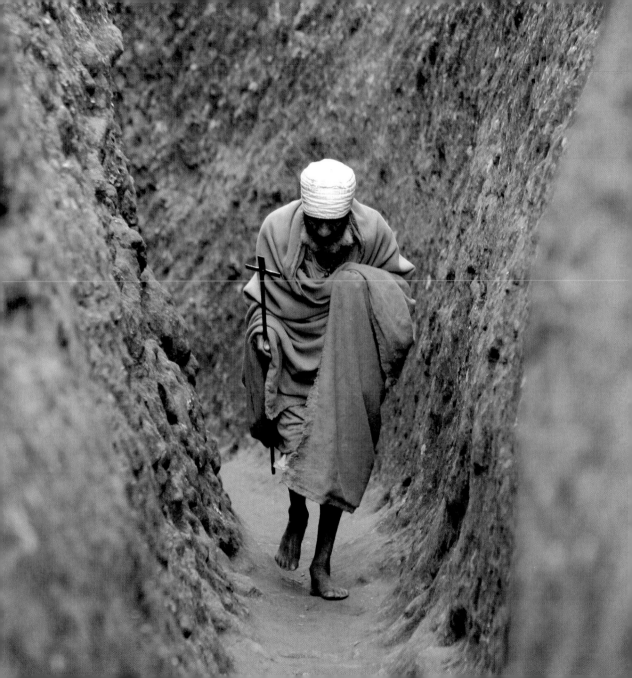

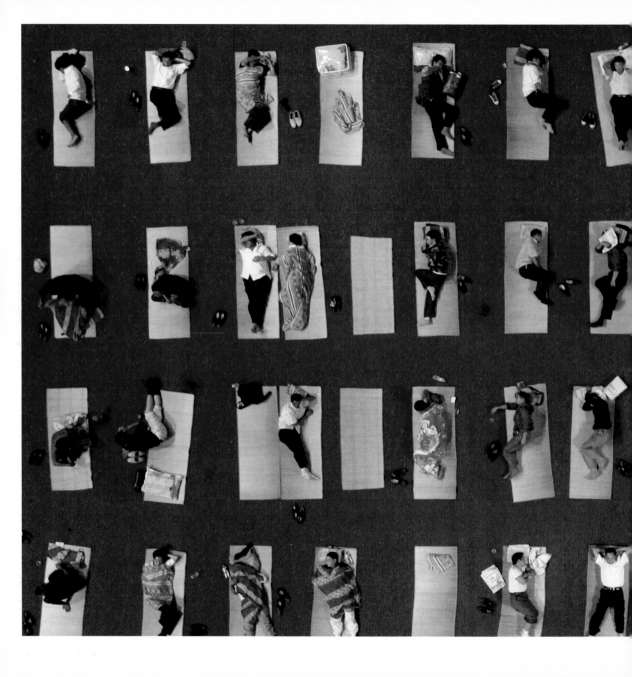

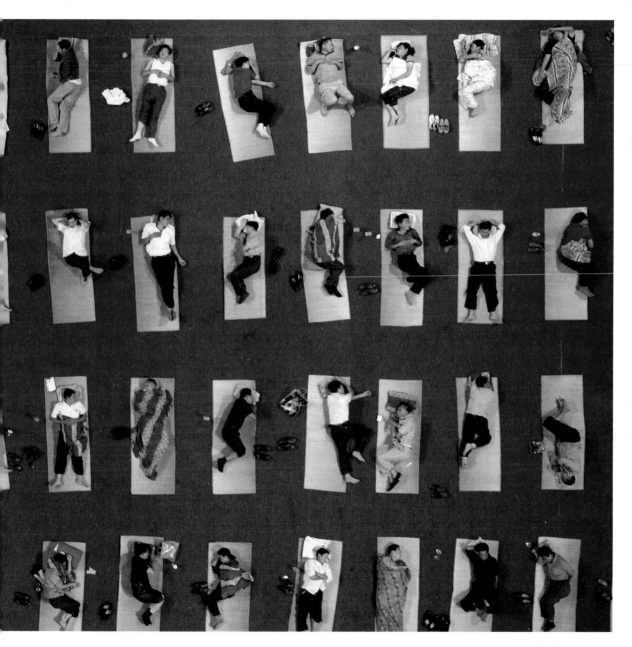

197 Wuhan, China

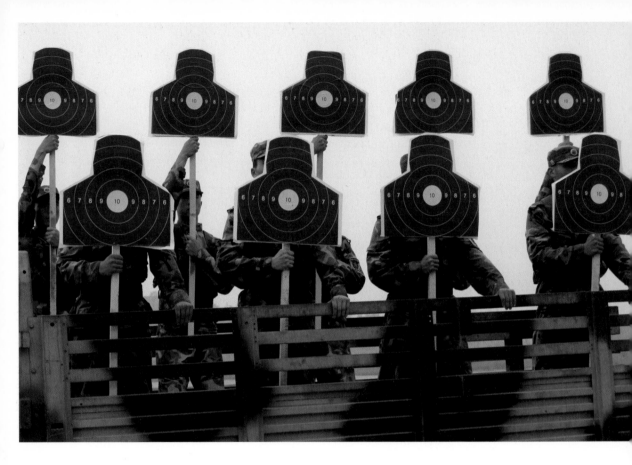

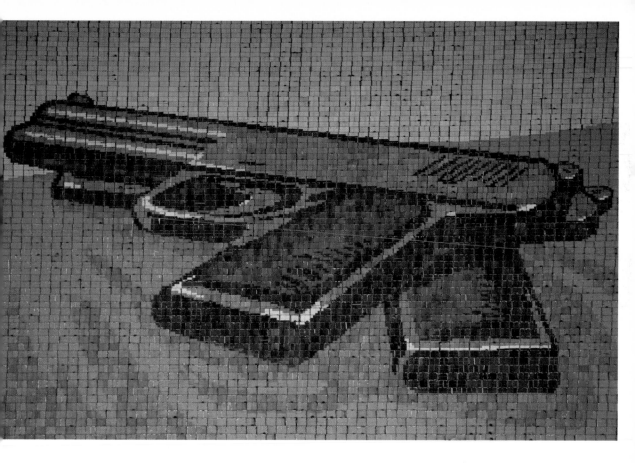

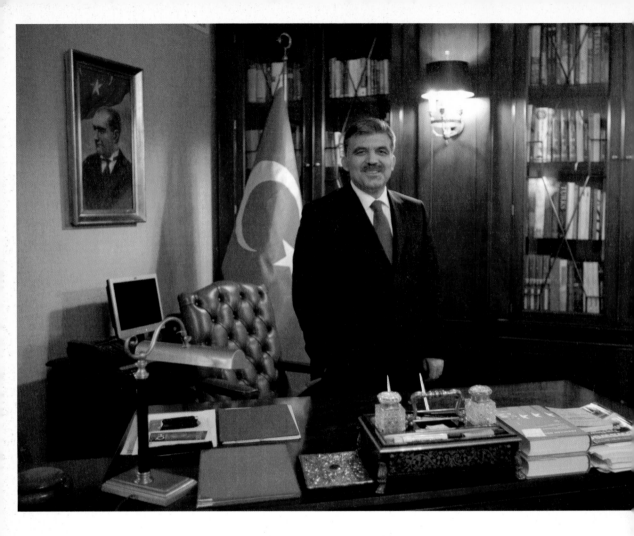

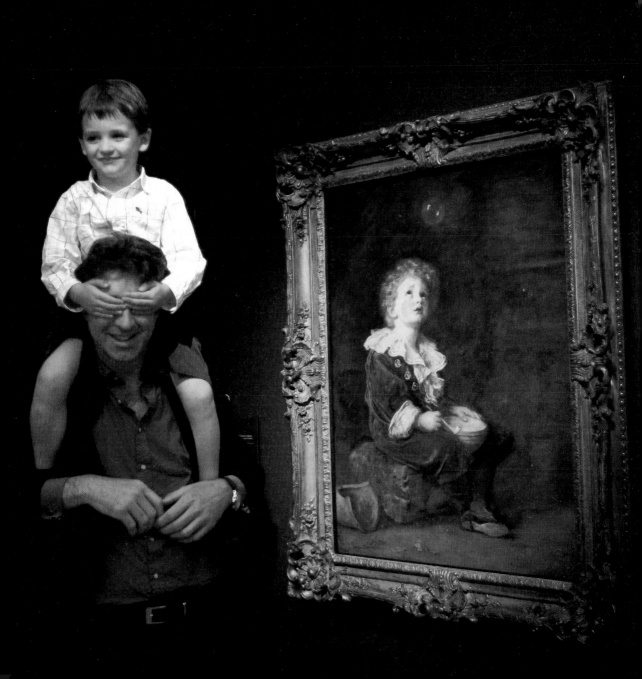

188 Alice Wright (left) and Rebecca Pinder from Withington Girls School in Manchester receive their A-level exam results. More than a quarter of British A-level papers were awarded the top grade in 2007, the highest percentage ever. 16 August 2007. Manchester, Britain. Phil Noble.

189 Women dressed in folk costumes apply lipstick as they take part in the Galicnik Wedding, a three-day celebration held each 'Petrovden' or St Peter's Day in the Macedonian village of Galicnik. The festivities involve costumes, rituals and dances that have been passed down over centuries. 15 July 2007. Galicnik, Macedonia. Ognen Teofilovski.

190 A child peers over a barrier into the corral where the fighting bulls are kept on the eve of the San Fermin festival in Pamplona. 5 July 2007. Pamplona, Spain. Eloy Alonso.

191 Venezuelan police use their shields to protect them from the rain while waiting for Argentina to play Peru in the Copa America soccer tournament in Barquisimeto. 8 July 2007. Barquisimeto, Venezuela. Marcos Brindicci.

192 Actors Nikki Blonsky (centre) and Zac Efron (right) perform a song from the new movie *Hairspray* on NBC's 'Today' show in New York. 20 July 2007. New York, United States. Brendan McDermid.

193 A zebra charges towards Kenya Wildlife Service rangers at the Marula ranch in Naivasha. At the end of July Kenya began a month-long exercise to move about 2,000 animals to Meru National Park, a once-famed game reserve devastated by poaching. 30 July 2007. Naivasha, Kenya. Boniface Mwangi.

194 A child runs by a sign outside the Mount Vernon School in Newark, New Jersey, where three college students were killed execution-style on 4 August in the school playground. 9 August 2007. Newark, United States. Shannon Stapleton.

195 An elderly woman walks on a street in the pilgrimage town of Vrindavan. 16 July 2007. Vrindavan, India. Adeel Halim.

196 A monk leaves morning prayers at St George, one of 11 rock-hewn churches in Lalibela, Ethiopia. Legend has it that these churches were carved below ground in the late 11th and early 12th centuries after God ordered King Lalibela to build churches the world had never seen – and dispatched angels to help him. 15 September 2007. Lalibela, Ethiopia. Radu Sigheti.

197 Parents of freshmen sleep on mats on the floor of a gymnasium inside a university campus in Wuhan, in central China's Hubei province. 3 September 2007. Wuhan, China. Chen Zhuo.

198 Soldiers from the Chinese People's Liberation Army take part in a military demonstration. 30 July 2007. Tianjin, China. Alfred Cheng Jin.

199 North Korean students hold boards to form a picture of a gun during the Arirang mass games in Pyongyang. The games – part circus act, part rhythmic gymnastics display – are the world's biggest choreographed extravaganza. 27 August 2007. Pyongyang, North Korea. Reinhard Krause.

200 Turkey's presidential hopeful Abdullah Gul poses in his office in Ankara. Elected president on 28 August, the former Islamist pledged to uphold the secular principles of the republic and to be an impartial head of state. The army and secularist establishment have deep suspicions that Gul and his AK Party have a hidden Islamist agenda. 14 August 2007. Ankara, Turkey. Umit Bektas.

201 Joshua and Jude Millais, the great great and great great great grandsons of British pre-Raphaelite painter John Everett Millais, are pictured in front of his work *Bubbles* at Tate Britain in London. 14 September 2007. London, Britain. Kieran Doherty.

202 A boy plays among a display of China's national flags in Chaoyang park in Beijing. 30 September 2007. Beijing, China. Jason Lee.

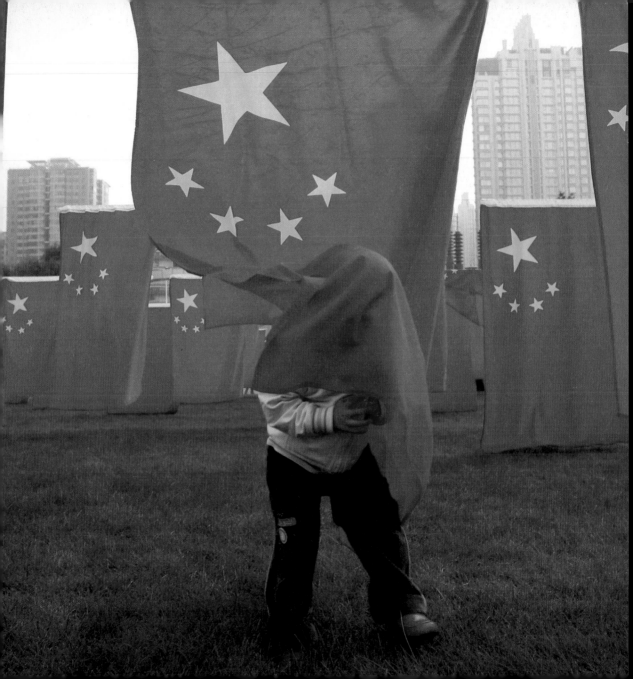

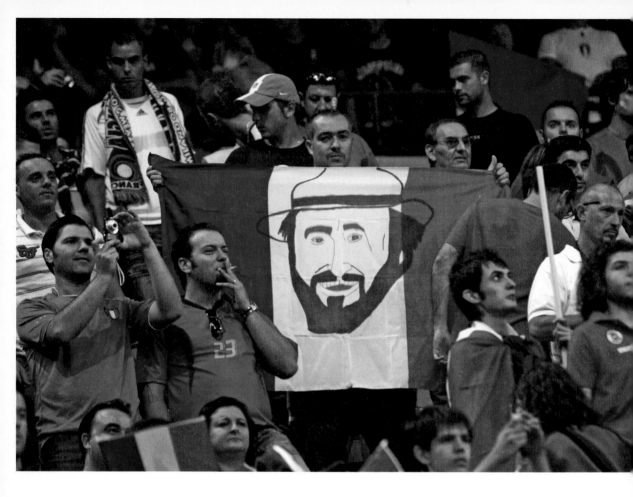

203 Milan, Italy

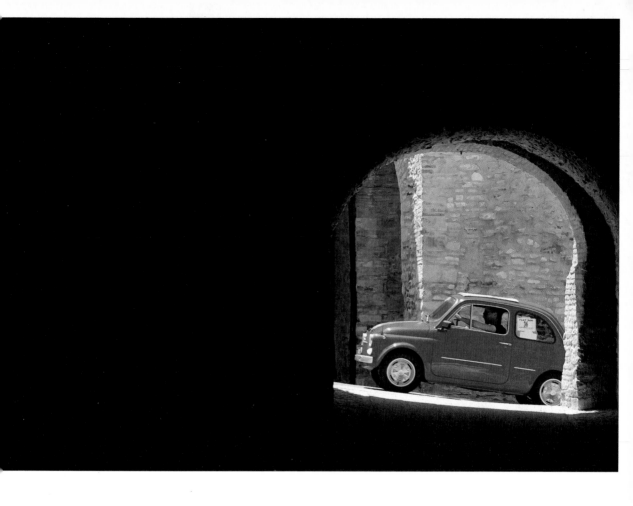

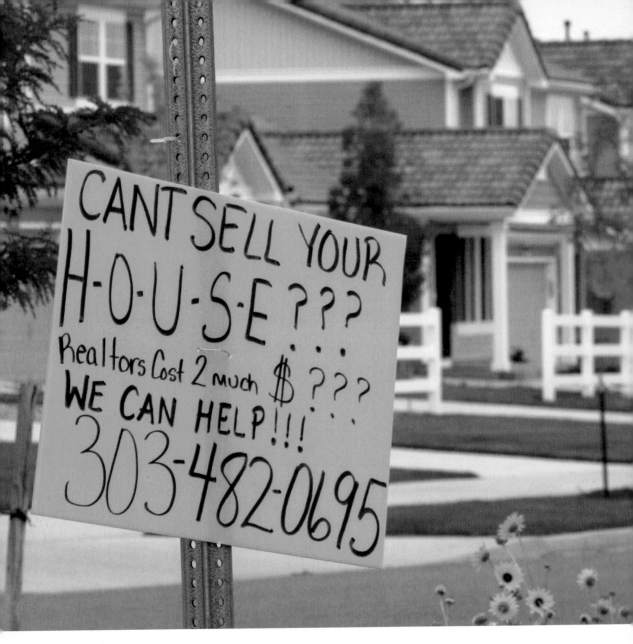

CANT SELL YOUR
H·O·U·S·E ???...
Realtors Cost 2 much $???
WE CAN HELP !!!
303·482·0695

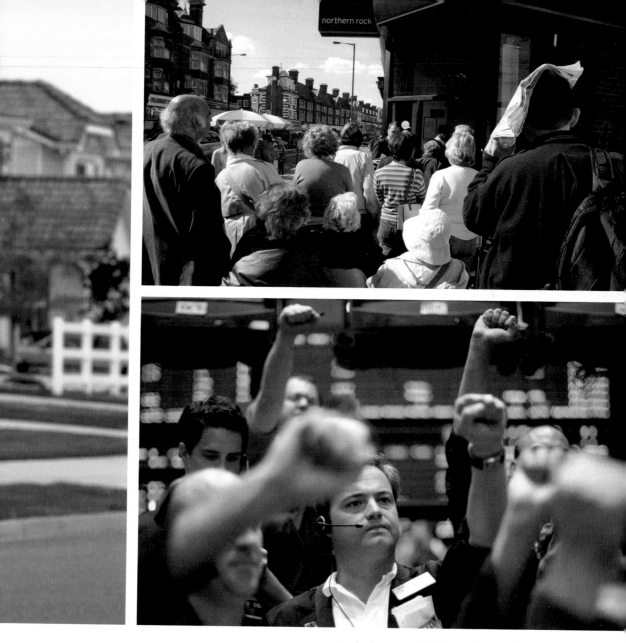

206 [TOP] London, Britain **207** [ABOVE] Chicago, United States

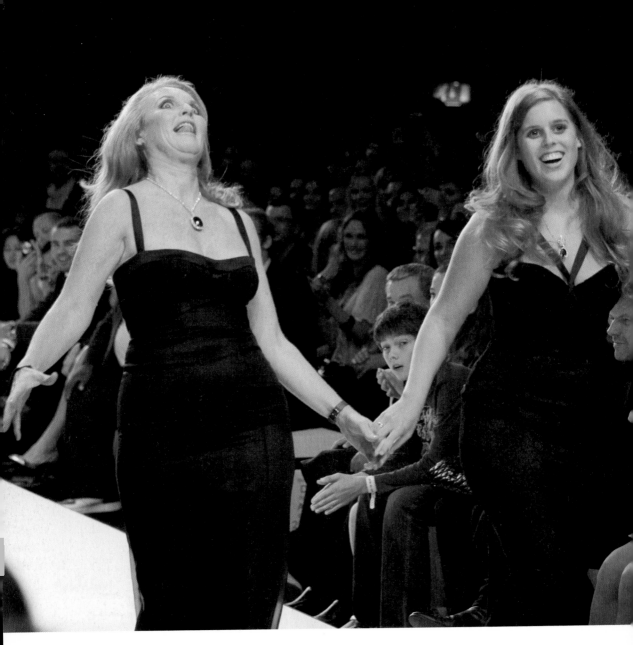

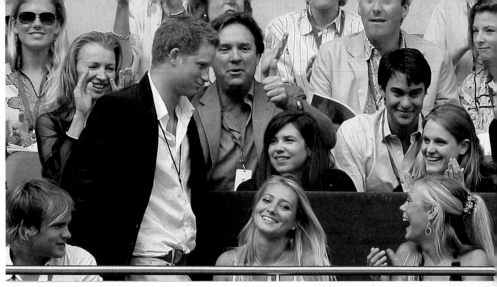

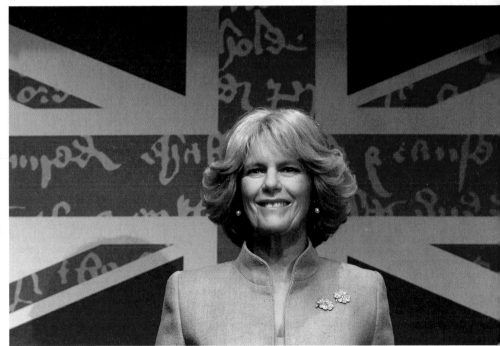

209 [TOP] **210** [ABOVE] London, Britain

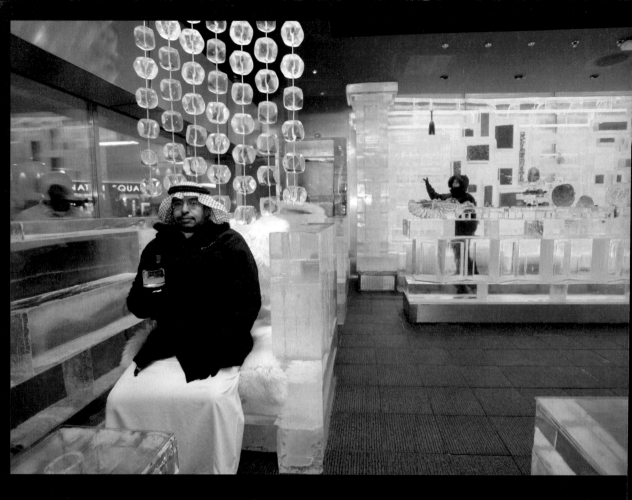

211 Dubai, United Arab Emirates

212 [OPPOSITE] New York, United Stat

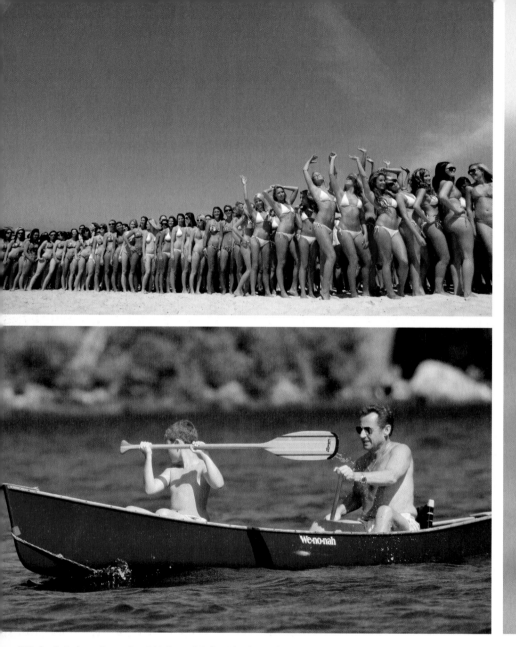

213 [TOP] Sydney, Australia **214** [ABOVE] Lake Winnipesaukee, United States

203

204

205

206

207

208

209

210

211

212

213

214

215

216

217

218

An Italy soccer supporter displays a flag bearing an image of the late Luciano Pavarotti at San Siro Stadium in Milan. On 8 September about 50,000 mourners paid tribute to the great tenor at his funeral in his hometown of Modena. 8 September 2007. Milan, Italy. Giampiero Sposito.

A member of the Italian Fiat 500 car club takes part in a rally through Fossato di Vico village in central Italy. July 2007. Fossato di Vico, Italy. Alessandro Bianchi.

A sign offering house-selling assistance is displayed in the Green Valley Ranch development in Denver, Colorado, as U.S. house prices and sales of new homes both slumped. 26 July 2007. Denver, United States. Rick Wilking.

Customers queue outside a branch of British mortgage lender Northern Rock in north London. The Bank of England stepped in to offer Northern Rock emergency loans in September after it was hit by a liquidity squeeze in financial markets. The news prompted the first run on the deposits of a major British bank in more than 140 years. 8 September 2007. London, Britain. Alessia Pierdomenico.

Traders relay deals on the floor of the Chicago Board of Trade. 9 July 2007. Chicago, United States. John Gress.

208 Sarah, Duchess of York (left), pretends to slip as she takes to the catwalk with her daughter Princess Beatrice during the Fashion for Relief charity fashion show in London. 20 September 2007. London, Britain. Kevin Coombs.

209 Britain's Prince Harry rejoins his girlfriend Chelsy Davy (bottom right) at Wembley Stadium in London for the 'Concert for Diana', held in memory of his mother Princess Diana on what would have been her 46th birthday. 1 July 2007. London, Britain. Stephen Hird.

210 A wax sculpture of Prince Charles's wife Camilla, Duchess of Cornwall, is unveiled at Madame Tussauds. 26 September 2007. London, Britain. Luke MacGregor.

211 An Arab guest drinks in the new Chill Out ice lounge in Dubai. 13 August 2007. Dubai, United Arab Emirates. Ahmed Jadallah.

212 Designer Betsey Johnson thanks the audience with her granddaughter Layla following her show during New York Fashion Week. 11 September 2007. New York, United States. Lucas Jackson.

213 Women dressed in bikinis pose on Sydney's Bondi Beach, setting a Guinness world record for the largest swimsuit photo shoot. 26 September 2007. Sydney, Australia. Tim Wimborne.

214 France's President Nicolas Sarkozy paddles a canoe with his son Louis while on vacation in New Hampshire. French magazine Paris Match was accused by a rival magazine of retouching this and other photos to erase the 52-year-old president's 'love handles'. The president's office said it had not made any request for the bulges to be retouched. 4 August 2007. Lake Winnipesaukee, United States. Neal Hamberg.

215 Actress Scarlett Johansson is seen on set in Barcelona during the first day's filming for Woody Allen's new film. 9 July 2007. Barcelona, Spain. Albert Gea.

216 Stefan Koch, who says he owns 1,200 Elvis Presley CDs, displays his tattoos in the Danish village of Ornsbjerg on the island of Funen, on the 30th anniversary of Elvis's death. 16 August 2007. Ornsbjerg, Denmark. Claus Fisker, Scanpix.

217 Bollywood poster painters work on a giant poster at the foot of Nelson's Column in Trafalgar Square, part of the 2007 Trafalgar Square Festival. 16 August 2007. London, Britain. Stephen Hird.

218 Princess Diana's wedding gown is seen at the Powerhouse Museum in Sydney, where it was to form the centrepiece of the exhibition 'Diana: a celebration'. 20 September 2007. Sydney, Australia. Mick Tsikas.

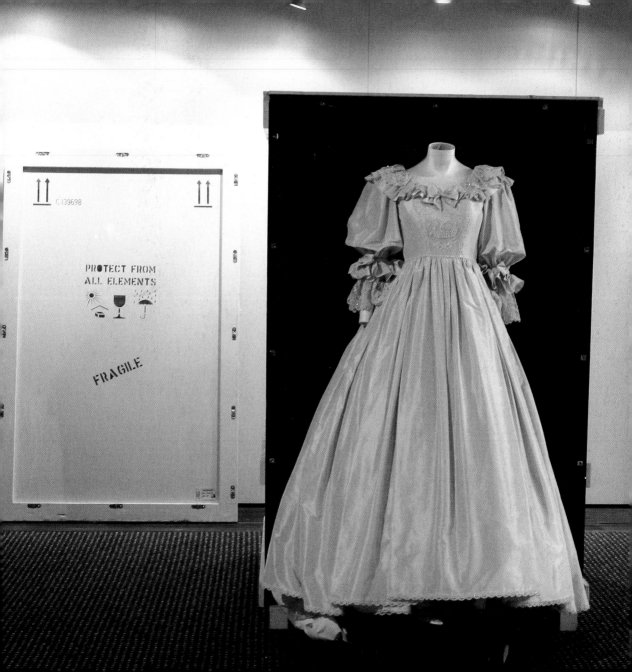

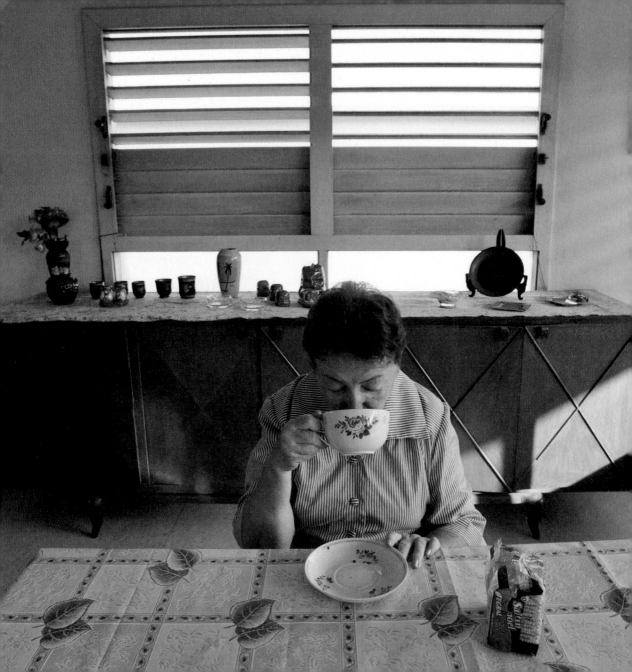

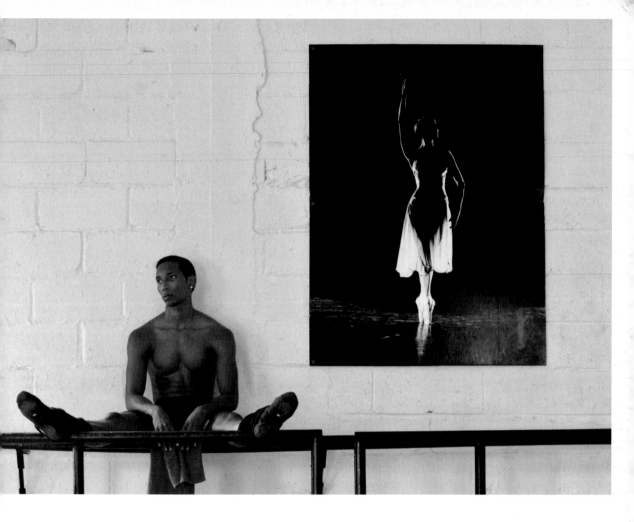

219 [OPPOSITE] **220** [ABOVE] Havana, Cuba

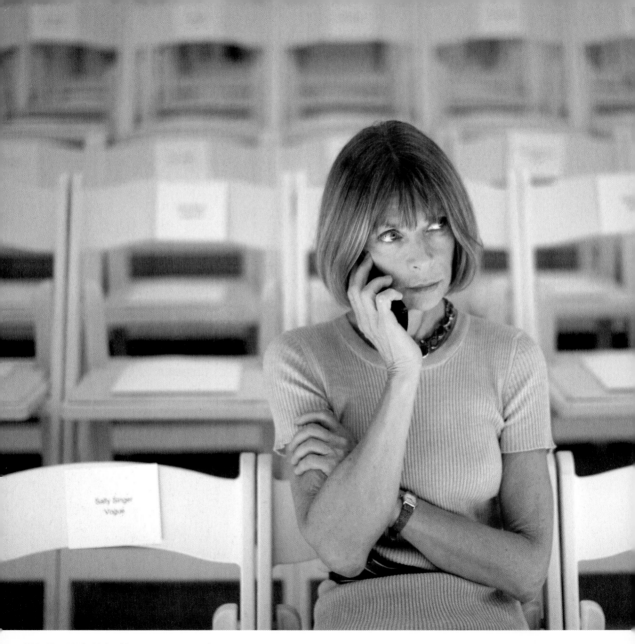

Sally Singer
Vogue

222 [TOP] New York, United States **223** [ABOVE] Palma de Mallorca, Spain

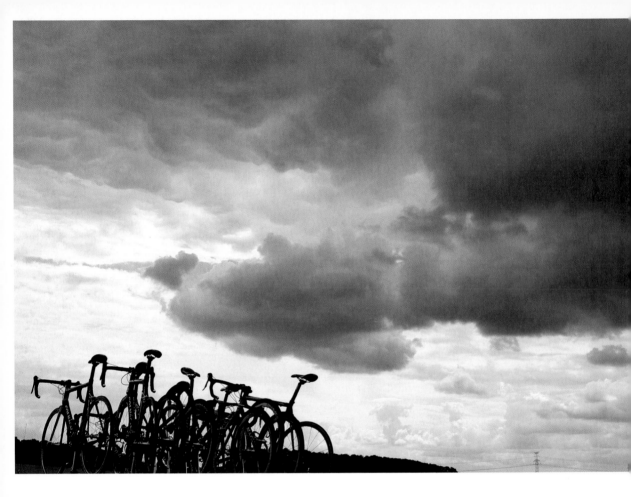

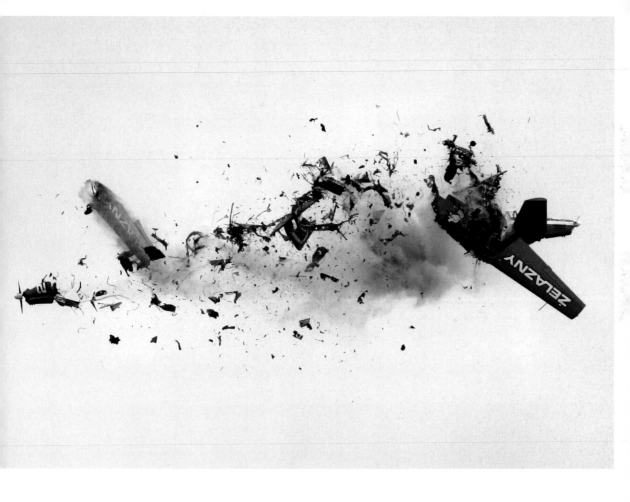

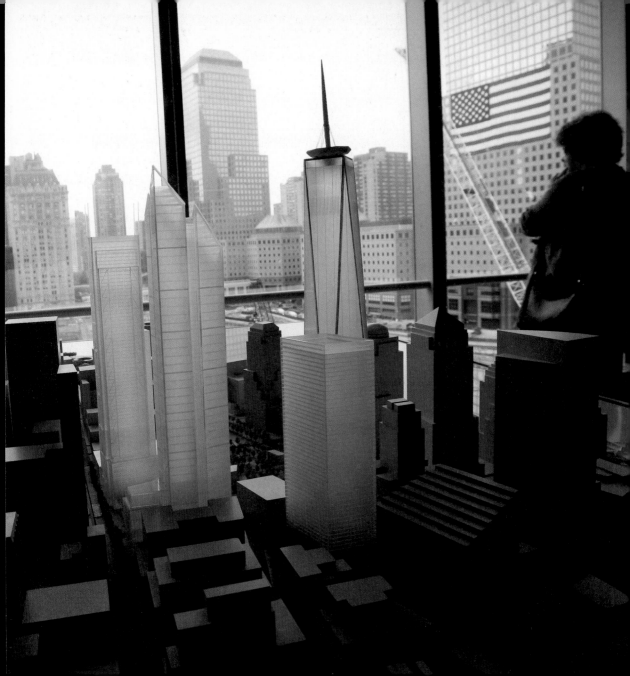

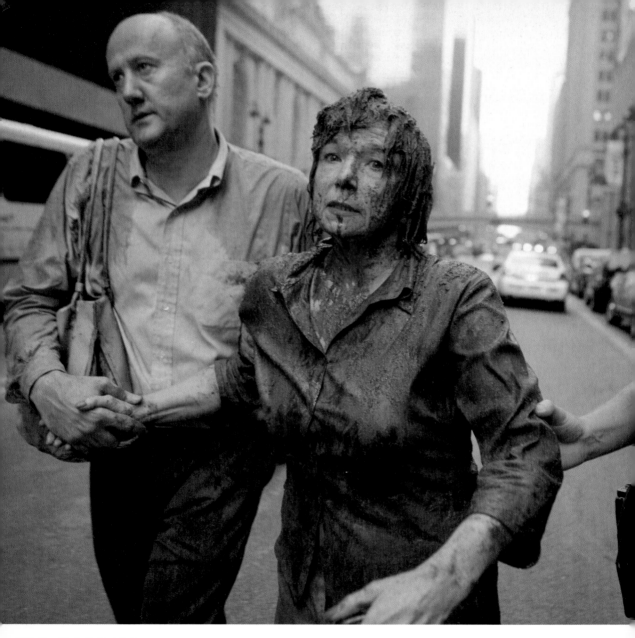

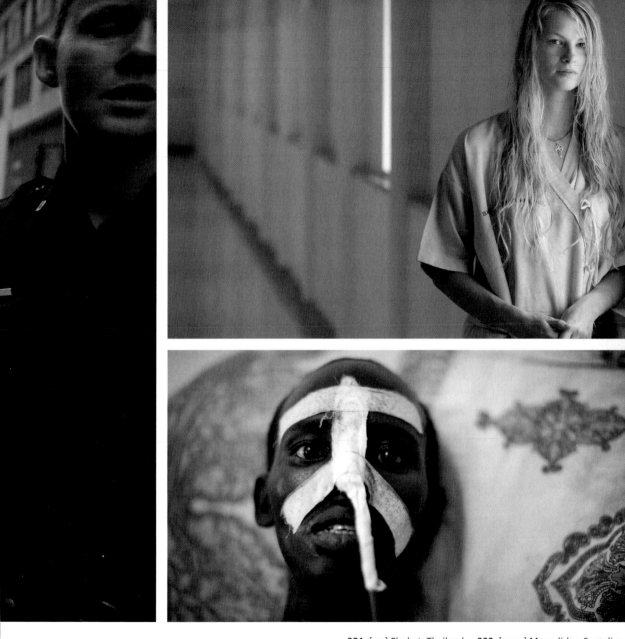

231 [TOP] Phuket, Thailand 232 [ABOVE] Mogadishu, Somalia

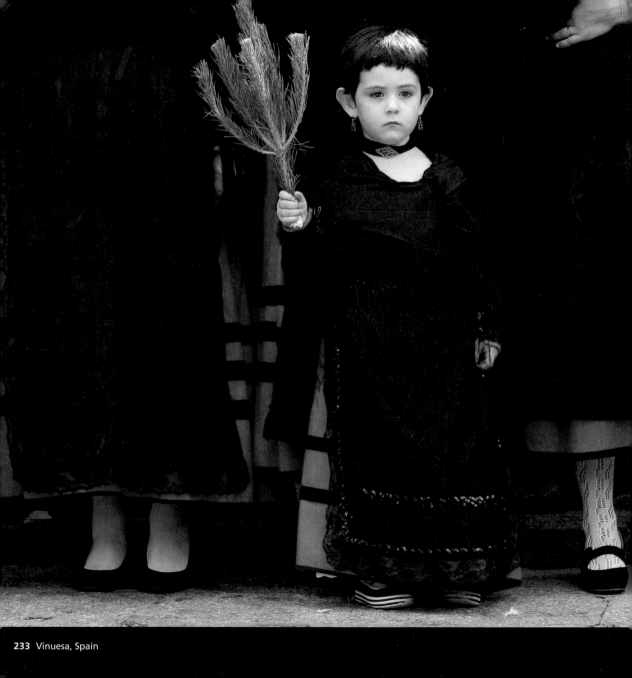

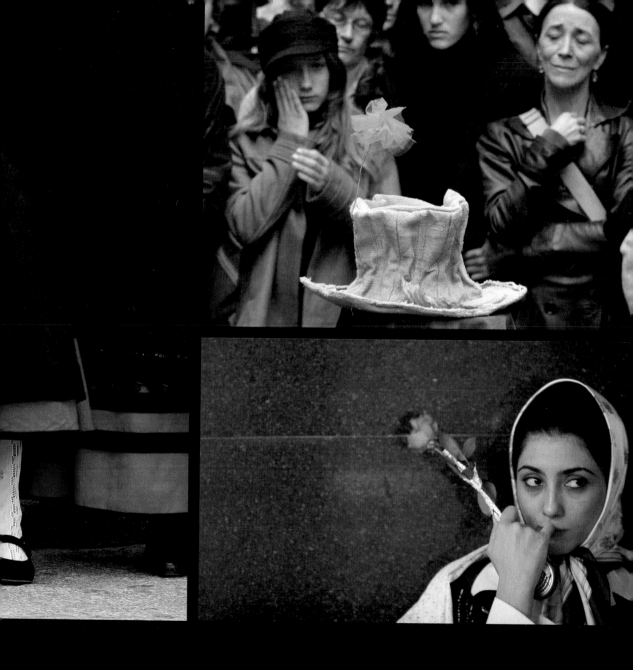

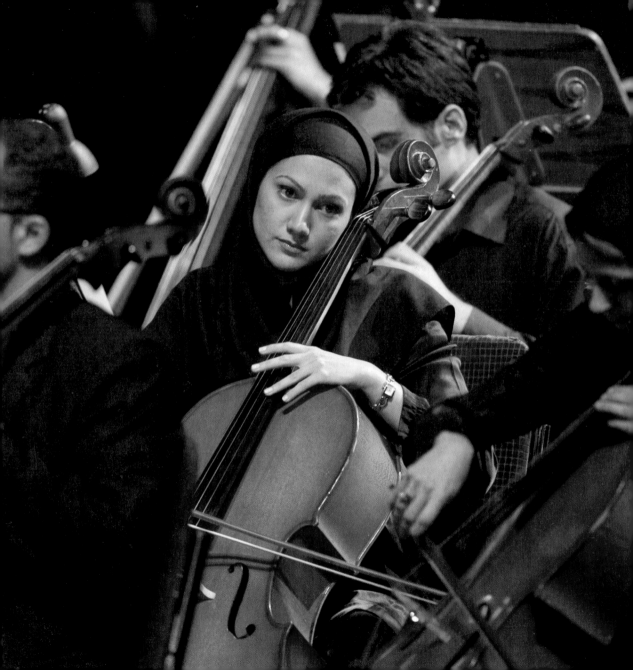

219 220 221 222 223 224 225 226 227
228 229 230 231 232 233 234 235 236

9 Film historian Zoia Barash, 72, drinks tea in her apartment in Havana. She is one of about 1,300 women from the former Soviet Union living in Cuba today. 5 September 2007. Havana, Cuba. Claudia Daut.

0 A dancer of Cuba's National Ballet takes a rest during rehearsals in Havana. 16 August 2007. Havana, Cuba. Enrique De La Osa.

1 Vogue editor Anna Wintour speaks on a cell phone during New York Fashion Week. 7 September 2007. New York, United States. Eric Thayer.

2 A girl watches the DKNY Spring 2008 collection during New York Fashion Week. 9 September 2007. New York, United States. Eric Thayer.

3 Spain's Princess Letizia (right), her daughter Leonor and Queen Sofia (left) watch the King's Cup sailing race aboard the yacht *Somni* in Palma de Mallorca. 31 July 2007. Palma de Mallorca, Spain.

4 Mary McCarthy, 107, prepares to leave for a diplomatic reception at her home in Havana. The assets McCarthy inherited when widowed in 1951 have been frozen in a Boston bank since the United States placed Cuba under sanctions after Fidel Castro's revolution in 1959. 10 August 2007. Havana, Cuba. Claudia Daut.

225 A portrait of former communist leader Erich Honecker stares down at guests in the new 'Ostel' guesthouse near Berlin's eastern train station which takes its design inspiration from the communist era. 1 July 2007. Berlin, Germany. Hannibal Hanschke.

226 Bicycles are seen under storm clouds during the 94th Tour de France. 11 July 2007. Joigny, France. Eric Gaillard.

227 Two planes crash mid-stunt in front of thousands of spectators at the Radom Air Show, about 100 km (60 miles) from Warsaw. 1 September 2007. Radom, Poland. Kacper Pempel.

228 A woman looks out at the World Trade Center site in New York beside a model of the Freedom Tower that is being built in the location of the former Twin Towers. 10 September 2007. New York, United States. Shannon Stapleton.

229 A girl listens to an audio guide at the new 'Port of Dreams – Emigrant World BallinStadt' museum in Hamburg, from where 5 million people set out for America. 4 July 2007. Hamburg, Germany. Christian Charisius.

230 Injured Eileen Shannon is led away from the site where an ageing steam pipe exploded near Grand Central Station in New York. 18 July 2007. New York, United States. Brendan McDermid.

231 Canadian Millie Furlong, 23, is pictured at the Phuket Hospital after she survived a plane crash on 16 September that killed 89 people on the Thai resort island. 18 September 2007. Phuket, Thailand. Adrees Latif.

232 Somali Hassan Mohammed, 28, recovers from gunshot wounds at the Madina hospital in Mogadishu after being caught in a crossfire between Islamist insurgents and government soldiers. 5 August 2007. Mogadishu, Somalia. Edward Ou.

233 A girl carries a pine branch during the 'Pinochada' festival in the northern Spanish village of Vinuesa. The festival honours the village's patron saint, the Virgin of the Pinetree. 16 August 2007. Vinuesa, Spain. Susana Vera.

234 Family members attend the funeral of mime artist Marcel Marceau at the Père-Lachaise cemetery in Paris. 26 September 2007. Paris, France. Benoit Tessier.

235 An Iranian bride waits for her groom during a mass wedding ceremony in central Tehran. 19 August 2007. Tehran, Iran. Morteza Nikoubazl.

236 A musician from the Tehran Symphony Orchestra pauses while performing at Vahdat Hall in central Tehran. 15 August 2007. Tehran, Iran. Morteza Nikoubazl.

236 [OPPOSITE] Tehran, Iran

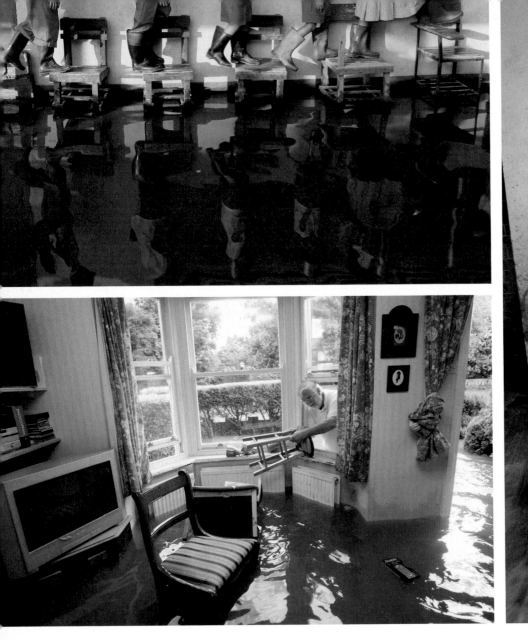

237 [TOP] Taytay, Philippines **238** [ABOVE] Tewkesbury, Britain

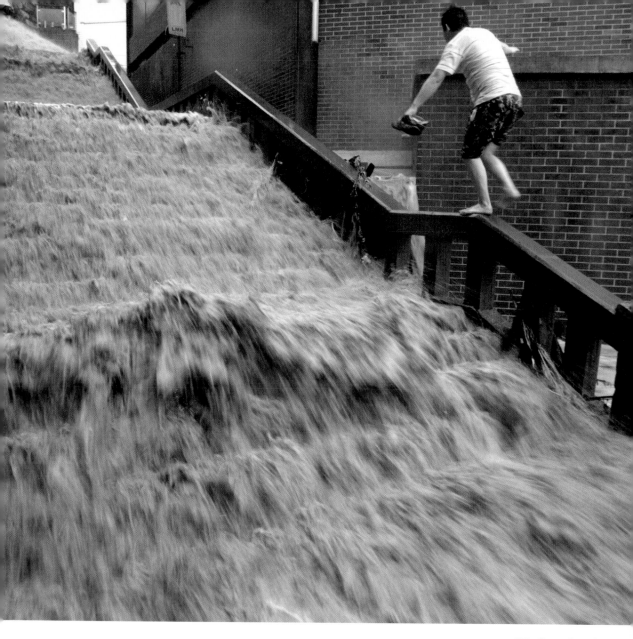

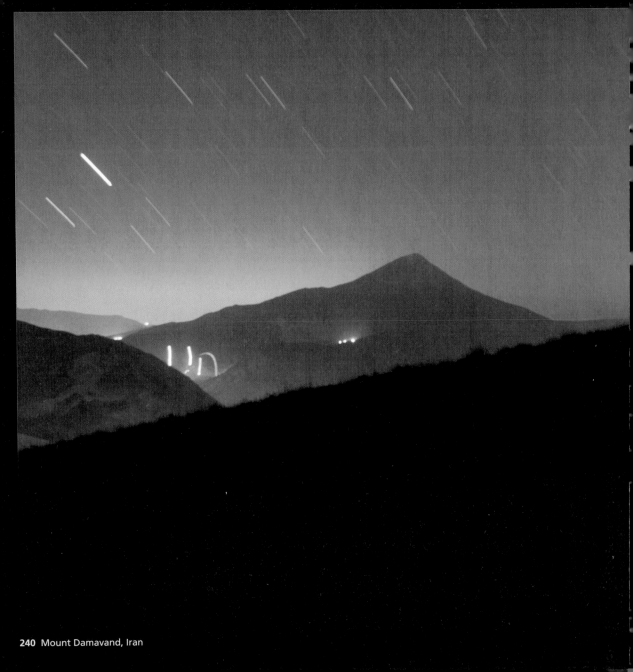

240 Mount Damavand, Iran

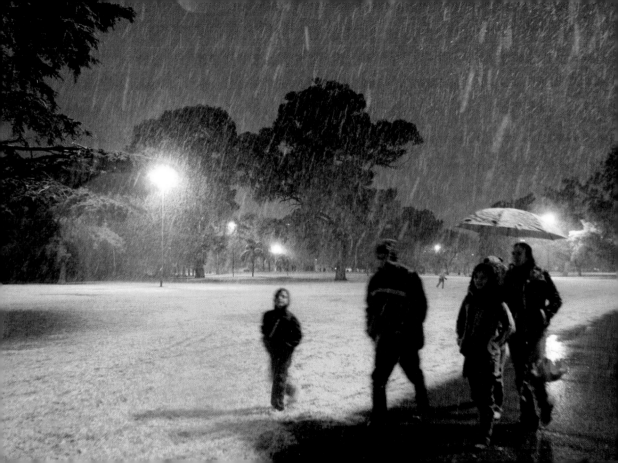

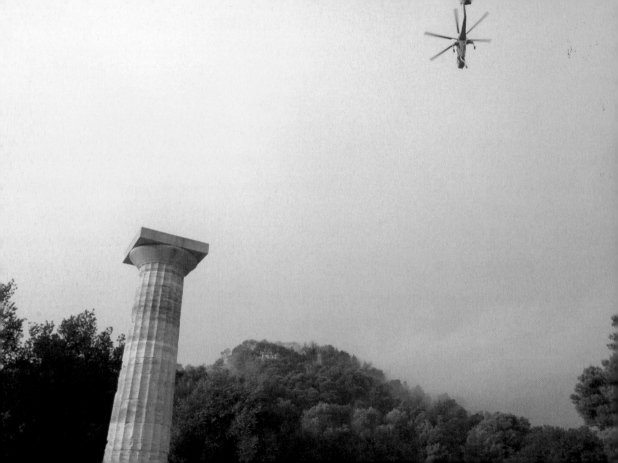

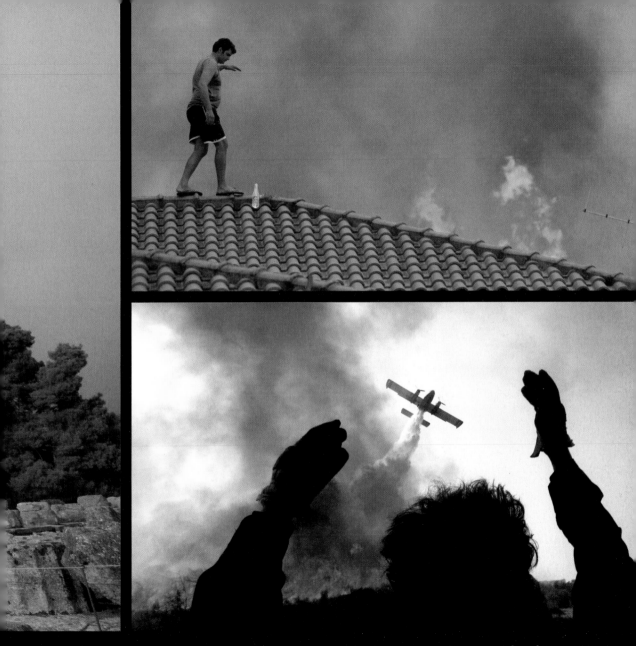

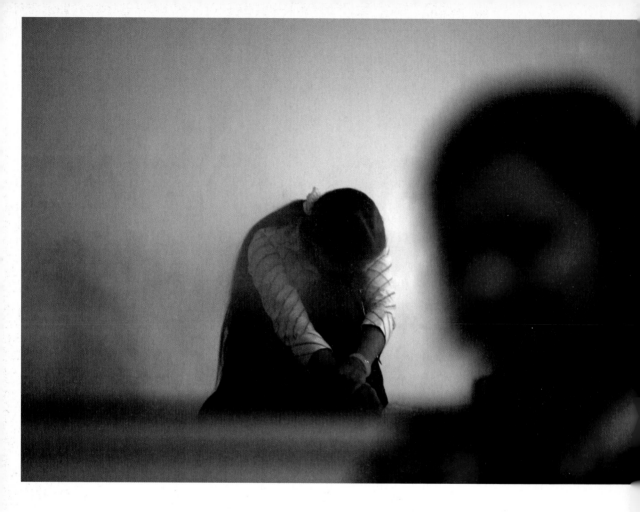

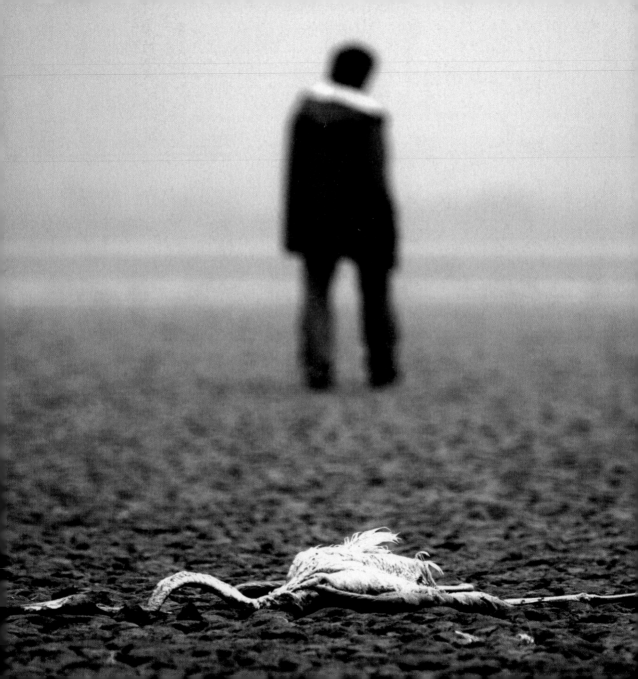

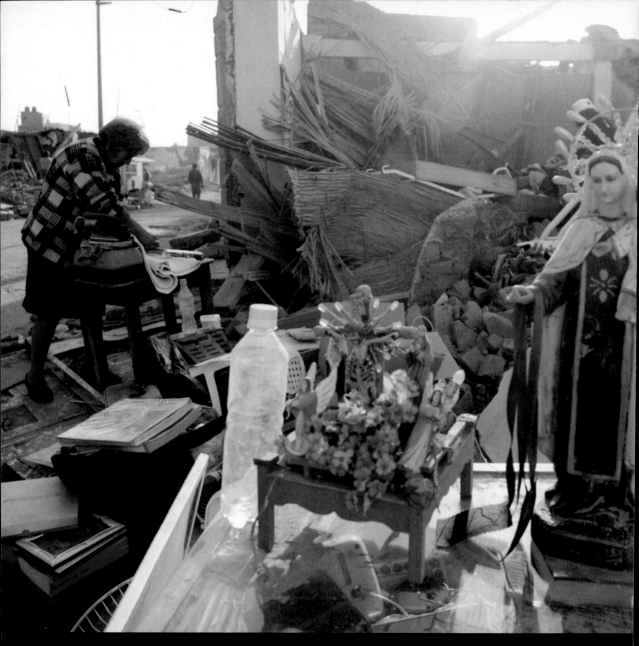

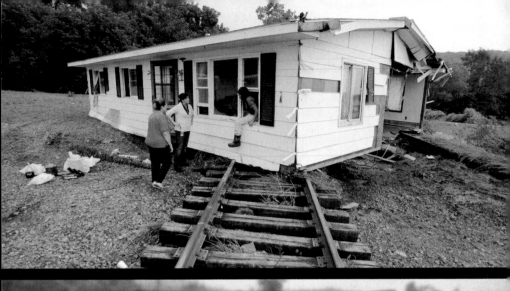
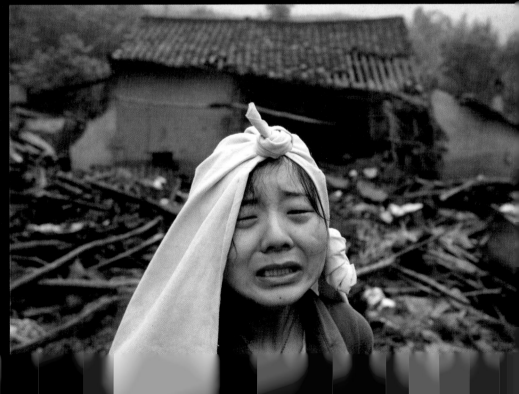

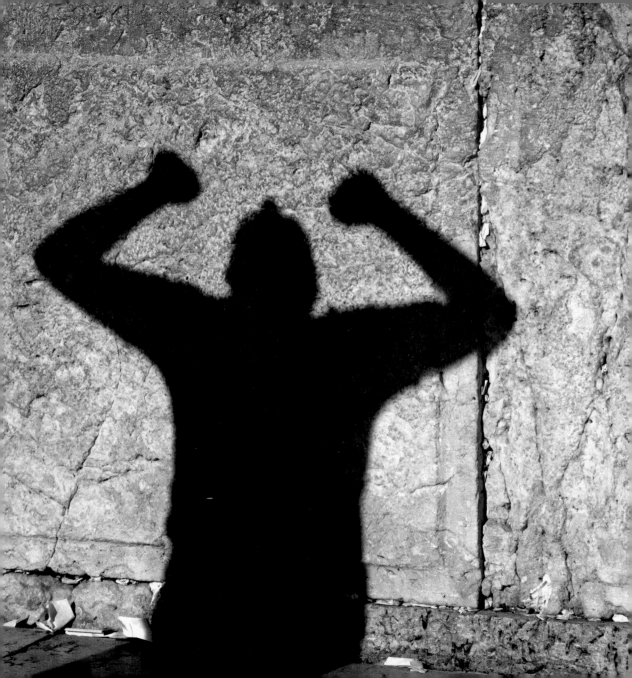

237 238 239 240 241 242 243 244 245

246 247 248 249 250

Students use chairs as a makeshift bridge to get to a classroom at the flooded Sitio Tapayan elementary school in Taytay, north of Manila. 18 July 2007. Taytay, Philippines. Romeo Ranoco.

Householder Jeff Clarke recovers furniture from his flooded home in Tewkesbury, central England. The wettest May–July period on record brought two bouts of flooding to parts of England, killing at least nine people, and causing damage estimated at about 3 billion pounds. 24 July 2007. Tewkesbury, Britain. Darren Staples.

A man walks on the handrail of a staircase at a flooded street in southwest China's Chongqing municipality. A 16-hour thunder storm in the region caused heavy flooding and left 37 people dead, the government and state media said. 17 July 2007. Chongqing, China. China Daily.

Mount Damavand, 110 km (70 miles) northeast of Tehran, at midnight. 13 August 2007. Mount Damavand, Iran. Morteza Nikoubazl.

People walk in a public park under a surprise snowfall in Buenos Aires. The last time it snowed in the Argentine capital was July 1928. 9 July 2007. Buenos Aires, Argentina. Enrique Marcarian.

242 **A firefighting helicopter flies over Ancient Olympia in south Peloponnese. Greece's worst forest fires in decades ravaged central and southern parts of the country for more than 10 days, killing over 60 people and leaving thousands homeless.** 26 August 2007. Ancient Olympia, Greece. John Kolesidis.

243 **A resident walks on the roof of his house in the village of Varvasaina in south Peloponnese as fire burns in the background.** 26 August 2007. Varvasaina, Greece. John Kolesidis.

244 **A firefighter signals to a plane to drop water near the village of Karytena in southwestern Greece.** 1 September 2007. Karytena, Greece. Yannis Behrakis.

245 **An Indonesian migrant worker sits in a room at Malaysia's biggest airport in Sepang as an employer waits to see immigration officers. Hundreds of newly arrived foreign workers had to take shelter when their employers failed to collect them.** 20 September 2007. Sepang, Malaysia. Bazuki Muhammad.

246 **Environmentalist Filotas Passios walks away from a dead flamingo on the dry bed of Lake Koronia in northern Greece, where a dramatic drop in the water level combined with increased pollution led to high death rates of fish and birds.** 20 September 2007. Lake Koronia, Greece. Yannis Behrakis.

247 **A woman collects her belongings in earthquake-ravaged Pisco. More than 500 people died and 60,000 homes were destroyed when an 8.0 magnitude earthquake struck Peru's central coast on 15 August.** 17 August 2007. Pisco, Peru. Mariana Bazo.

248 **Bonnie Oldham of the United States climbs out of the window of her flood-damaged home, which was swept onto railroad tracks in Stockton, Minnesota.** 21 August 2007. Stockton, United States. Eric Miller.

249 **Peng Zhu, whose grandmother and mother were killed during floods, mourns near her damaged house in Yunxi county, in central China's Hubei province. According to officials, the 2007 death toll across China due to flooding had reached 1,138 by late August, though this was 50 percent lower than the average for the same period of previous years.** 29 July 2007. Yunxi, China. Tao Debin.

250 **A Jewish man prays at the Western Wall (Wailing Wall) during evening prayers in Jerusalem's old city.** 22 August 2007. Jerusalem. Yannis Behrakis.

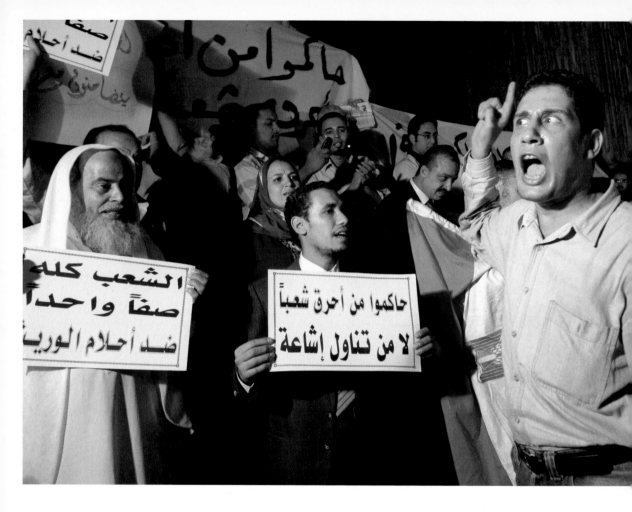

251 Cairo, Egypt

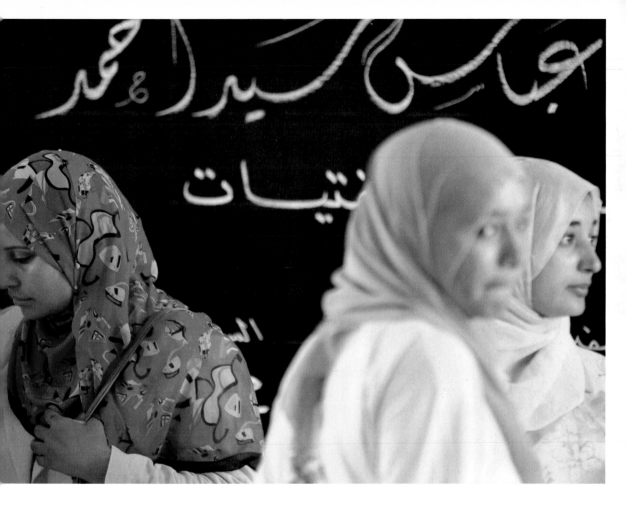

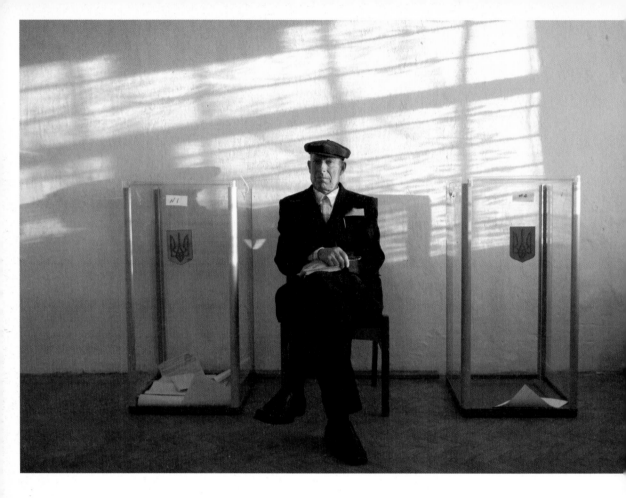

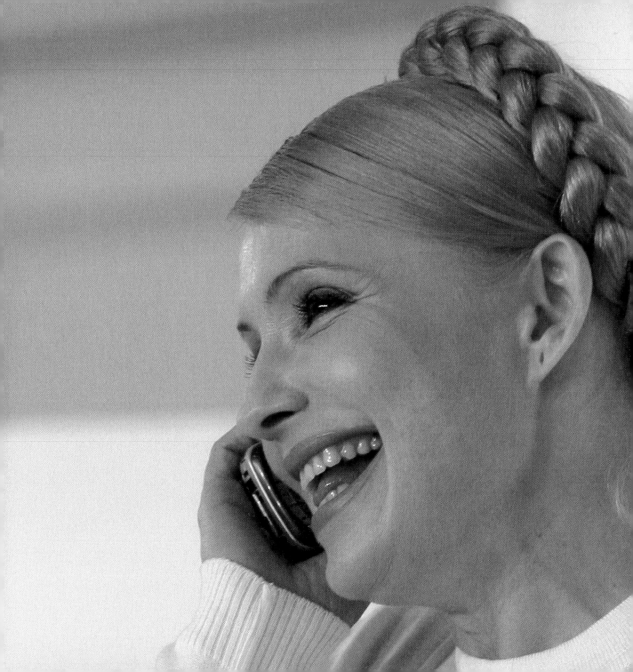

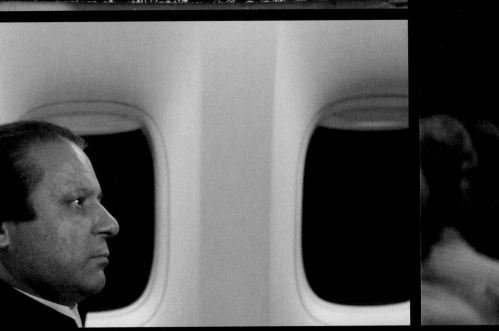

255 [TOP] Bol, Chad 256 [ABOVE] London, Britain

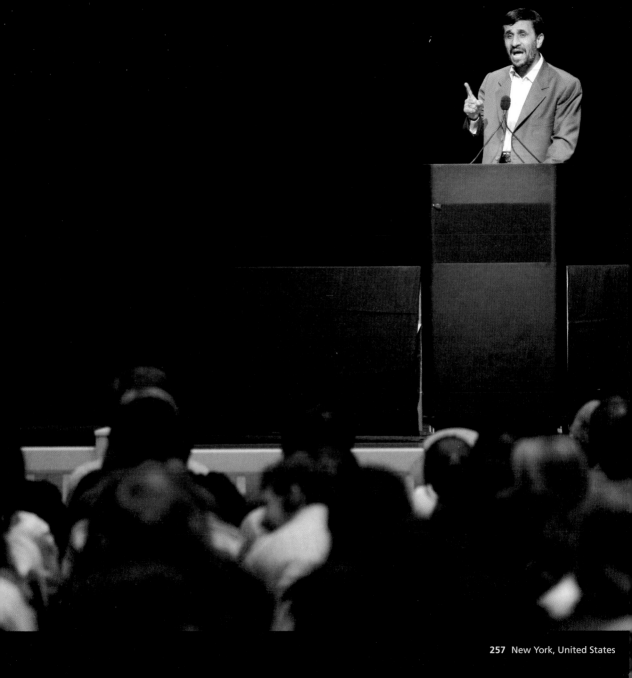

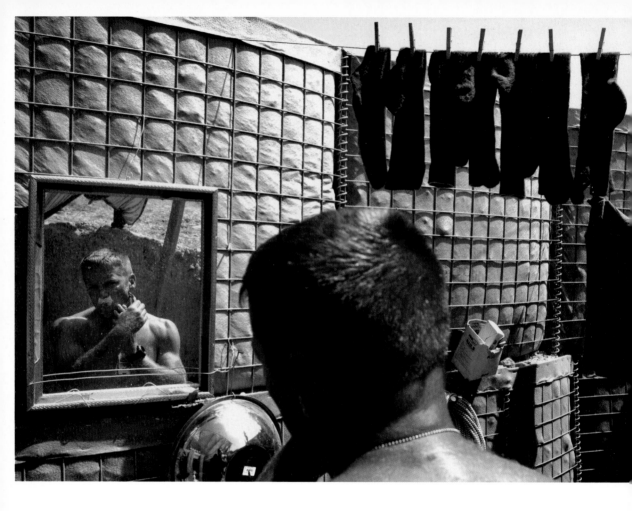

SUN/DIM CANADA DAY
FÊTE DU CANADA

MON/LUN

TUE/MAR

 INDEPENDENCE
DAY (US)
VED/MER JOUR DE
L'INDÉPENDANCE
(É-U)

THU/JEU

RI/VEN

259 Ma'sum Ghar, Afghanistan

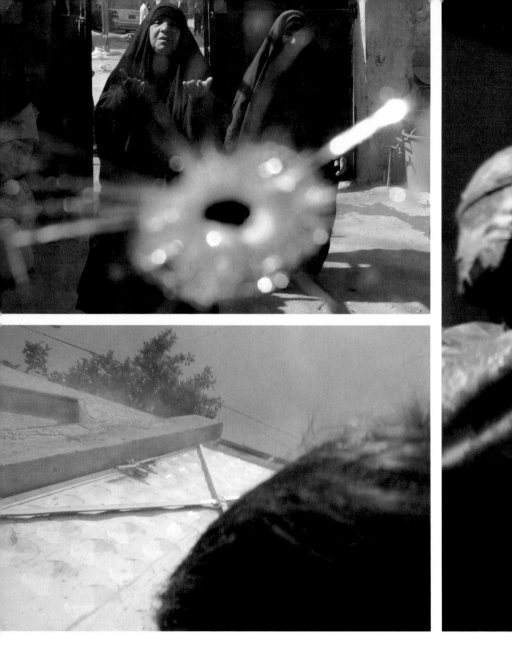

260 [TOP] **261** [ABOVE] Baghdad, Iraq

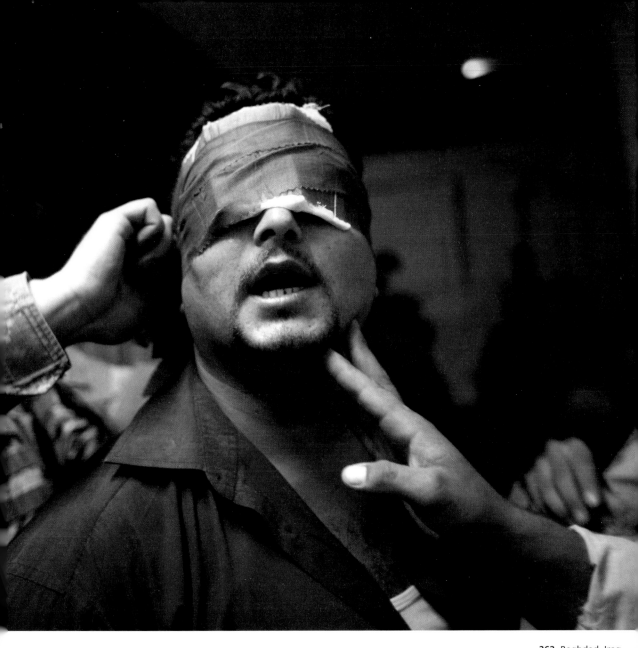

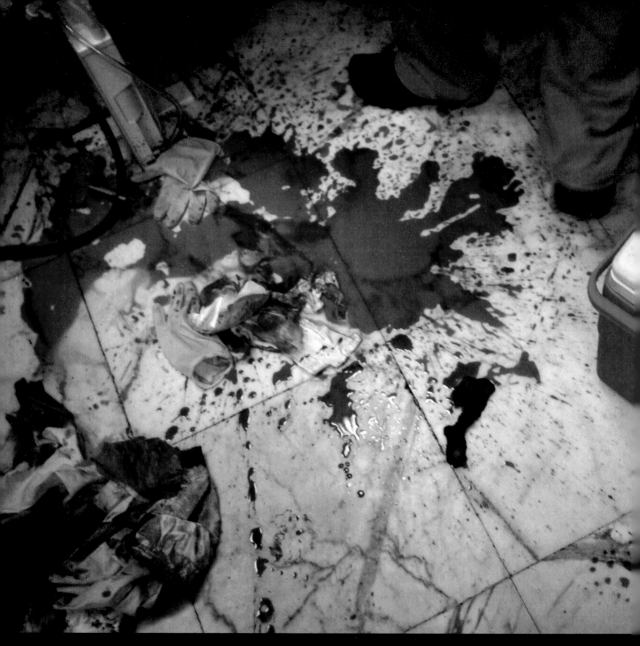

263 Baghdad, Iraq

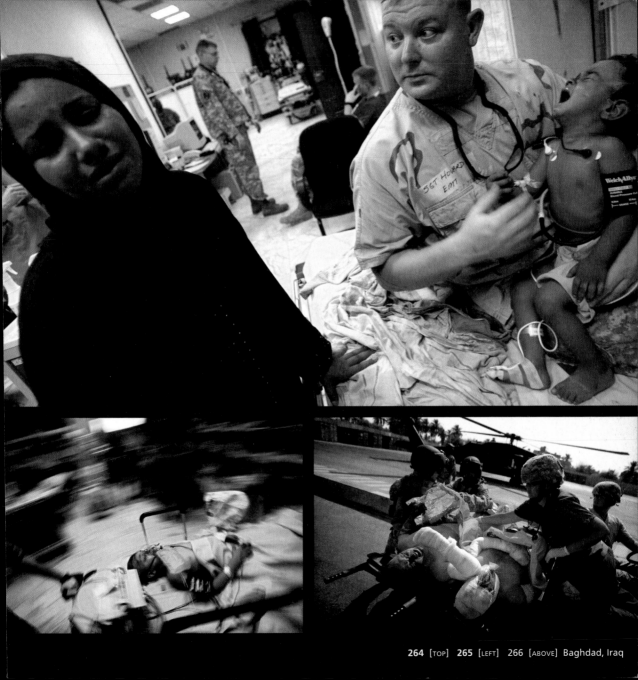

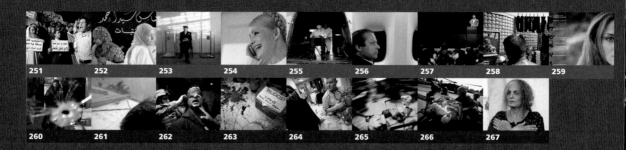

251 **Protesters demonstrate before the Press Syndicate in Cairo. An Egyptian court sentenced four newspaper editors to a year in prison with labour for defaming President Hosni Mubarak and his politician son, drawing condemnation from human rights groups.** 20 September 2007. Cairo, Egypt. Nasser Nuri.

252 **Teachers stand in front of a blackboard in the town of Abu Homous, 165 km (100 miles) northwest of Cairo. The school is part of a project with the United Nations, EU and local organizations to give girls in rural areas access to education.** 15 August 2007. Abu Homous, Egypt. Tara Todras-Whitehill.

253 **A Ukrainian election official awaits voters at a polling station in the village of Suvyd, some 80 km (50 miles) north of the capital Kiev.** 30 September 2007. Suvyd, Ukraine. Ivan Chernichkin.

254 **Yulia Tymoshenko, a central figure in Ukraine's 2004 'Orange Revolution', speaks on the phone with Georgia's President Mikhail Saakashvili during a news conference in Kiev. Parties linked to the revolution won a slim parliamentary majority in the election on 30 September.** 30 September 2007. Kiev, Ukraine. Grigory Dukor.

255 **U.N. Secretary-General Ban Ki-moon leaves Bol on Lake Chad.** 7 September 2007. Bol, Chad. Zohra Bensemra.

256 **Former Pakistani Prime Minister Nawaz Sharif returns to Pakistan after seven years in exile. He was arrested and deported within hours of his arrival.** 10 September 2007. London, Britain. Petr Josek.

257 **Iran's President Mahmoud Ahmadinejad speaks at Columbia University at the start of a visit to New York for a U.N. General Assembly meeting. He received a caustic reception.** 24 September 2007. New York, United States. Shannon Stapleton.

258 **Canadian Warrant Officer Ray Green from the NATO-led coalition shaves at Three Tank Hill base in southern Afghanistan.** 12 July 2007. Panjwaii, Afghanistan. Finbarr O'Reilly.

259 **A pin-up calendar counts down the remaining days of a Canadian soldier's tour of duty in Afghanistan.** 4 July 2007. Ma'sum Ghar, Afghanistan. Finbarr O'Reilly.

260 **Two women approach a window pierced by a bullet in Baghdad's al-Amin al-Thaniyah district. This is one of the last pictures taken by Reuters Iraqi photographer Namir Noor-Eldeen before he was killed in a U.S. helicopter air strike.** 12 July 2007. Baghdad, Iraq. Namir Noor-Eldeen.

261 **This picture appears to be the last taken by Reuters Iraqi photographer Namir Noor-Eldeen before he was killed.** 12 July 2007. Baghdad, Iraq. Namir Noor-Eldeen.

262 **U.S. soldiers blindfold an Iraqi man after arresting him during a night patrol in the Zafraniya neighbourhood southeast of Baghdad.** 4 September 2007. Baghdad, Iraq. Carlos Barria.

263 **Blood drips on the floor of the 28th Combat Support Hospital in the Green Zone in Baghdad as doctors treat a seriously injured U.S. soldier.** 18 August 2007. Baghdad, Iraq. Damir Sagolj.

264 **U.S. medic Sgt William Howard talks to an Iraqi woman as he holds her injured son in the emergency room of 28th Combat Support Hospital.** 21 August 2007. Baghdad, Iraq. Damir Sagolj.

265 **U.S. military doctors rush an 8-year-old Iraqi boy with serious head wounds to the emergency room of 28th Combat Support Hospital.** 22 August 2007. Baghdad, Iraq. Damir Sagolj.

266 **A military doctor wraps a blanket around injured U.S. soldiers as they are brought to the emergency room of 28th Combat Support Hospital.** 18 August 2007. Baghdad, Iraq. Damir Sagolj.

267 **An Iraqi woman stands outside a morgue after the death of her daughter by stray bullets in Mahmoudiya as gun-toting revellers celebrated Iraq winning the 2007 AFC Asian Cup soccer tournament in Jakarta.** 29 July 2007. Mahmoudiya, Iraq. Ibrahim Sultan.

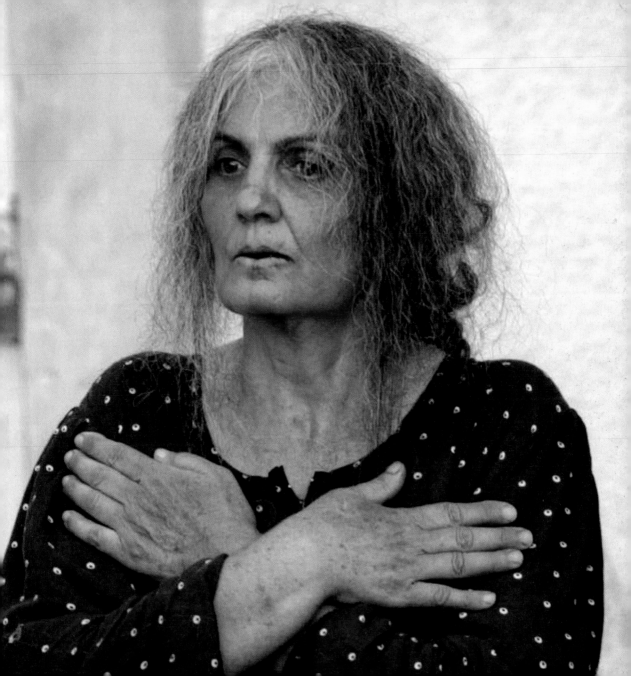

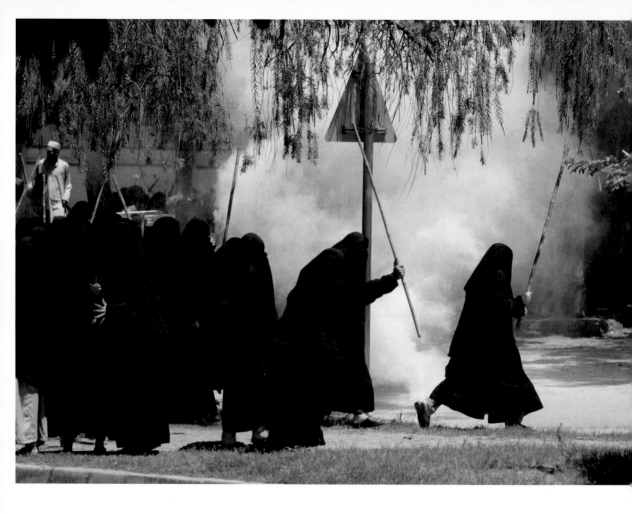

269 Islamabad, Pakistan

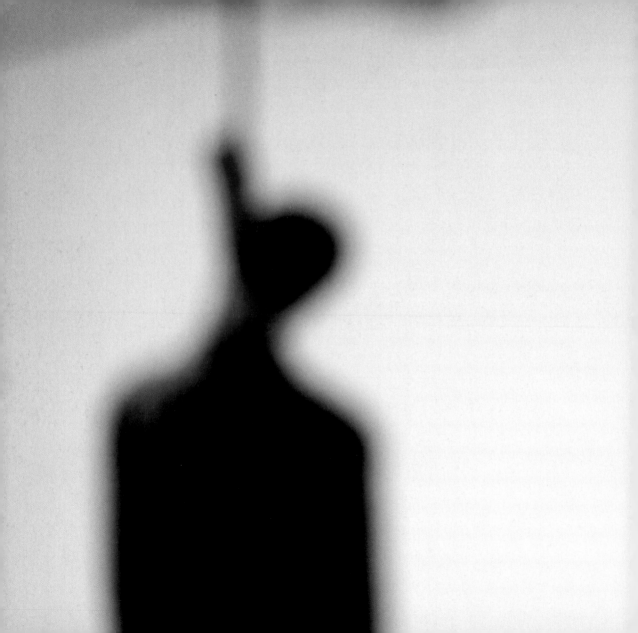

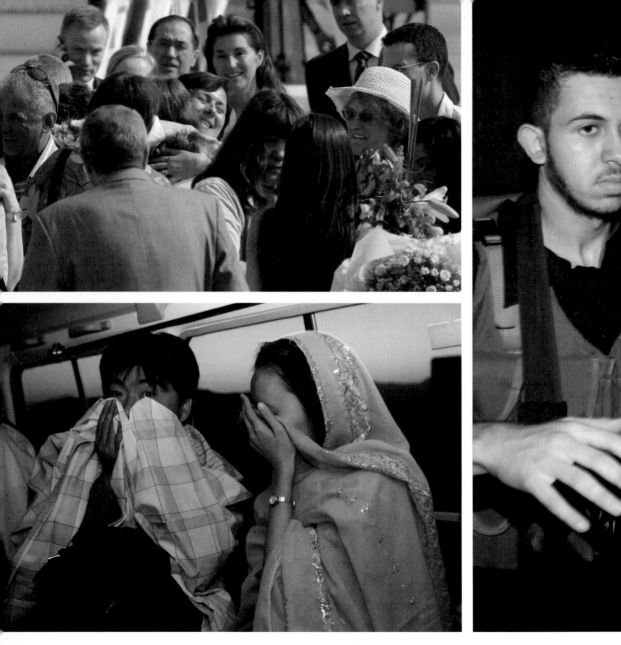

273 [TOP] Sofia, Bulgaria **274** [ABOVE] Galan, Afghanistan

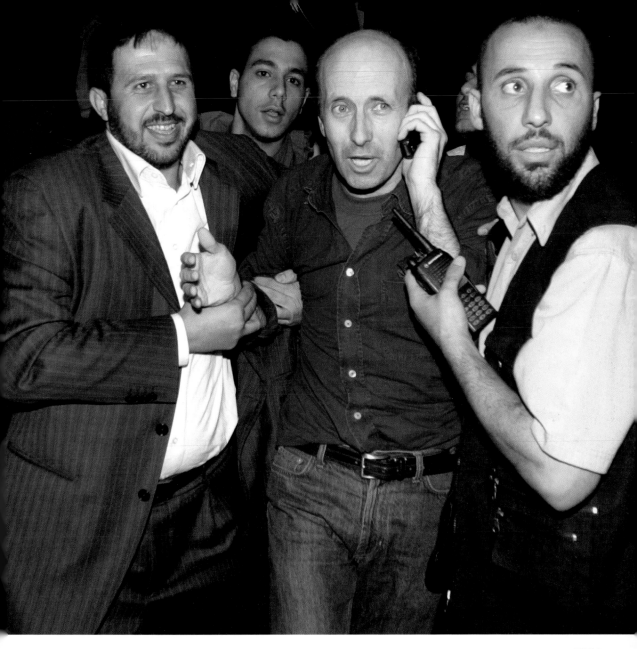

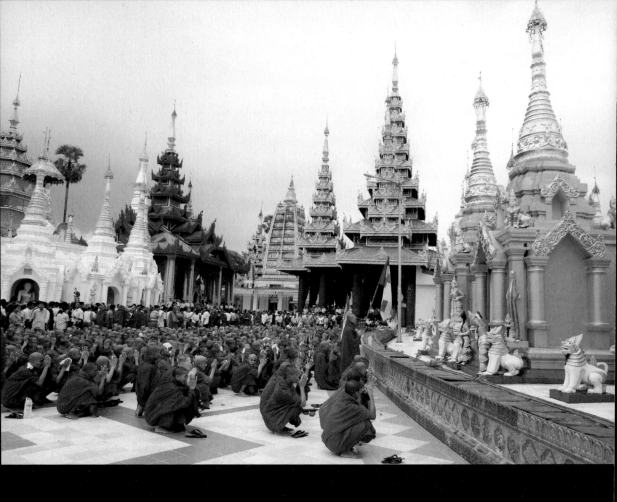

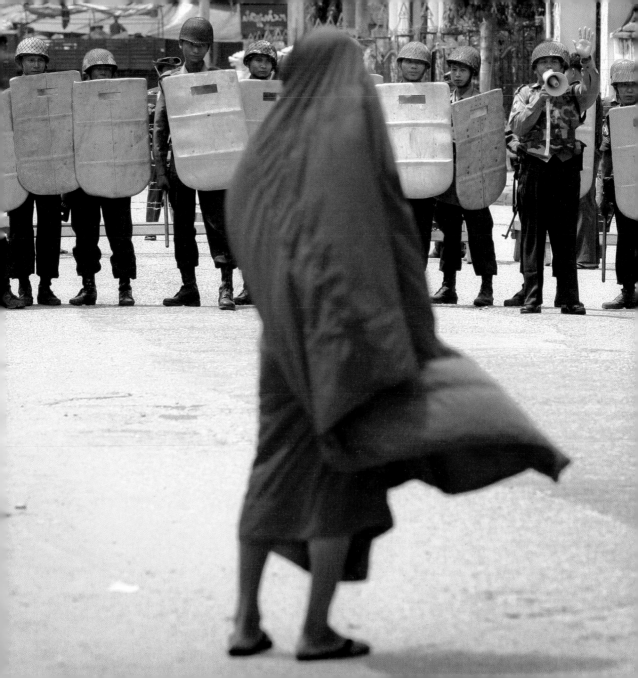

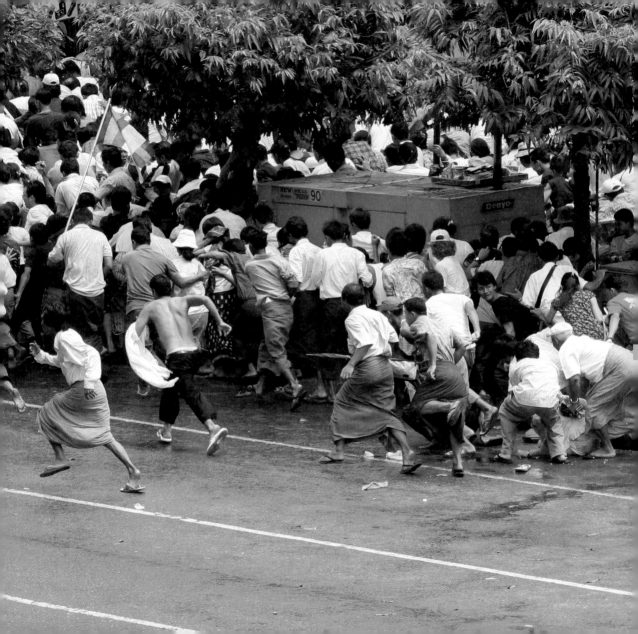

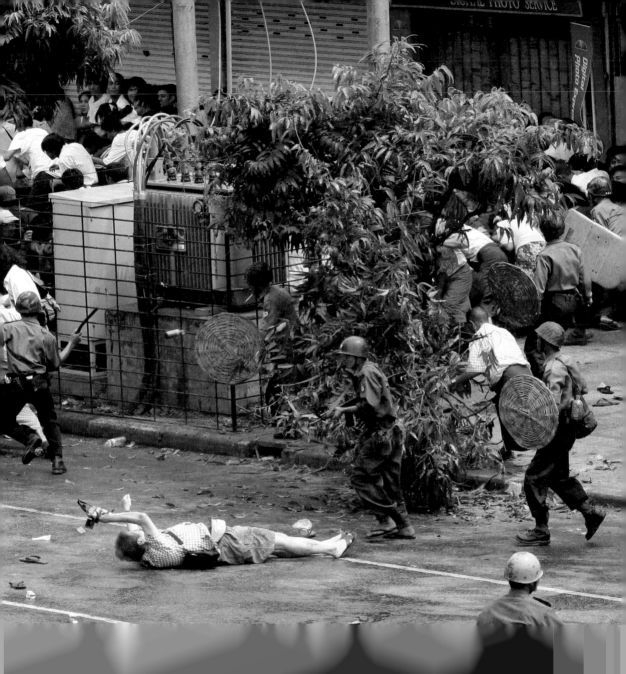

268 | 269 | 270 | 271 | 272 | 273 | 274 | 275 | 276
277 | 278 | 279

268 Pakistani religious students flee teargas outside the Red Mosque in Islamabad. Security forces laid siege to the mosque on 3 July, before launching a full-scale assault a week later after followers of a Taliban-style movement refused to surrender. More than 100 people were killed. 3 July 2007. Islamabad, Pakistan. Mian Khursheed.

269 A worker of the Pakistani Gas Company peers out of a hole in the road near the Red Mosque as the authorities ordered the gas supply to the mosque to be shut down. 7 July 2007. Islamabad, Pakistan. Mian Khursheed.

270 Majid Kavousifar and his nephew Hossein Kavousifar hang from the cable of a crane before a crowd of hundreds of people in Tehran. The pair were convicted of killing a judge who had jailed several reformist dissidents. Iran has one of the highest rates of execution in the world, though public executions are relatively rare. 2 August 2007. Tehran, Iran. Morteza Nikoubazl.

271 Opposition activists in Belarus sit in a police van after being detained for staging an unlawful protest in Baranovichi, some 150 km (90 miles) southeast of Minsk. Two journalists covering the event, including a Reuters photographer, were also briefly detained. 10 September 2007. Baranovichi, Belarus. Vasily Fedosenko.

272 Colombian army soldiers escort drug trafficker Diego Montoya after his arrest in Bogota. Montoya was the country's biggest narcotics arrest in a decade. 10 September 2007. Bogota, Colombia. Daniel Munoz.

273 Cecilia Sarkozy (back centre), then wife of France's President Nicolas Sarkozy, accompanies released Bulgarian nurses as they are reunited with relatives at Sofia airport. Six foreign medics convicted of deliberately infecting hundreds of Libyan children with HIV were freed after a deal between Tripoli and the European Union. 24 July 2007. Sofia, Bulgaria. Nikolay Doychinov.

274 South Korean hostages cover their faces after their release in Ghazni province, southwest of Kabul. The Christian volunteers were freed by Taliban insurgents following a deal that Afghan officials said included a ransom payment by Seoul. 30 August 2007. Galan, Afghanistan. Omar Sobhani.

275 BBC journalist Alan Johnston is surrounded by Hamas fighters and other people after his release in Gaza following a deal between the ruling Hamas Islamists and the al Qaeda-inspired clan group that kidnapped him in March. 4 July 2007. Gaza. Suhaib Salem.

276 Buddhist monks pray at the Shwedagon Pagoda before starting an anti-government march to the city centre of Yangon. The demonstrations were the biggest against Myanmar's ruling generals in nearly 20 years. 24 September 2007. Yangon, Myanmar. Adrees Latif.

277 A monk is halted in Yangon by riot police and military officials. 26 September 2007. Yangon, Myanmar. Adrees Latif.

278 Japanese video journalist Kenji Nagai, 50, falls to the ground fatally wounded as soldiers and police fire upon and then charge at protesters in Yangon. 27 September 2007. Yangon, Myanmar. Adrees Latif.

279 Monks pray at the Sule Pagoda after taking part in anti-government demonstrations. 24 September 2007. Yangon, Myanmar. Adrees Latif.

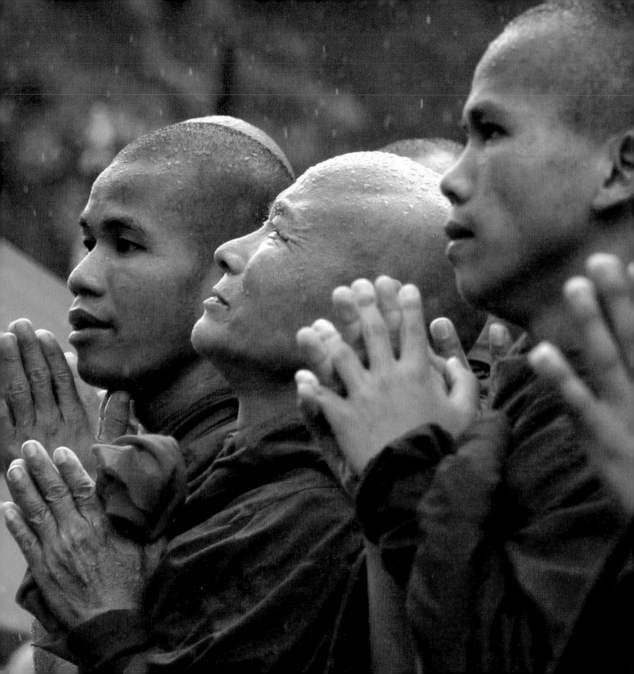

October / November / December

281 Karachi, Pakistan

282 [OPPOSITE] Guangzhou, Ch

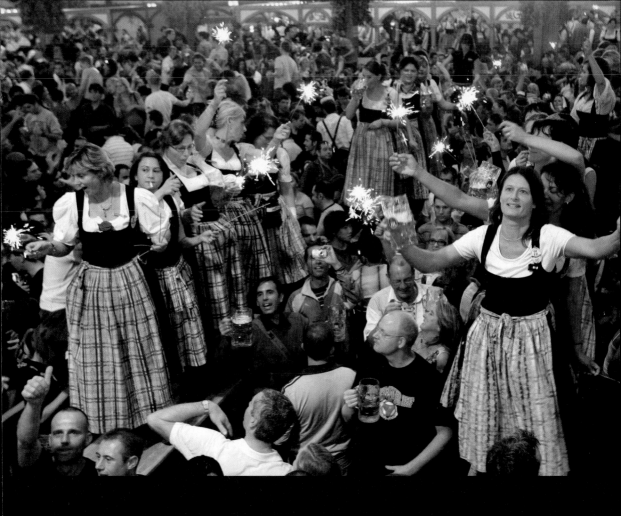

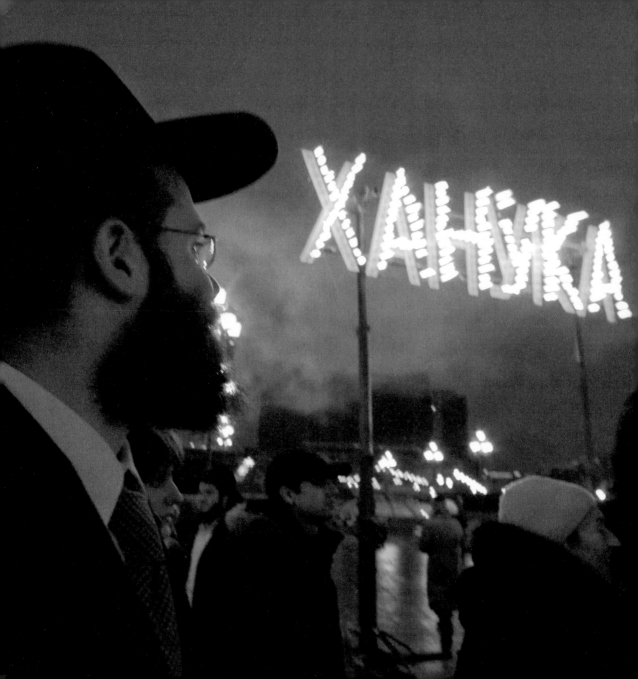

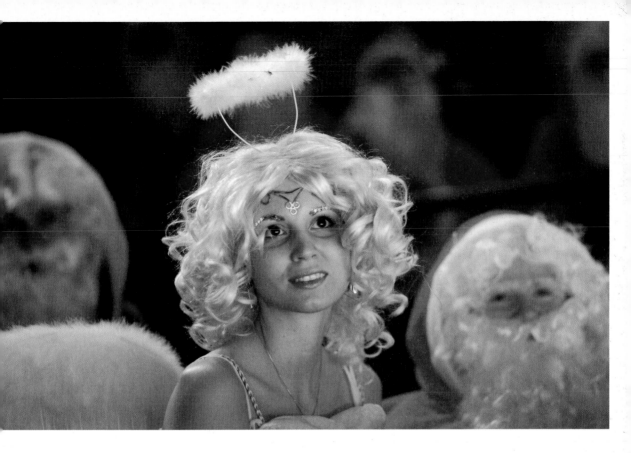

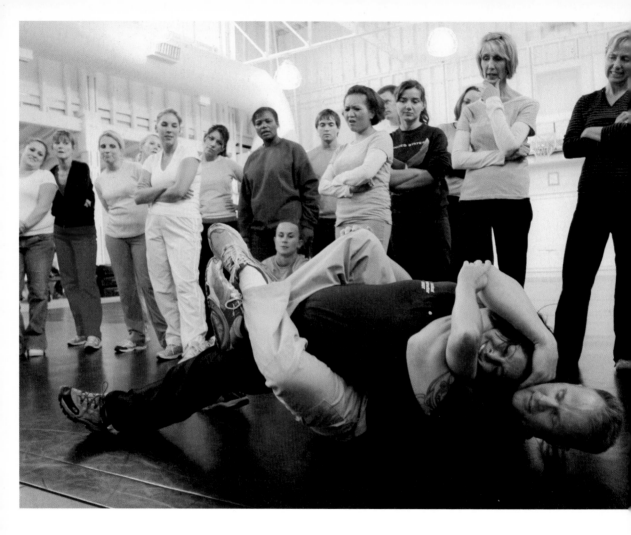

289 Denver, United States

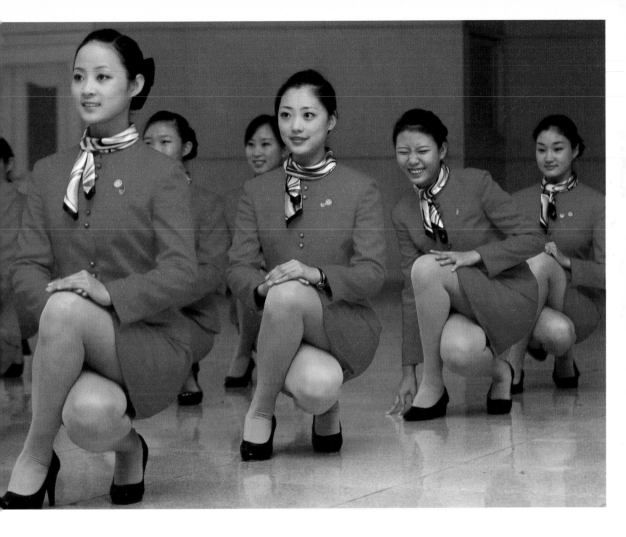

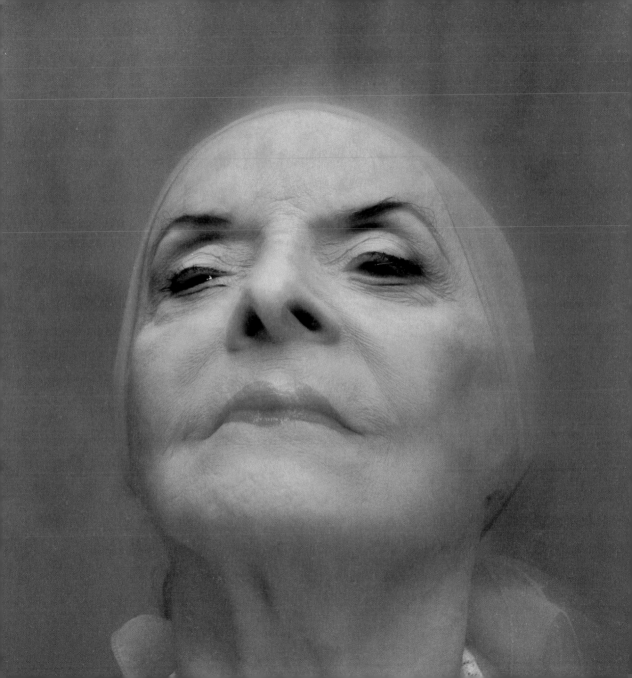

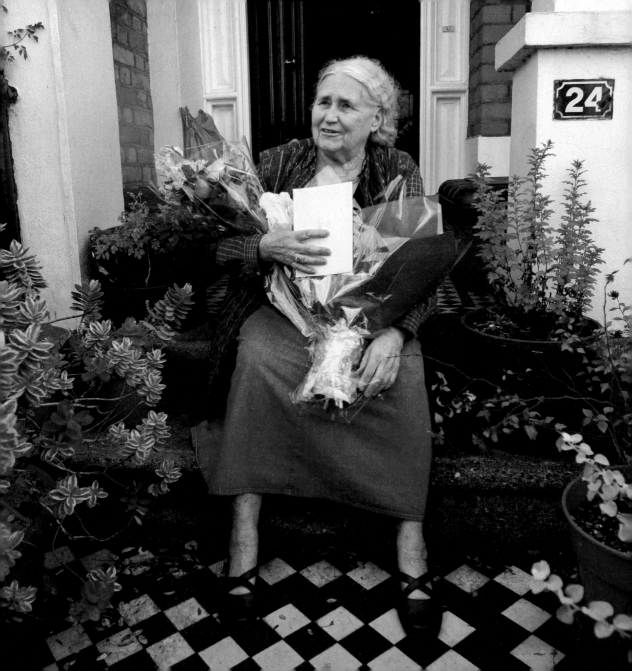

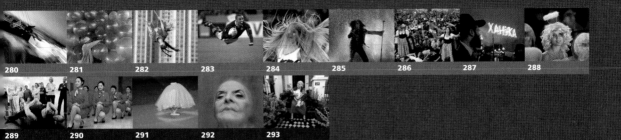

280 281 282 283 284 285 286 287 288

289 290 291 292 293

A man enjoys a fairground ride at a Christmas market at Schlossplatz in Berlin. 6 December 2007. Berlin, Germany. Hannibal Hanschke.

A vendor waits for customers during the festival of Eid al-Fitr in Karachi. Eid al-Fitr marks the end of Ramadan, the Muslim month of fasting. 14 October 2007. Karachi, Pakistan. Zahid Hussein.

A contestant takes part in the 8th Chinese Traditional Gamesof Ethnic Nationalities in Guangzhou, in south China's Guangdong province. 14 November 2007. Guangzhou, China. Joe Tan.

South Africa's Bryan Habana scores a try against Argentina during their semi-final Rugby World Cup match at the Stade de France Stadium in Saint-Denis, near Paris. 14 October 2007. Paris, France. Eddie Keogh.

A cheerleader performs during a Euroleague basketball match in Ljubljana. 21 November 2007. Ljubljana, Slovenia. Srdjan Zivulovic.

285 Lead singer of German band Tokio Hotel, Bill Kaulitz, performs during the MTV Europe Awards gala in Munich. 1 November 2007. Munich, Germany. Michael Dalder.

286 Waitresses dance on tables with sparklers while celebrating the end of Munich's 174th Oktoberfest. The 16-day beer festival drew around 6.2 million visitors. 7 October 2007. Munich, Germany. Michaela Rehle.

287 Jewish men celebrate Hanukkah, the Festival of Lights, at Manezhnaya square in the centre of Moscow. 4 December 2007. Moscow, Russia. Sergei Karpukhin.

288 A student dressed as a Christmas angel attends the annual meeting of the rent-a-Santa Claus service of Berlin's universities. 1 December 2007. Berlin, Germany. Hannibal Hanschke.

289 Instructors Marlena Candelaria (left) and Martin Garland demonstrate how to get free from an attacker during a self-defence course in Denver for Frontier Airlines flight attendants. All new flight crew joining the airline are required to take the course. 16 November 2007. Denver, United States. Rick Wilking.

290 Students take part in etiquette training in Beijing to serve as stewards during the 2008 Beijing Olympics. 25 October 2007. Beijing, China. Jason Lee.

291 Russian clown Micha Usov performs in a ballet costume during a charity circus gala with VIP participants in Munich. The 'Stars in der Manege' gala is broadcast on German television. 1 December 2007. Munich, Germany. Michaela Rehle.

292 Alicia Alonso, the matriarch of Cuban ballet, speaks about the 60th anniversary of the National Ballet of Cuba. 29 October 2007. Havana, Cuba. Enrique De La Osa.

293 British novelist Doris Lessing smiles on the doorstep of her house in London after hearing that she has won the 2007 Nobel Prize for Literature. 11 October 2007. London, Britain. Kieran Doherty.

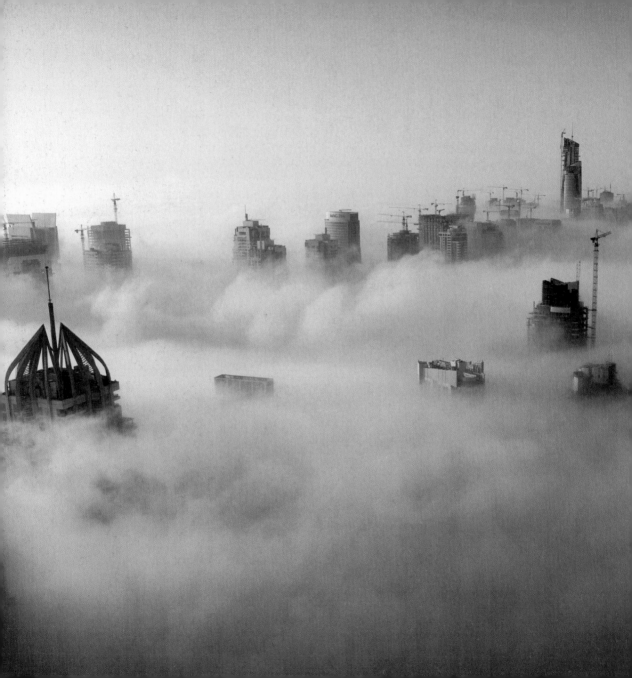

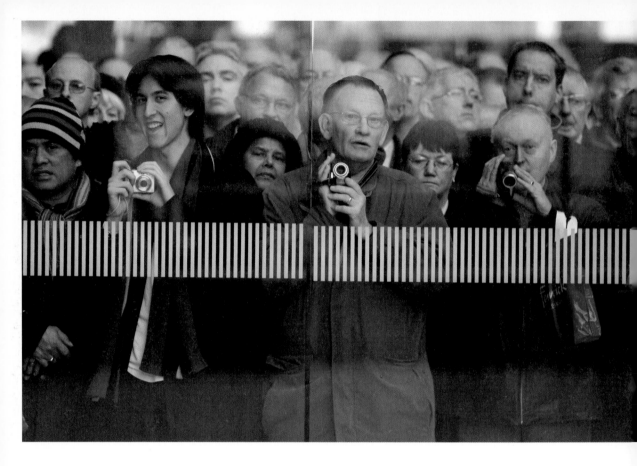

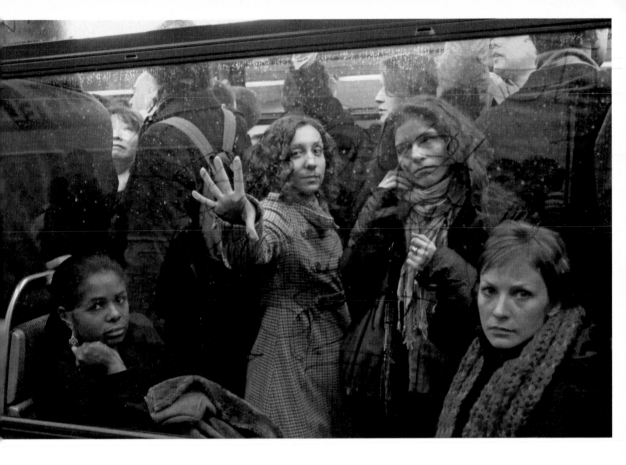

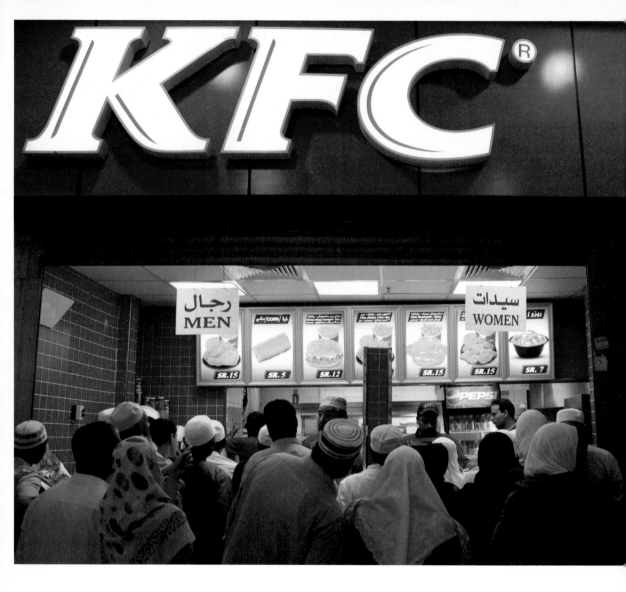

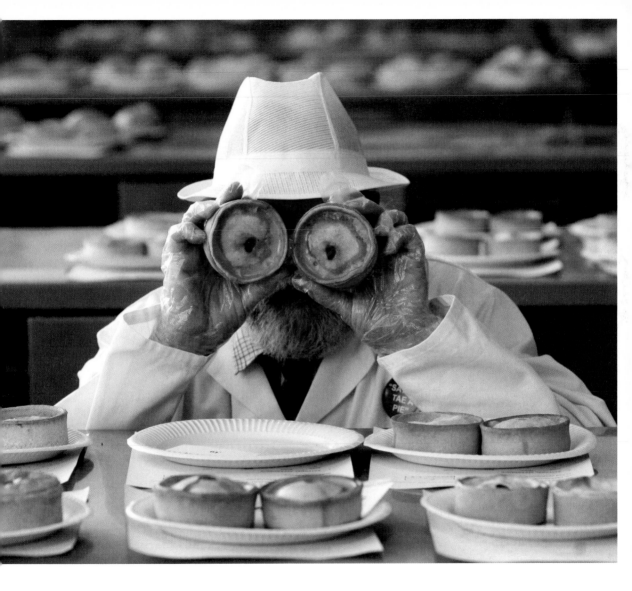

301 Macau, China

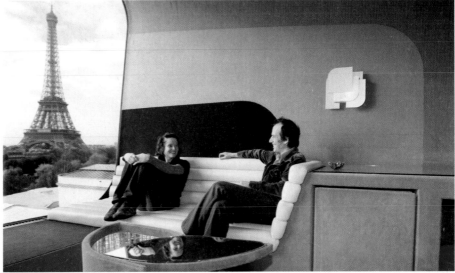

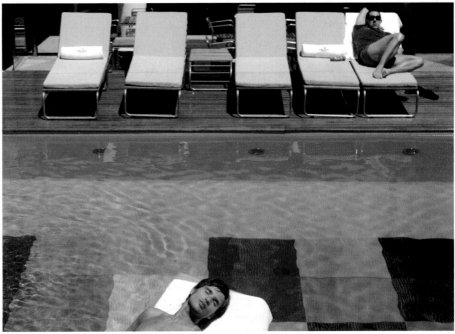

302 [TOP] Paris, France **303** [ABOVE] Buenos Aires, Argentina

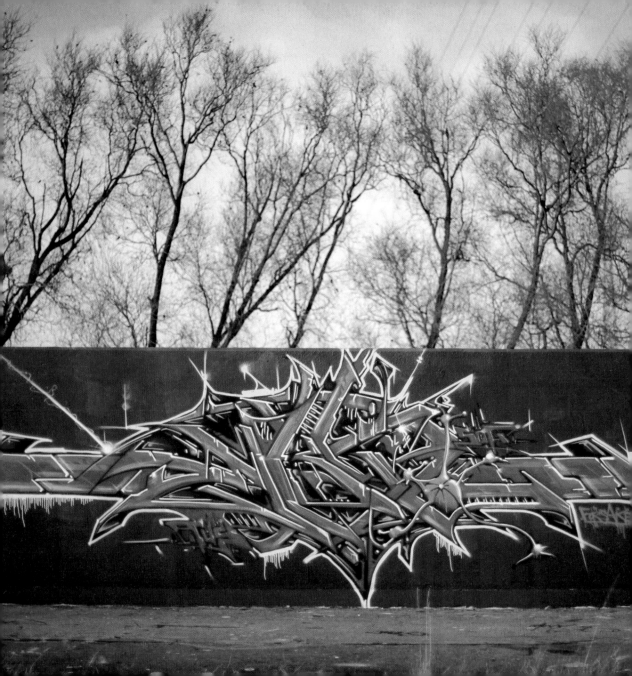

Heavy fog rolls by early in the morning near the Dubai Marina. 21 November 2007. Dubai, United Arab Emirates. Steve Crisp.

Trucks block a highway toll booth on the outskirts of Rome during a strike against high fuel costs and poor working conditions. Blockades dried up fuel supplies, closed factories and prevented food reaching the shops. 12 December 2007. Rome, Italy. Alberto Berti.

Airline employees and travellers are reflected in a wall of mirrors at Logan International Airport in Boston, Massachusetts, as record numbers of Americans travelled ahead of the traditional Thanksgiving holiday. 21 November 2007. Boston, United States. Brian Snyder.

Members of the public wait to see the first Eurostar train leave the newly restored St Pancras station in London. 14 November 2007. London, Britain. Stephen Hird.

298 Commuters crowd into the metro at Châtelet station in Paris during a nationwide strike by French SNCF railway workers in protest against pension reform. 19 November 2007. Paris, France. Gonzalo Fuentes.

299 Muslim pilgrims queue up at a KFC restaurant outside the Grand Mosque in Mecca as an expected 1.5 million Muslims from around the world began to arrive in Saudi Arabia for the annual *haj* pilgrimage. 13 December 2007. Mecca, Saudi Arabia. Ali Jarekji.

300 World Pie Championship judge John Young poses for photographers during the judging of the competition in Dunfermline, Scotland. 7 November 2007. Dunfermline, Britain. David Moir.

301 Employees staff the reception desk of the newly opened MGM Grand Macau hotel. The 600-room, Las Vegas-style luxury resort is a joint venture between MGM Mirage and businesswoman Pansy Ho. Macau is the only place casinos are legal in China. 13 December 2007. Macau, China. Victor Fraile.

302 Swiss artists Sabina Lang and Daniel Baumann sit inside their creation *Hôtel Everland*, situated on the roof of the Palais de Tokyo contemporary art museum in Paris. The art installation consists of a one-room hotel offering 1970s style and a view of the Eiffel Tower. It will remain in place until November 2008, functioning as both a gallery exhibit and a room where people can reserve to stay overnight. 16 October 2007. Paris, France. Philippe Wojazer.

303 Hotel guest Gerardo Gentile (below) sunbathes at the new pool of the Axel Hotel in Buenos Aires, Argentina's first luxury gay hotel. 1 November 2007. Buenos Aires, Argentina. Marcos Brindicci.

304 Graffiti adorns a wall in an industrial area on the banks of the River Thames in east London. 15 December 2007. London, Britain. Finbarr O'Reilly.

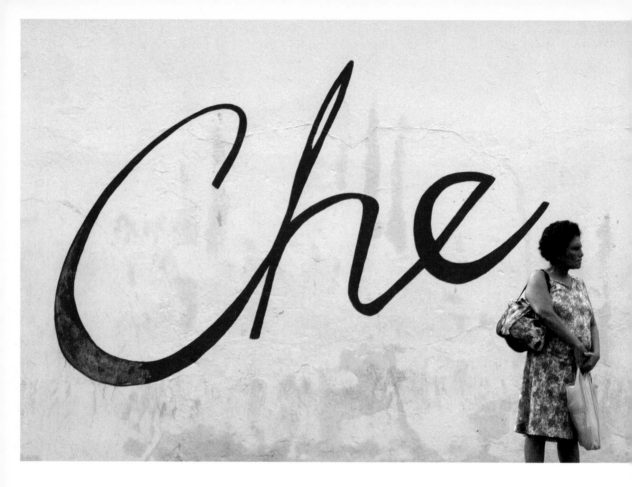

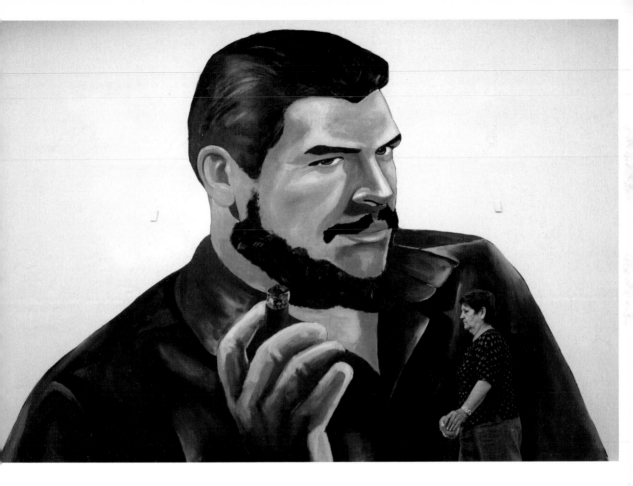

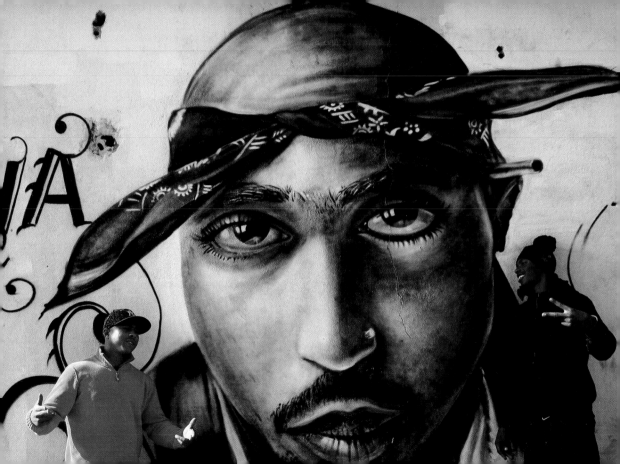

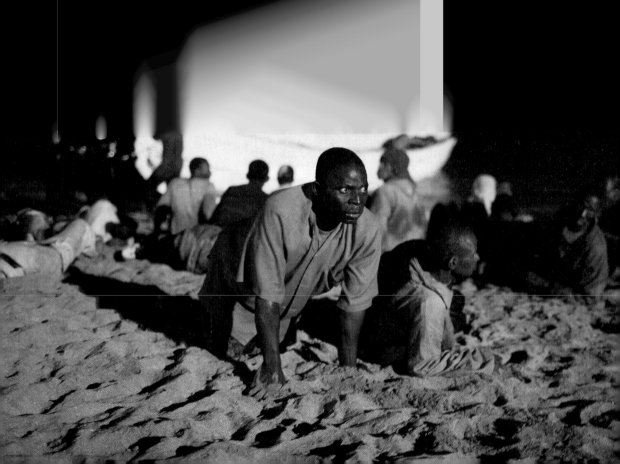

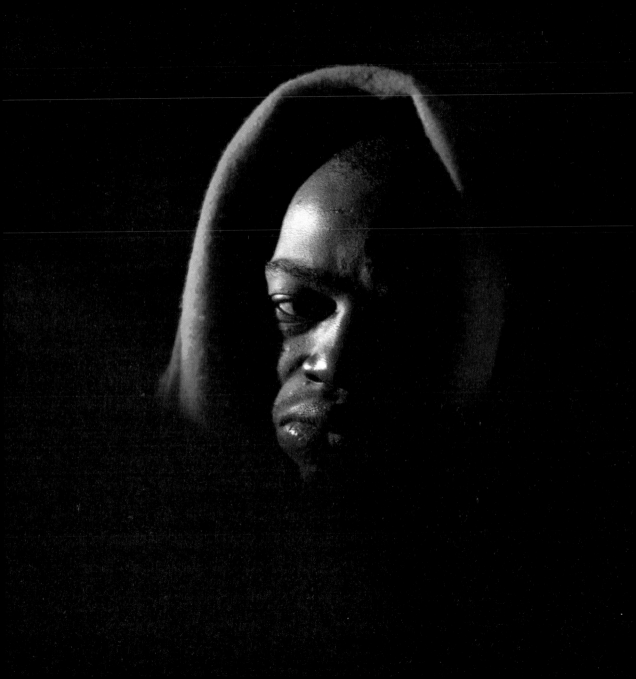

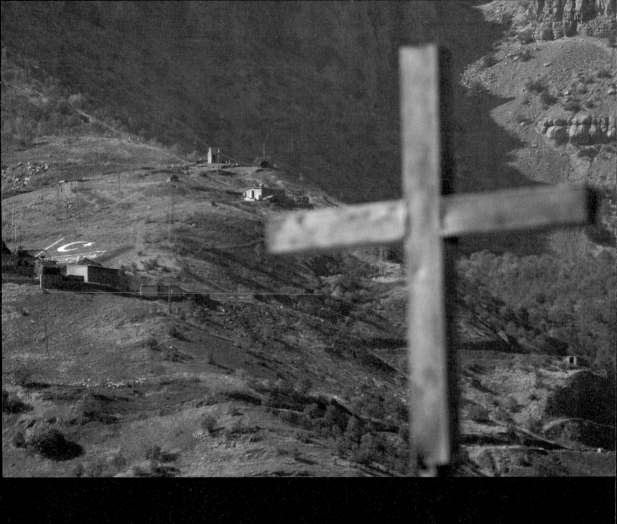

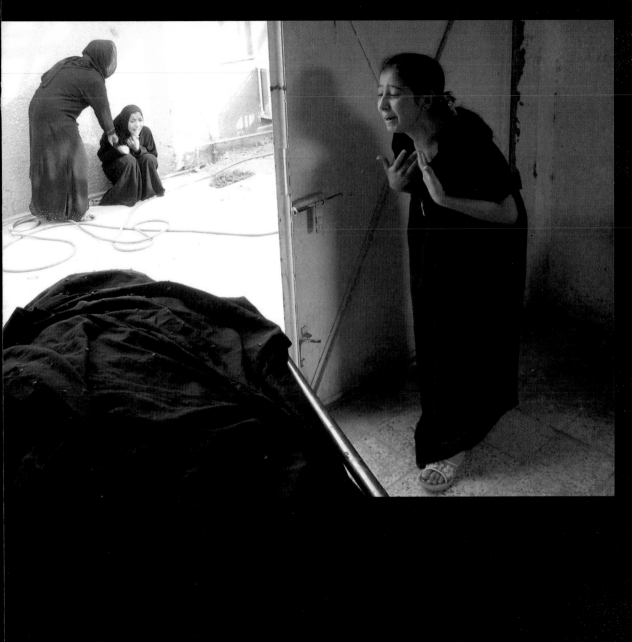

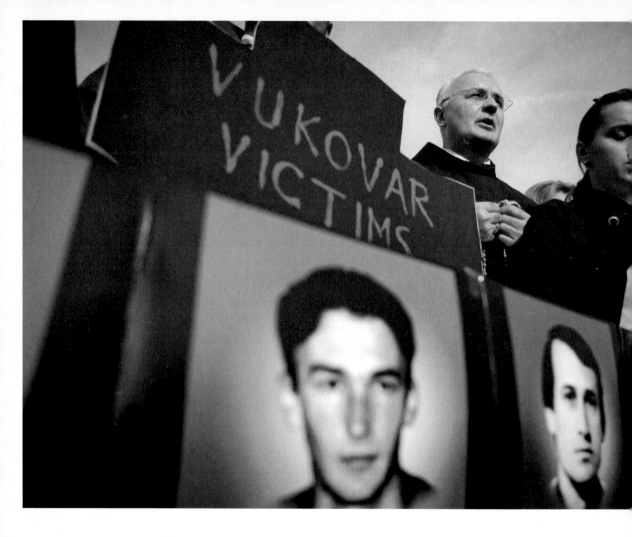

313 The Hague, Netherlands

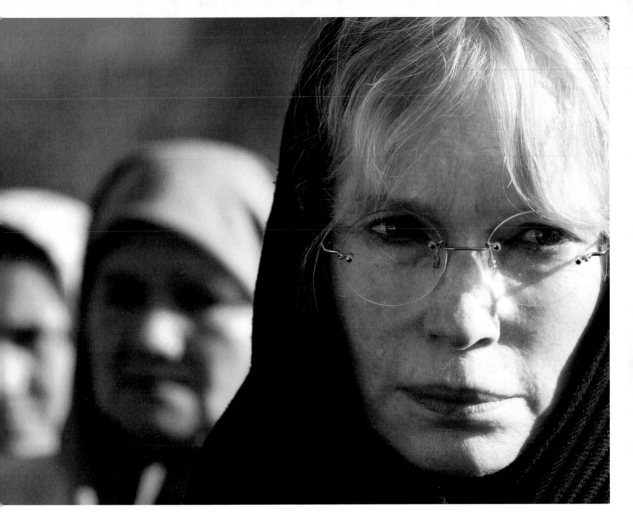

305 306 307 308 309 310 311 312 313

314 315

305 A woman stands before a mural of the signature of rebel hero Ernesto 'Che' Guevara in Havana. Forty years after his execution by soldiers in a Bolivian jungle, the Argentine-born Guevara is still a national hero in Cuba. 3 October 2007. Havana, Cuba. Enrique De La Osa.

06 A woman walks past a mural portrait of 'Che' Guevara in Havana. 3 October 2007. Havana, Cuba. Enrique De La Osa.

07 Thousands of fans pay their respects to Macedonian pop star Tose Proeski in Skopje. One of the biggest stars in the Balkans, the 26-year-old was killed in a car crash. 16 October 2007. Skopje, Macedonia. Ognen Teofilovski.

08 Young African immigrants are pictured in front of a mural of murdered rapper Tupac Shakur in Lisbon's Cova da Moura district. 6 December 2007. Lisbon, Portugal. Nacho Doce.

09 Would-be immigrants arrive at Las Vistas beach near Los Cristianos on Spain's Canary Island of Tenerife. Some 92 migrants were intercepted aboard two fishing boats. 5 December 2007. Los Cristianos, Spain. Santiago Ferrero.

310 A would-be immigrant rests at the port of Los Cristianos on Tenerife. On this occasion some 58 would-be immigrants were intercepted aboard a fishing boat. 25 November 2007. Los Cristianos, Spain. Santiago Ferrero.

311 The cross on a Catholic church is seen in the northern Iraqi village of Deshtatakh, near a Turkish army camp on Ankara's side of the mountainous Iraq–Turkey border. Turkish forces have shelled and bombed Iraqi villages in retaliation against attacks on targets within Turkey by separatist Kurdish rebels based across the border. 23 October 2007. Deshtatakh, Iraq. Ceerwan Aziz.

312 Women cry near the body of their mother in a morgue in Baquba. Suspected insurgents gunned down the woman and her husband while they were shopping in a market, police said. 11 October 2007. Baquba, Iraq. Helmiy al-Azawi.

313 Croatian relatives and survivors hold photographs of those killed by Serb forces in the town of Vukovar in 1991. Their protest, staged in front of the International Criminal Tribunal for the Former Yugoslavia in The Hague, was against what they said were lenient sentences handed down to three Serb war criminals. 11 October 2007. The Hague, Netherlands. Jerry Lampen.

314 Actress and UNICEF ambassador Mia Farrow weeps as she visits the cemetery where victims of a 1995 massacre of up to 8,000 Muslim men and boys are buried in Srebrenica. Farrow and fellow activists are staging an Olympic-style torch relay through countries that have suffered genocide in order to pressure China, host of the 2008 Olympic Games, to use its influence to help end violence in Sudan's Darfur region. 6 December 2007. Srebrenica, Bosnia. Danilo Krstanovic.

315 A chestnut tree, estimated at between 150 and 170 years old, is seen from the attic where Anne Frank hid from the Nazis in Amsterdam. Frank drew comfort from the tree and mentioned it several times in her diary. Some experts say that it is now so diseased there is a risk it could topple over. Conservationists are campaigning to save it from the chop. 16 November 2007. Amsterdam, Netherlands. Jerry Lampen.

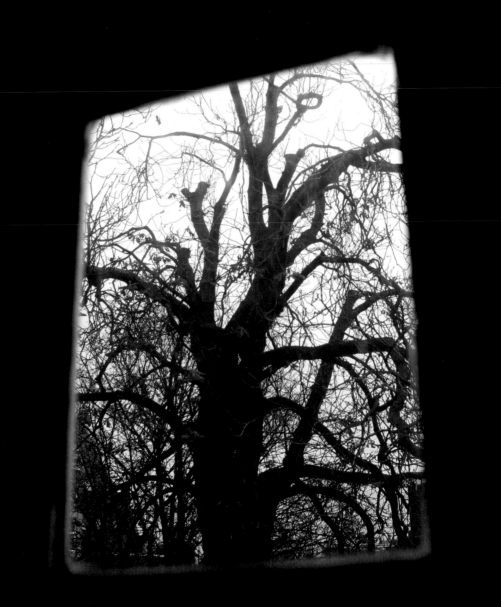

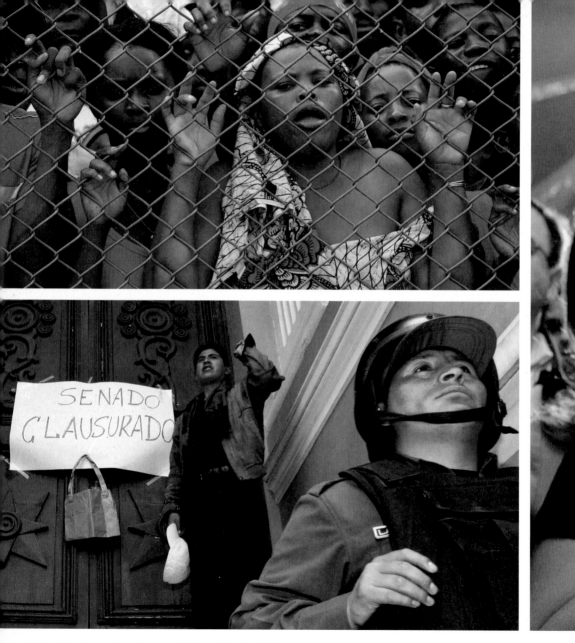

316 [TOP] Freetown, Sierra Leone **317** [ABOVE] La Paz, Bolivia

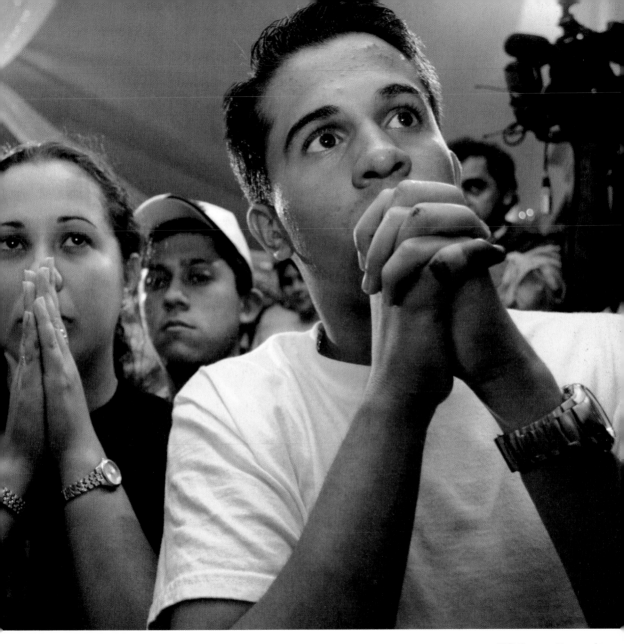

319 Sevastopol, Ukraine

320 [OPPOSITE] St Petersburg, R

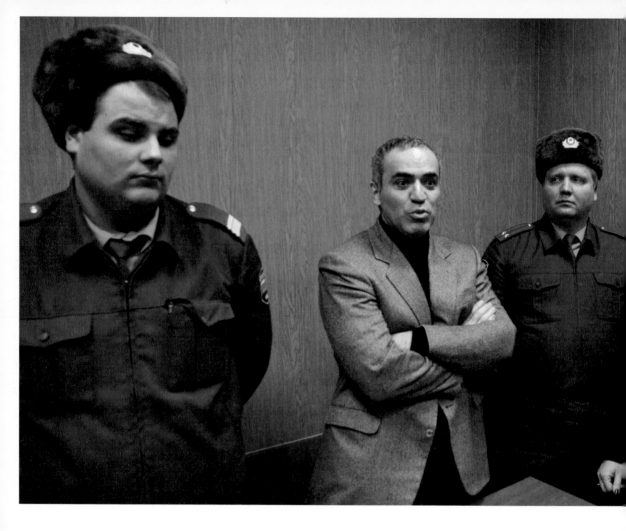

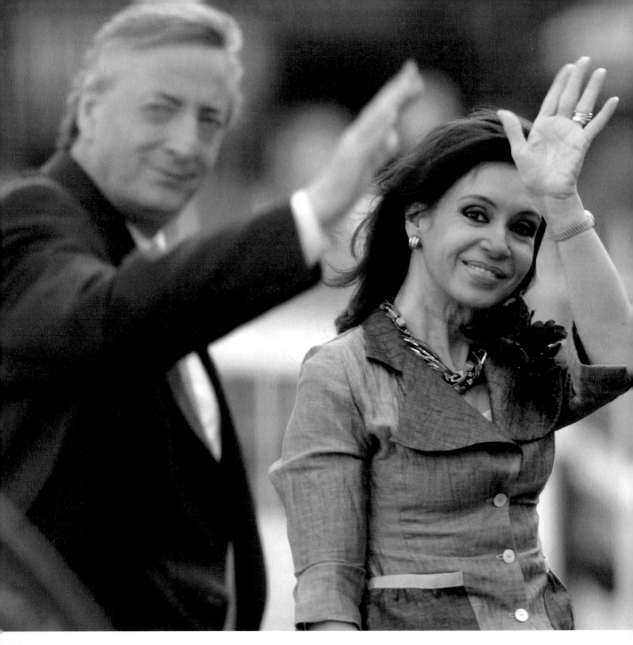

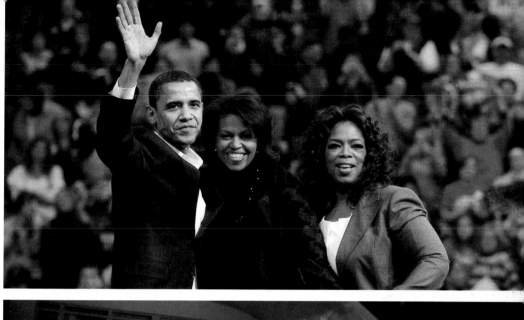

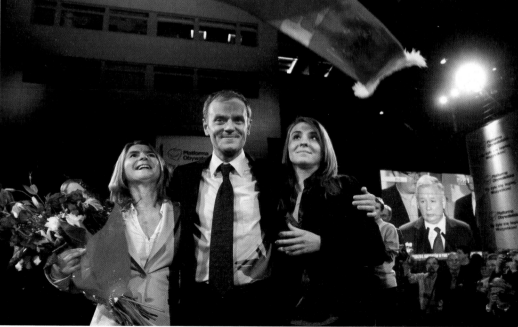

324 [TOP] Manchester, United States **325** [ABOVE] Warsaw, Poland

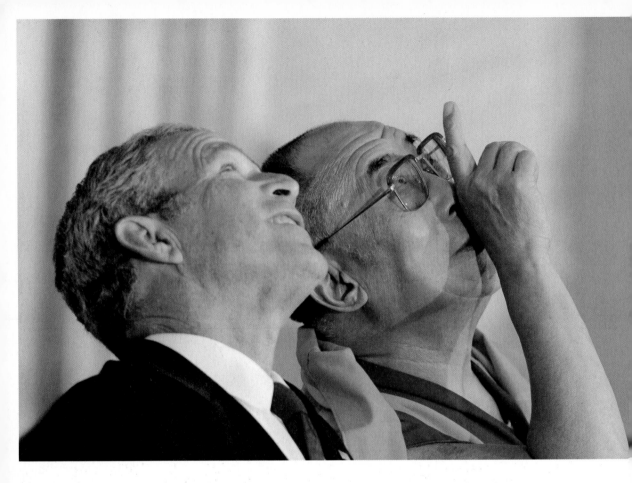

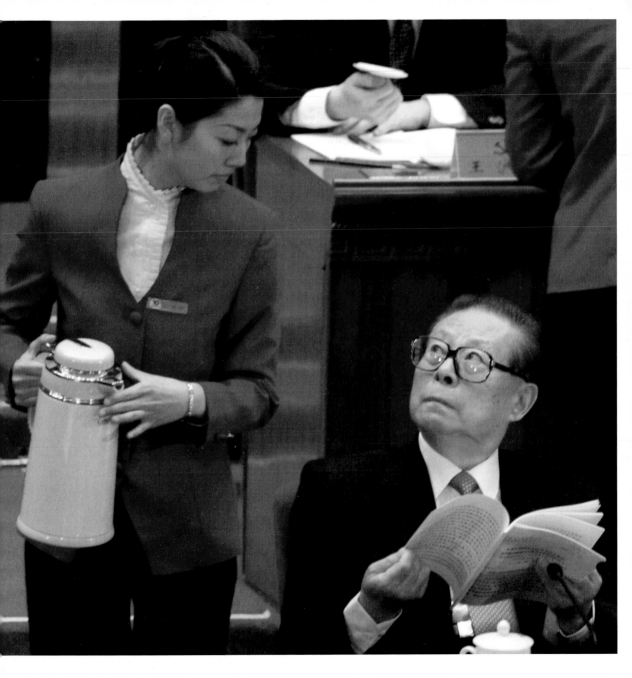

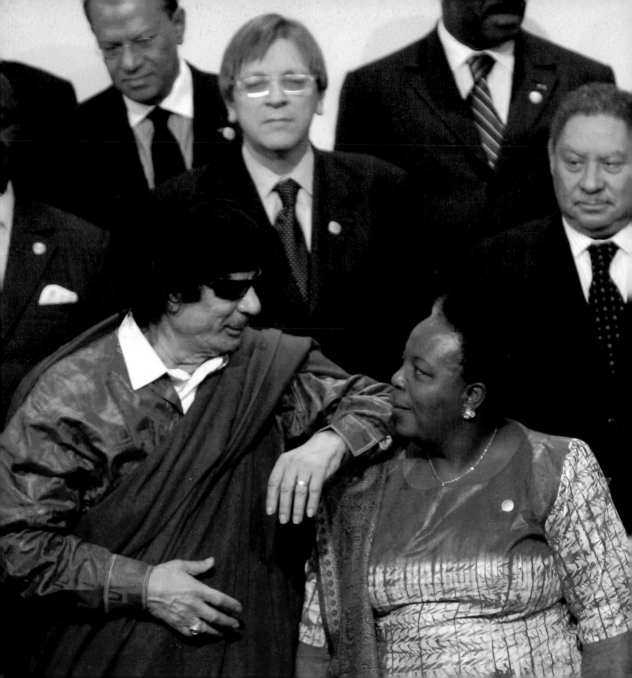

316 317 318 319 320 321 322 323 324

325 326 327 328

6 **Supporters of Sierra Leone's President Ernest Bai Koroma await his inauguration ceremony in Freetown.** 15 November 2007. Freetown, Sierra Leone. Katrina Manson.

7 **A Bolivian protester hangs a sign that reads 'Senate Closed' during a demonstration to demand that the opposition-controlled Senate either approve a series of law projects presented by President Evo Morales, or be closed. The leftist leader has accused the Senate of blocking nearly a hundred bills approved by the lower chamber, where his party has a comfortable majority.** 21 November 2007. La Paz, Bolivia. Jose Luis Quintana.

8 **Venezuelan opposition supporters pray before the results of a referendum in Caracas. President Hugo Chavez conceded defeat in the vote on plans to expand his powers and make him a Cuban-style president-for-life, saying 'We could not do it, for now.'** 3 December 2007. Caracas, Venezuela. Carlos Garcia Rawlins.

9 **A sailor of Russia's Black Sea fleet fills out a ballot paper in the Ukrainian port of Sevastopol. President Vladimir Putin's party won a landslide victory in the parliamentary election, but foreign monitors said the poll was unfair and called for an inquiry.** 2 December 2007. Sevastopol, Ukraine. Gleb Garanich.

320 **Communist supporters take part in a rally in central St Petersburg to mark the 90th anniversary of the Bolshevik revolution.** 7 November 2007. St Petersburg, Russia. Alexander Demianchuk.

321 **Russian opposition leader and former chess champion Garry Kasparov (centre) speaks during a court hearing after he was detained during an opposition street march in Moscow.** 26 November 2007. Moscow, Russia. Mikhail Kusnetsov.

322 **Iranian President Mahmoud Ahmadinejad (right) and his Russian counterpart Vladimir Putin attend a ceremony in Tehran.** 16 October 2007. Tehran, Iran. Morteza Nikoubazl.

323 **Argentina's first lady and president-elect Senator Cristina Fernández de Kirchner and President Nestor Kirchner wave at the Casa Rosada presidential palace in Buenos Aires as she undertakes her first official ceremony after her victory in the presidential election.** 30 October 2007. Buenos Aires, Argentina. Marcos Brindicci.

324 **Democratic presidential candidate U.S. Senator Barack Obama, his wife Michelle and talk show host Oprah Winfrey wave to the crowd at a campaign rally in Manchester, New Hampshire.** 9 December 2007. Manchester, United States. Brian Snyder.

325 **Donald Tusk, leader of Polish centre-right opposition party Civic Platform, together with his wife and daughter, acknowledges applause from party members after first polls show him ahead in Poland's parliamentary election. The result saw his party defeat the conservative Law and Justice Party of Prime Minister Jaroslaw Kaczynski, pictured on a television screen in the background.** 21 October 2007. Warsaw, Poland. Wolfgang Rattay.

326 **U.S. President George W. Bush looks up at the Capitol Rotunda with the Dalai Lama during a ceremony to present the Congressional Gold Medal to the exiled Tibetan spiritual leader. The award was bitterly denounced by Beijing.** 17 October 2007. Washington, DC, United States. Larry Downing.

327 **China's former president Jiang Zemin is served by a steward during the opening ceremony of the 17th Party Congress at the Great Hall of the People in Beijing.** 15 October 2007. Beijing, China. Jason Lee.

328 **Libyan leader Muammar Gaddafi talks with the president of the Pan-African Parliament Gertrude Mongella from Tanzania during the family photo of the first EU-Africa summit in seven years.** 8 December 2007. Lisbon, Portugal. Andrea Comas.

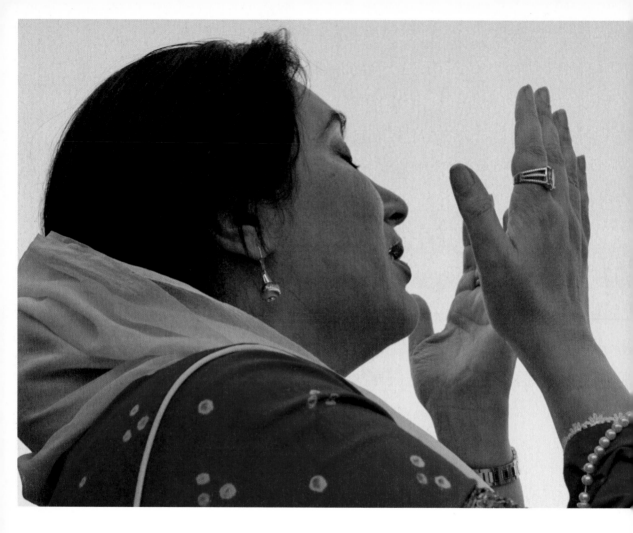

329 Karachi, Pakistan

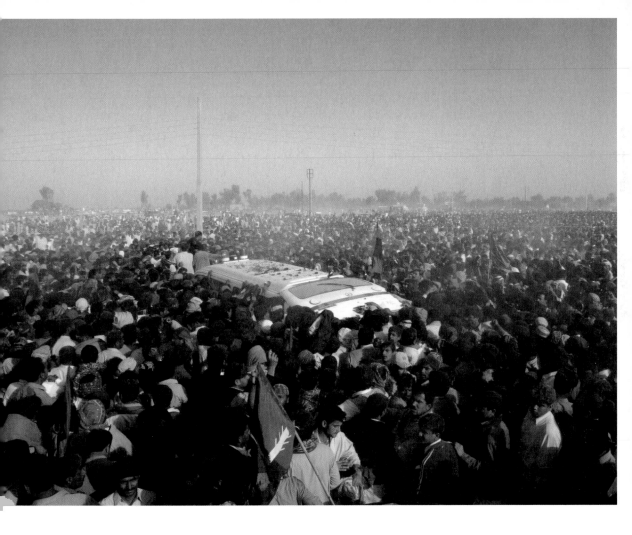

330 Garhi Khuda Bakhsh, Pakistan

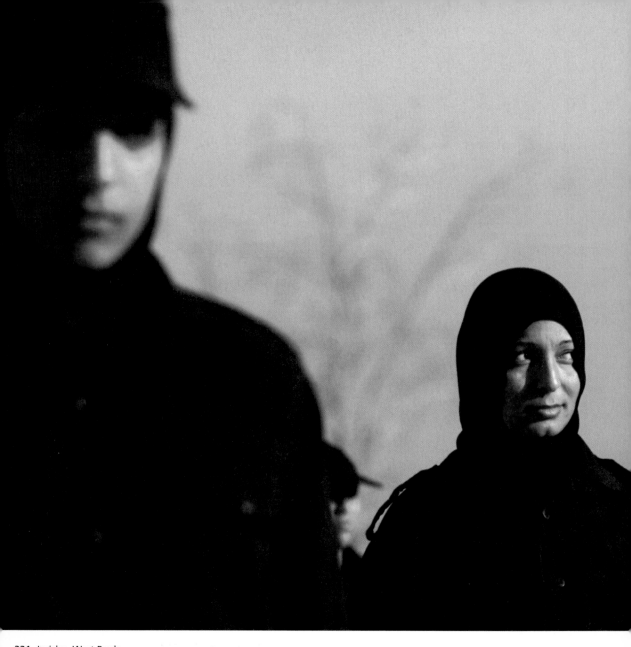

331 Jericho, West Bank

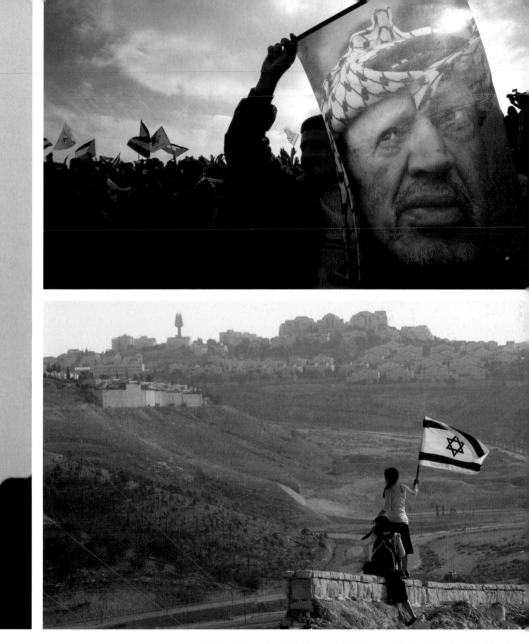

332 [TOP] Ramallah, West Bank **333** [ABOVE] Maale Adumim, West Bank

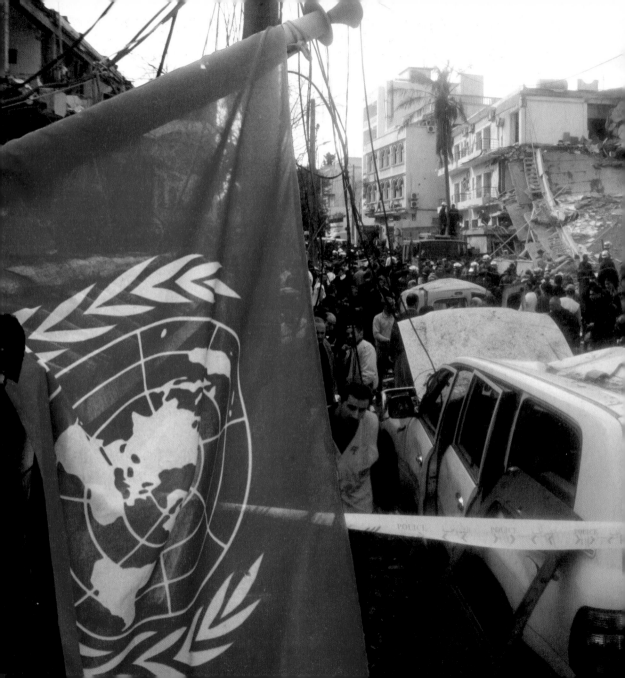

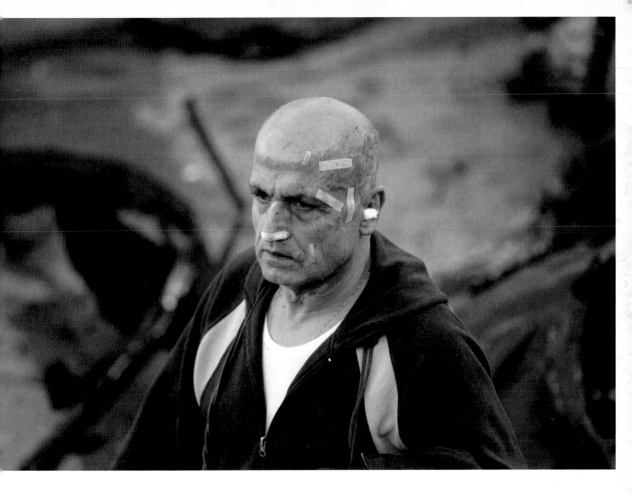

336 Nusa Kambangan Island, Indonesia

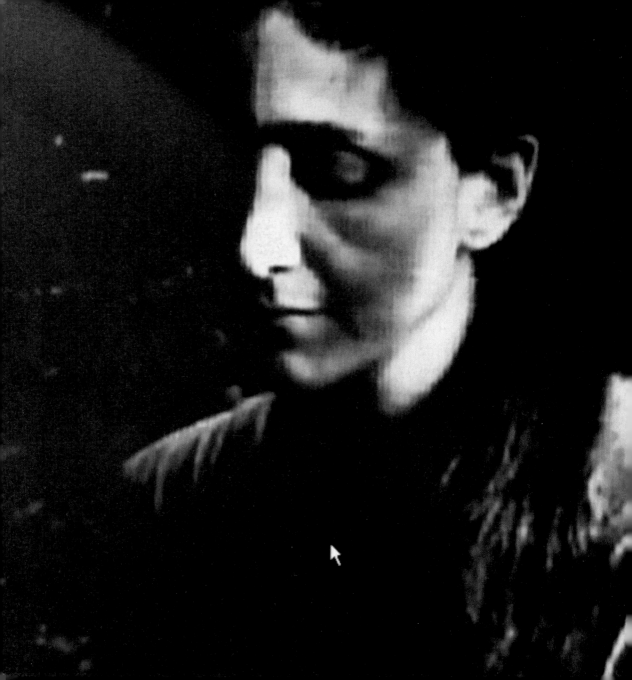

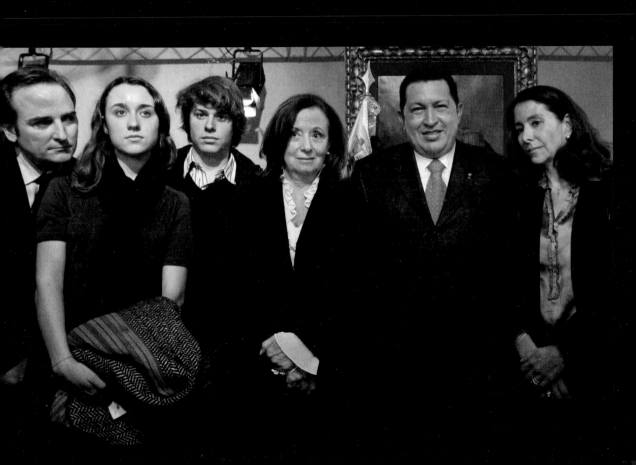

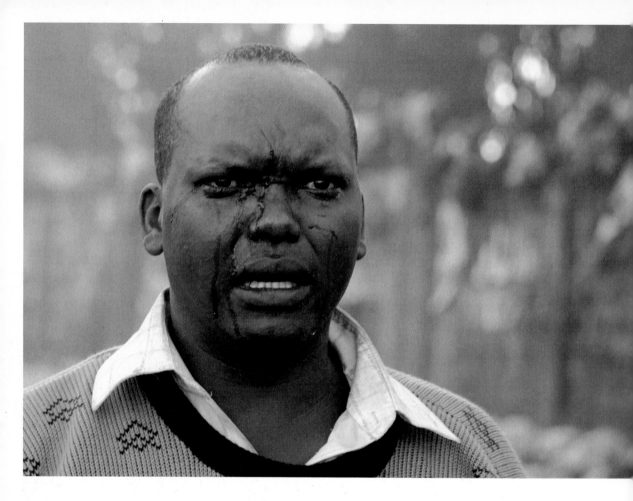

340 Nairobi, Kenya

341 [OPPOSITE] Minova, Democratic Republic of Co

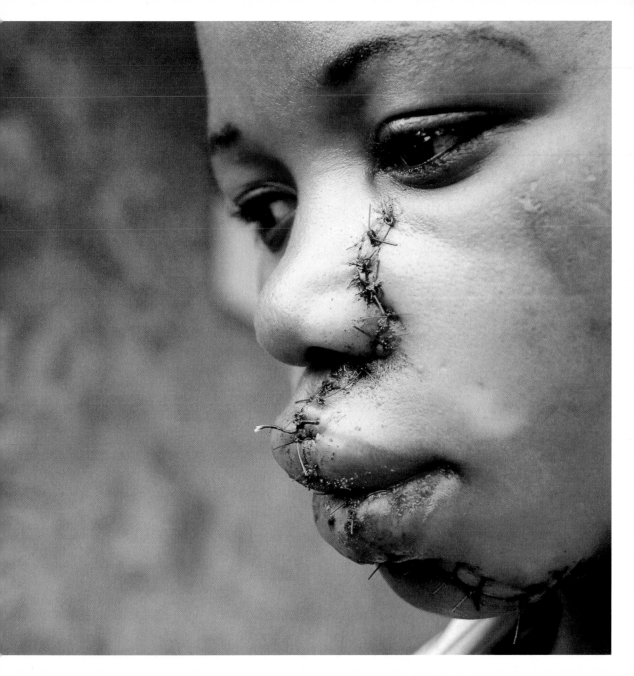

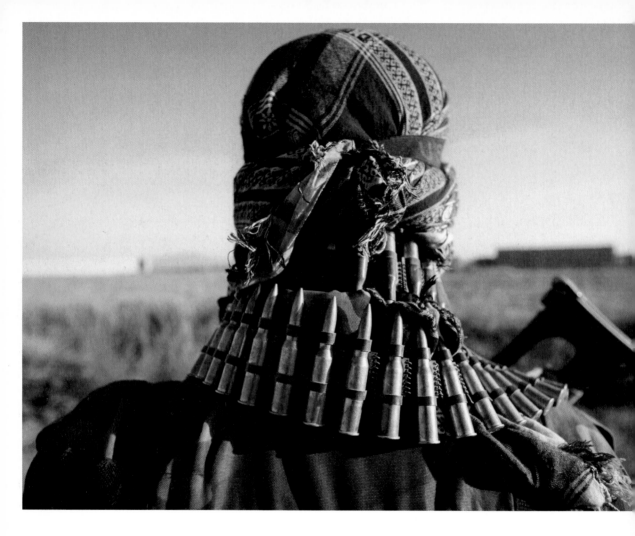

342 Kolk, Afghanistan

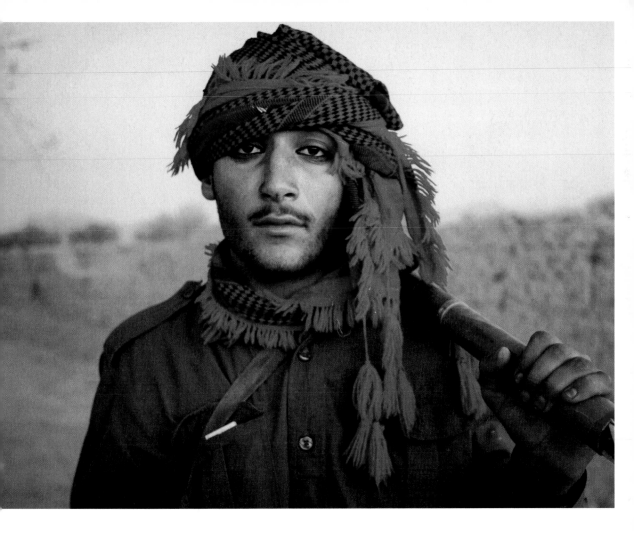

343 Kolk, Afghanistan

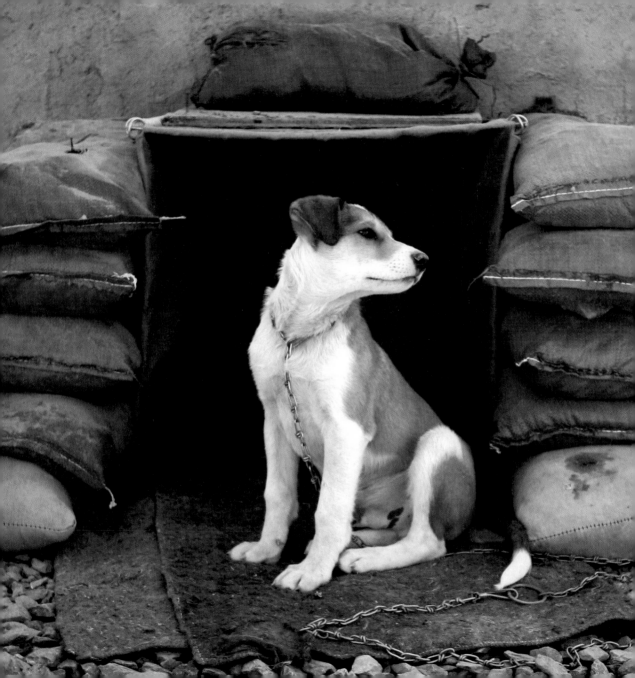

329 Former Pakistani Prime Minister Benazir Bhutto prays as she arrives in Karachi after eight years of self-exile. 18 October 2007. Karachi, Pakistan. Petr Josek.

330 Thousands of mourners surround an ambulance carrying Benazir Bhutto's body during her funeral procession in Garhi Khuda Bakhsh near Naudero. She was assassinated on 27 December in a gun and bomb attack at a rally in Rawalpindi. 28 December 2007. Garhi Khuda Bakhsh, Pakistan. Zahid Hussein.

331 Members of the Palestinian security forces are pictured at a training facility in the West Bank town of Jericho. The first class to graduate from the new police academy included some 45 Palestinian women. 20 November 2007. Jericho, West Bank. Eliana Aponte.

332 A Palestinian holds a banner depicting the late Palestinian leader Yasser Arafat during a rally in the West Bank city of Ramallah marking the third anniversary of his death. 11 November 2007. Ramallah, West Bank. Oleg Popov.

333 A right-wing Israeli activist holds a national flag on a West Bank hilltop near the Jewish settlement of Maale Adumim. 9 December 2007. Maale Adumim, West Bank. Gil Cohen Magen.

334 A United Nations flag is seen at the site of a blast at U.N. offices in Algiers. Twin suicide car bombs on 11 December killed up to 37 people in the Algerian capital, including 17 U.N. staff. The bombings were claimed by al Qaeda's north Africa wing. 11 December 2007. Algiers, Algeria. Louafi Larbi.

335 A wounded man walks near the site of an explosion in Beirut after a car bomb killed a senior army officer and his bodyguard. 12 December 2007. Beirut, Lebanon. Mohamed Azakir.

336 Convicted Bali bomber Imam Samudra talks to his daughter during his last family visit in Indonesia's top security Batu Prison. 29 October 2007. Nusa Kambangan Island, Indonesia. Beawiharta.

337 Members of French humanitarian group Zoe's Ark, arrested on suspicion of trying to kidnap 103 African children, wait to appear before a judge in the Chadian capital N'Djamena. Six were convicted on 26 December and flown to France to serve their sentences. 5 November 2007. N'Djamena, Chad. Luc Gnago.

338 Ingrid Betancourt, French-Colombian politician and former Colombian presidential candidate held hostage since February 2002, is seen in a video seized by Colombian troops from captured leftist guerrillas. 30 November 2007. Bogota, Colombia. Daniel Munoz.

339 Venezuela's President Hugo Chavez (second right) poses with family members of Ingrid Betancourt after a news conference in Paris. 20 November 2007. Paris, France. Benoit Tessier.

340 A wounded man walks during protests by opposition supporters in Nairobi's Kibera slum amidst ethnic violence that broke out following disputed elections in Kenya. 30 December 2007. Nairobi, Kenya. Noor Khamis.

341 A woman undergoes treatment in Minova hospital, 50 km (30 miles) west of Goma, as hundreds of civilians and wounded soldiers flee fighting between the Congolese army and rebels loyal to renegade Tutsi General Laurent Nkunda. 11 December 2007. Minova, Democratic Republic of Congo. James Akena.

342 An Afghan National Army soldier keeps watch in the Taliban stronghold of Kolk in southern Afghanistan. 15 November 2007. Kolk, Afghanistan. Finbarr O'Reilly.

343 An Afghan policeman returns to his base in Kolk. 15 November 2007. Kolk, Afghanistan. Finbarr O'Reilly.

344 An Afghan puppy adopted by Canadian soldiers from the NATO-led coalition sits in his sandbagged kennel at Three Tank Hill base near Panjwaii town in southern Afghanistan. 27 October 2007. Panjwaii, Afghanistan. Finbarr O'Reilly.

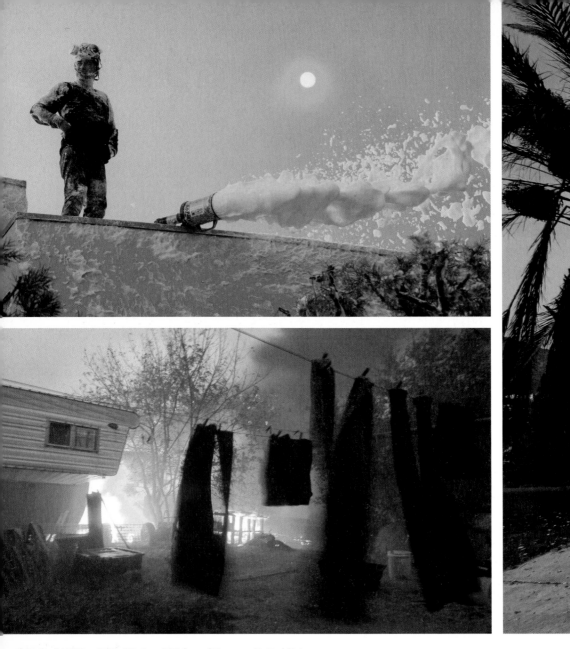

345 [TOP] Malibu, United States **346** [ABOVE] Ramona, United States

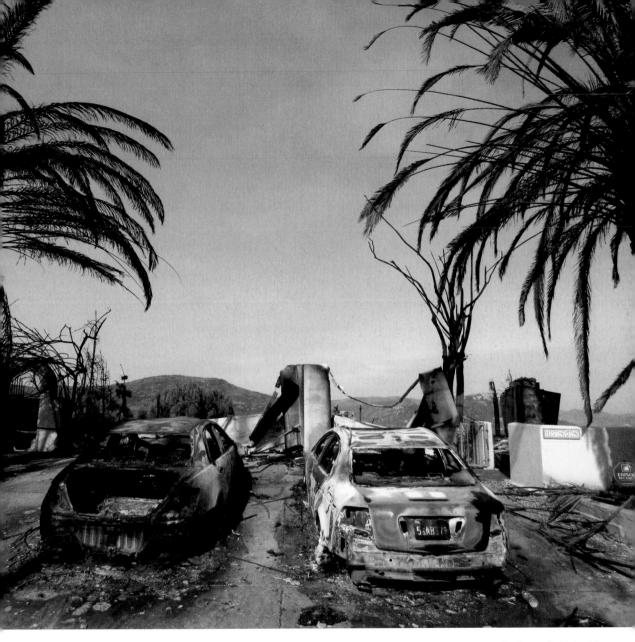

347 Rancho Bernardo, United States

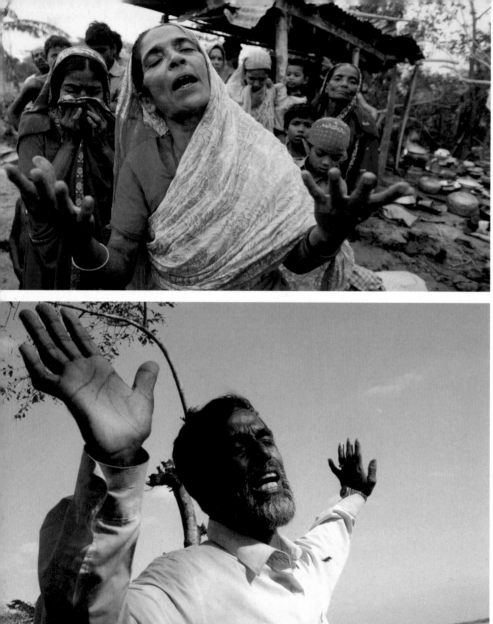

348 [TOP] Bakerganj, Bangladesh **349** [ABOVE] Mirzaganj, Bangladesh

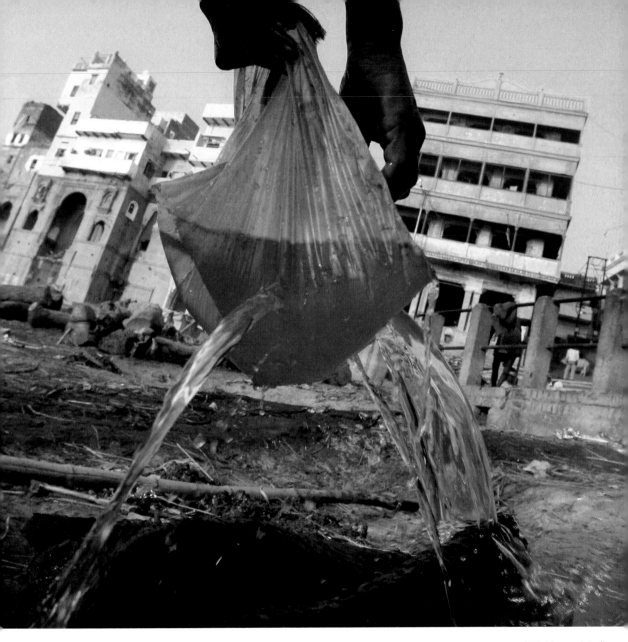

350 Varanasi, India

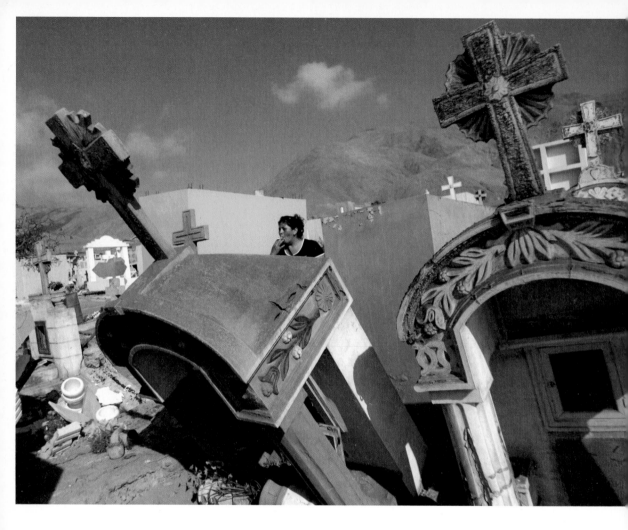

351 Tocopilla, Chile

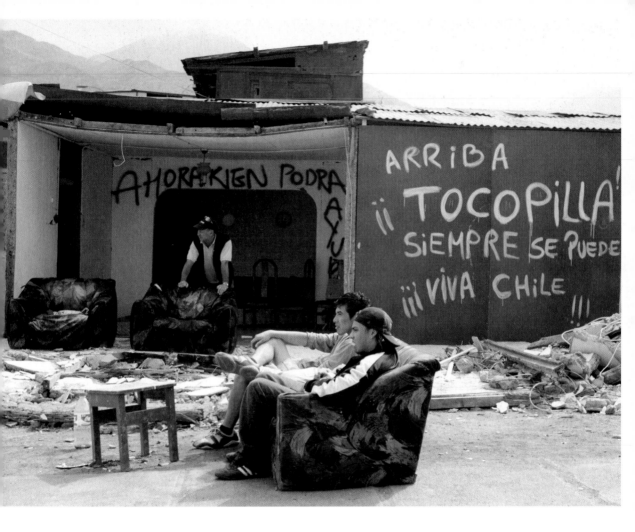

352 Tocopilla, Chile

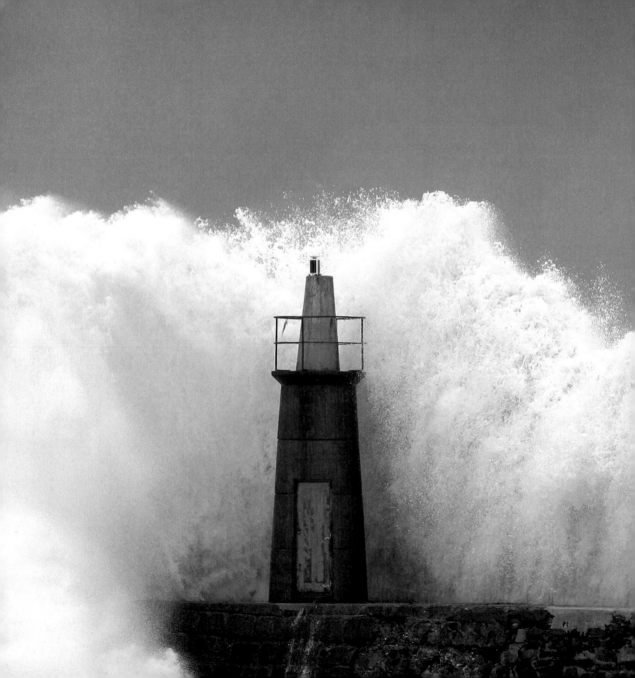

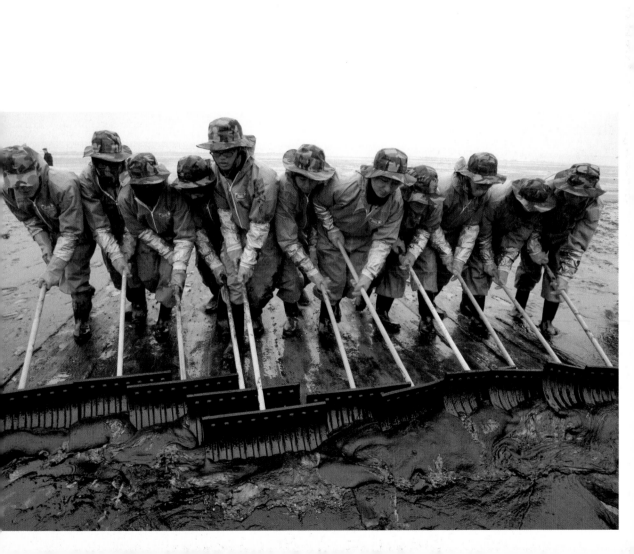

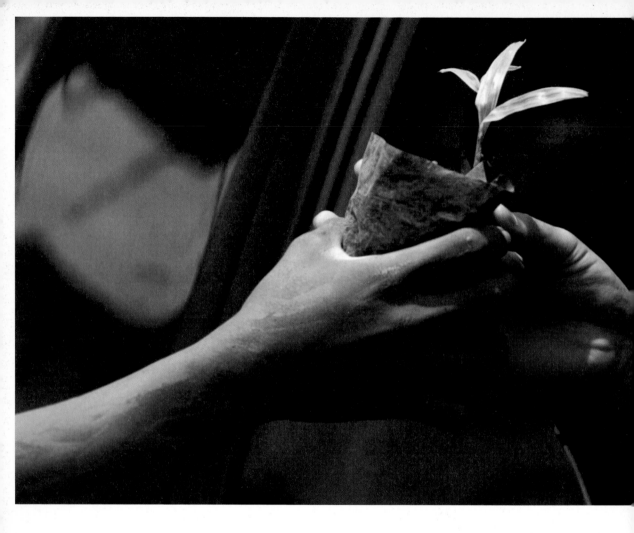

355 Surabaya, Indonesia

356 [OPPOSITE] Barcelona, Spa

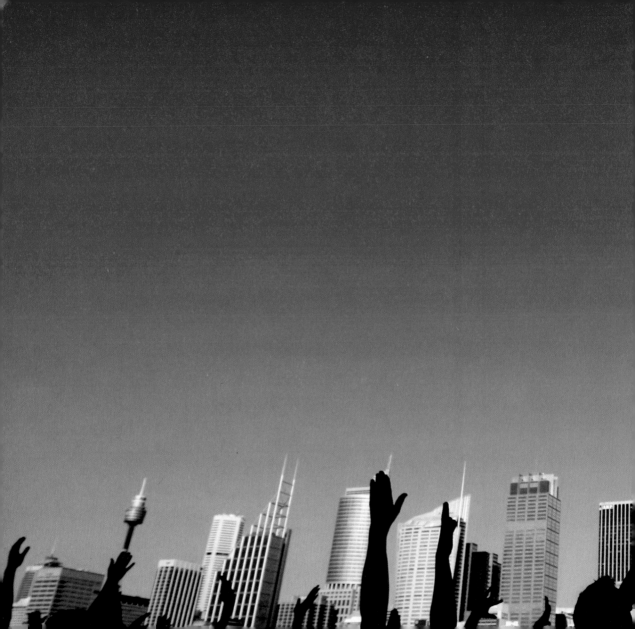

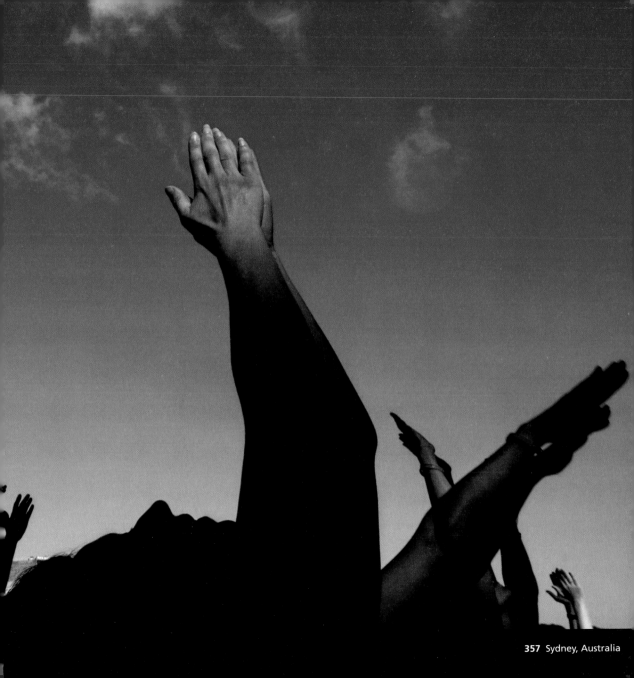

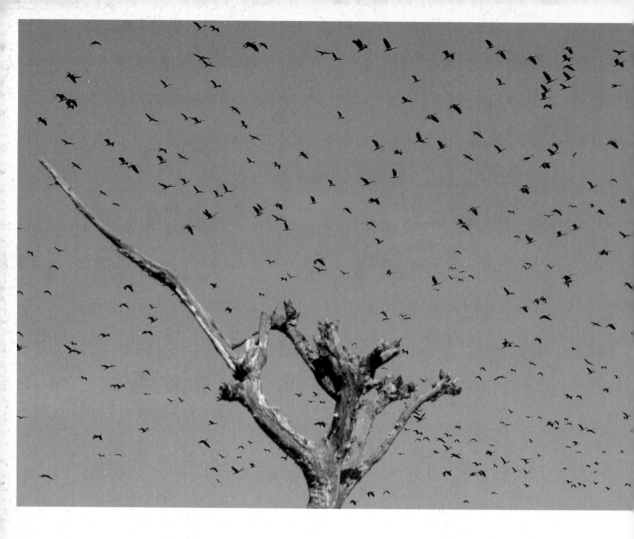

358 Sipaijala, India

359 [OPPOSITE] Sidon, Leban

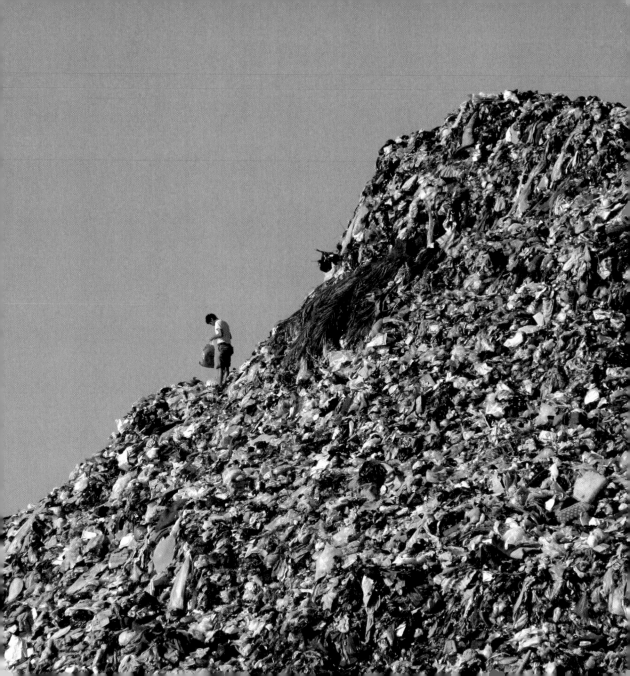

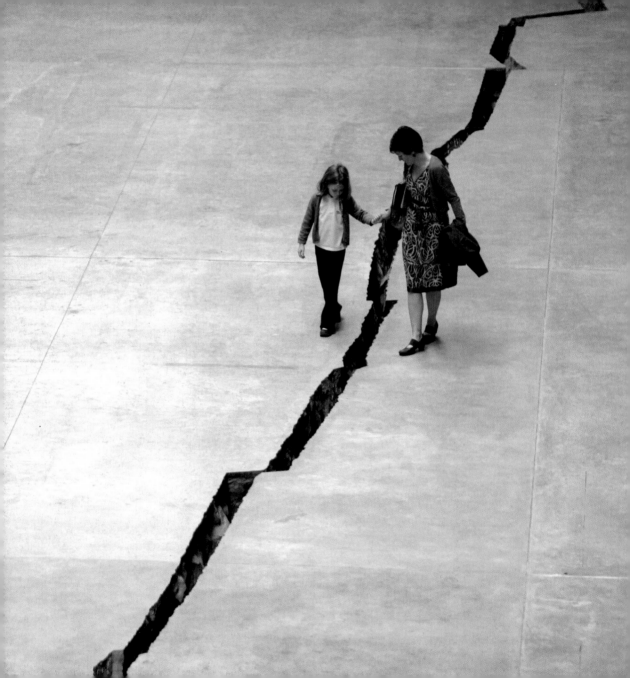

345 346 347 348 349 350 351 352 353

354 355 356 357 358 359 360

A worker sprays fire retardant foam as firefighters battle to contain a wildfire in Malibu, California. Wildfires toppled power lines, blackened hillsides and reduced homes to piles of melted metal and concrete. They forced the largest evacuations in California's modern history. 21 October 2007. Malibu, United States. Phil McCarten.

Jeans flap on a clothesline in the dry Santa Ana winds as flames approach a house in Ramona, California. 21 October 2007. Ramona, United States. Fred Greaves.

The remains of a home smoulder after being destroyed by wildfire in the Rancho Bernardo neighbourhood north of San Diego. 24 October 2007. Rancho Bernardo, United States. Mike Blake.

Niru Begum tells how her 80-year-old mother died when their house collapsed in Bakerganj, 340 km (210 miles) southwest of Dhaka. Grieving survivors and rescuers picked through the rubble after a super cyclone killed more than 3,200 people and made millions homeless. 17 November 2007. Bakerganj, Bangladesh. Rafiqur Rahman.

Altaf Sikdar describes how the cyclone destroyed his property on the banks of the River Paira in Mirzaganj, 310 km (190 miles) from Dhaka. 18 November 2007. Mirzaganj, Bangladesh. Rafiqur Rahman.

350 A worker douses a pyre at a cremation ground on the banks of the Ganges in the northern Indian city of Varanasi. Hindus believe that dying in Varanasi and having their remains scattered in the Ganges allows their soul to escape a cycle of death and rebirth, attaining *moksha* or salvation. 16 December 2007. Varanasi, India. Arko Datta.

351 A woman surveys the cemetery in Tocopilla, some 1,560 km (970 miles) north of Santiago. A powerful earthquake hit northern Chile on 14 November, killing at least two people, injuring more than 100, and halting output at some of the world's largest copper mines. 15 November 2007. Tocopilla, Chile. Ivan Alvarado.

352 Earthquake victims in Tocopilla gather outside their damaged homes. 6 November 2007. Tocopilla, Chile. Mariana Bazo.

353 Huge waves crash onto Viavelez's seafront in the northern Spanish region of Asturias. 9 December 2007. Viavelez, Spain. Eloy Alonso.

354 South Korean soldiers work to clean Mallipo beach after 10,500 tonnes of crude oil spilled from a tanker off Taean, about 170 km (110 miles) southwest of Seoul, an area known for its wildlife and vibrant marine economy. 10 December 2007. Taean, South Korea. Jo Yong-Hak.

355 An environmental activist hands a seedling to a car driver in Surabaya ahead of U.N.-led climate change talks in Bali. 8 December 2007. Surabaya, Indonesia. Sigit Pamungkas.

356 Al Gore, former U.S. vice president and 2007 Nobel Peace Prize winner, addresses the 2007 INMAS (Integrated Management Systems) Forum in Barcelona. 23 October 2007. Barcelona, Spain. Gustau Nacarino.

357 Yoga enthusiasts perform sun salutations in front of the Sydney skyline to support the charity Yoga Aid Challenge. 10 October 2007. Sydney, Australia. Tim Wimborne.

358 Migratory birds fly over the Sipaijala lake wetland in northeastern India. 13 November 2007. Sipaijala, India. Jayanta Dey.

359 A scavenger picks through a huge rubbish dump on the Sidon seafront in south Lebanon. About 20 metres (60 feet) high, the dump is close to schools, hospitals and apartment blocks. 12 November 2007. Sidon, Lebanon. Jamal Saidi.

360 Visitors inspect Colombian artist Doris Salcedo's *Shibboleth* in Tate Modern art gallery, London. The work is a trench cut into the concrete floor of the former power station and running its entire 167 metre (550 foot) length. 8 October 2007. London, Britain. Luke MacGregor.

Acknowledgments

Picture Editor Ayperi Karabuda Ecer is Vice-President of Development of Photography at Reuters, heading a team dedicated to enhancing news photography. She was Editor-in-Chief of Magnum Photos Paris for 12 years and Bureau Chief for Sipa Press in New York. Ayperi is of Swedish–Turkish origin, based in Paris.

Project Director Jassim Ahmad joined Reuters in 2000 and works in the Media division as Head of Visual Projects, with responsibility for producing photographic books, exhibitions and other visual communications. Jassim is of British–Indian nationality and is based in Reuters' London headquarters.

With thanks to Paul Barker, Valerie Bezzina, Jane Chiapoco, Simon Newman, Alexia Singh, Akio Suga, Thomas Szlukovenyi, Aldrina Thirunagaran, Thomas White, Alison Williams and Dennis Yeo.

Contributing Photographers

The country that follows each name represents the photographer's nationality

Abed Omar Qusini, Palestinian Territories
Adeel Halim, India
Adnan Abidi, India
Adrees Latif, United States
Ahmad Masood, Afghanistan
Ahmed Jadallah, Palestinian Territories
Ahmet Ada, Turkey
Albert Gea, Spain
Alberto Berti, Italy
Alessandro Bianchi, Italy
Alessia Pierdomenico, Italy
Alexander Demianchuk, Ukraine
Alfred Cheng Jin, China
Ali Jarekji, Syria
Aly Song, China
Amir Cohen, Israel
Amit Gupta, India
Ammar Awad, Israel
Amr Dalsh, Egypt
Andrea Comas, Spain
Andres Stapff, Uruguay
Anton Meres, Spain
Arko Datta, India
Bai Gang, China
Bazuki Muhammad, Malaysia
Beawiharta, Indonesia
Benoit Tessier, France
Bob Strong, United States
Bobby Yip, Japan
Boniface Mwangi, Kenya
Brendan McDermid, United States
Brian Snyder, United States
Bruno Domingos, Brazil
Caren Firouz, Iran
Carlos Barria, Argentina
Carlos Garcia Rawlins, Venezuela
Ceerwan Aziz, Iraq
Charles Platiau, France
Chavosh Homavandi, Iran
Chen Zhuo, China
Chor Sokunthea, Cambodia
Christian Charisius, Argentina
Christian Hartmann, France
Christinne Muschi, Canada
Claudia Daut, Germany
Damir Sagolj, Bosnia
Daniel Munoz, Colombia
Danilo Krstanovic, Bosnia
Darren Staples, Britain

Darren Whiteside, Canada
Darrin Zammit Lupi, Malta
David Carlson, United States
David Gray, Australia
David Mdzinarishvili, Georgia
David Moir, Britain
Denis Sinyakov, Russia
Desmond Boylan, Ireland
Dylan Martinez, Britain
Eddie Keogh, Britain
Eduard Korniyenko, Russia
Eduardo Munoz, Colombia
Edward Ou, Canada
Eliana Aponte, Colombia
Eloy Alonso, Spain
Enrique Castro-Mendivil, Peru
Enrique De La Osa, Cuba
Enrique Marcarian, Argentina
Eric Gaillard, France
Eric Miller, United States
Eric Thayer, United States
Fabrizio Bensch, Germany
Faisal Mahmood, Pakistan
Fatih Saribas, Turkey
Fayaz Kabli, India
Finbarr O'Reilly, Canada
Francesco Spotorno, Venezuela
Francois Lenoir, Belgium
Fred Greaves, United States
Giampiero Sposito, Italy
Gil Cohen Magen, Israel
Gleb Garanich, Russia
Gonzalo Fuentes, Mexico
Goran Tomasevic, Serbia
Grigory Dukor, Russia
Gustau Nacarino, Spain
Hannibal Hanschke, Germany
Hazir Reka, Kosovo
Helmiy al-Azawi , Iraq
Ibraheem Abu Mustafa, Palestinian
 Territories
Ibrahim Sultan, Iraq
Ivan Alvarado, Colombia
Ivan Chernichkin, Ukraine
Jamal Saidi, Lebanon
James Akena, Uganda
Jamil Bittar, Brazil
Jason Lee, China
Jason Reed, Australia
Jayanta Dey, India
Jayanta Shaw, India
Jean-Paul Pelissier, France
Jerry Lampen, Netherlands
Jim Bourg, United States
Jim Young, Canada

Jitendra Prakash, India
Jo Yong-Hak, South Korea
Joe Tan, China
John Gress, United States
John Kolesidis, Greece
Jon Nazca, Spain
Jonathan Ernst, United States
Jorge Silva, Mexico
Jose Luis Quintana, Bolivia
Joshua Roberts, United States
Juan Medina, Argentina
Kacper Pempel, Poland
Kai Pfaffenbach, Germany
Katrina Manson, Britain
Kena Betancur, Haiti
Kevin Coombs, Britain
Kevin Lamarque, United States
Khaled Abdullah, Yemen
Kieran Doherty, Britain
Kim Kyung-Hoon, South Korea
Koen van Weel, Netherlands
Krishnendu Halder, India
Larry Downing, United States
Laszlo Balogh, Hungary
Leo Lang, China
Louafi Larbi, Algeria
Luc Gnago, Ivory Coast
Lucas Jackson, United States
Luke Macgregor, Britain
Marcos Brindicci, Argentina
Mariana Bazo, Peru
Mario Anzuoni, Italy
Max Morse, United States
Max Rossi, Italy
Mian Khursheed, Pakistan
Michael Dalder, Germany
Michaela Rehle, Germany
Mick Tsikas, Australia
Miguel Vidal, Spain
Mike Blake, Canada
Mikhail Kuznetsov, Russia
Mohamed Azakir, Lebanon
Mohammad Babaei, Iran
Mohammed Salem, Palestinian Territories
Morteza Nikoubazl, Iran
Nacho Doce, Spain
Namir Noor-Eldeen, Iraq
Nasser Nuri, Egypt
Nayef Hashlamoun, Palestinian Territories
Neal Hamberg, United States
Nicky Loh, Singapore
Nikolay Doychinov, Bulgaria
Nir Elias, Israel
Noor Khamis, Kenya
Ognen Teofilovski, Macedonia

Oleg Popov, Bulgaria
Omar Sobhani, Afghanistan
Pan Bing, China
Parth Sanyal, India
Patricio Valenzuela Hohmann, Chile
Paul Yeung, Hong Kong, China
Petr Josek, Czech Republic
Phil McCarten, United States
Phil Noble, Britain
Philippe Wojazer, France
Radu Sigheti, Romania
Rafael Marchante, Spain
Rafiqur Rahman, Bangladesh
Reinhard Krause, Germany
Rick Wilking, United States
Robert Galbraith, United States
Romeo Ranoco, Philippines
Ronen Zvulun, Israel
Russell Boyce, Britain
Said Tsarnayev, Russia
Santiago Ferrero, Spain
Sean Yong, China
Sergei Karpukhin, Russia
Shannon Stapleton, United States
Sharon Perry, United States
Sheng Li, China
Sigit Pamungkas, Indonesia
Siphiwe Sibeko, South Africa
Srdjan Zivulovic, Slovenia
Stephen Hird, Britain
Steve Crisp, Britain
Suhaib Salem, Palestinian Territories
Supri, Indonesia
Susana Vera, Spain
Tao Debin, China
Tara Todras-Whitehill, United States
Thomas Peter, Germany
Tim Wimborne, Australia
Tobias Schwarz, Germany
Toby Melville, Britain
Umit Bektas, Turkey
Utpal Baruah, India
Vasily Fedosenko, Belarus
Victor Fraile, Spain
Wolfgang Rattay, Germany
Yannis Behrakis, Greece
Yiorgos Karahalis, Greece
Yonathan Weitzman, Israel
Yuri Maltsev, Russia
Zahid Hussein, Pakistan
Zohra Bensemra, Algeria